THIS BUSINESS OF ART

THIS BUSINESS OF ART

DIANE COCHRANE

WATSON-GUPTILL PUBLICATIONS/NEW YORK

Copyright © 1988 by Diane Cochrane

First published 1988 in the United States and Canada by Watson-Guptill Publications, a division of Billboard Publications, Inc., 1515 Broadway, New York, N.Y. 10036.

Library of Congress Cataloging-in-Publication Data

Cochrane, Diane.
 This business of art.

 Bibliography: p.
 Includes index.
 1. Art—United States—Marketing. I. Title.
N8600.C62 1988 706'.8'8 87-29614
ISBN 0-8230-5361-X

Distributed in the United Kingdom by Phaidon Press Ltd., Littlegate House, St. Ebbe's St., Oxford

Manufactured in the U.S.A.

First Printing, 1988

5 6 7 8 9 10/99 98 97 96 95 94

To Donald Holden

Special thanks for the expertise and assistance of Howard Thorkelson, Esquire, in writing the first edition of *This Business of Art* and for the help and encouragement of Calvin Goodman and Tad Crawford, Esquire, in writing both editions.

CONTENTS

One

FIRST THINGS FIRST: CONTRACTS

ELEMENTS OF A CONTRACT

WRITTEN VERSUS ORAL

OFFER AND ACCEPTANCE

GETTING IT IN WRITING

BREACH OF CONTRACT

SUING

The millennium has arrived. In the mid-eighties, *The New York Times* announced in an article entitled "A Different Bohemia" that the idea of the poor, struggling artist had been rejected. Said one observer of the new art scene, "It's not chic to be a starving artist anymore." Another commented, "These people [artists] are ambitious and goal-oriented and they want to make money and be successful." Even John Russell, the *Times*'s chief art critic, was quoted as saying, "Bohemia used to be a place to hide. Now it's a place to hustle."

All fine and good. A certain amount of materialism never hurt anyone, not even a painter or printmaker. It takes more than ambition to be successful, however; it takes business know-how. You have to know how to negotiate contracts, how to protect your rights, how to keep your books.

The reason artists usually seem to come off badly in business dealings is not that they like to struggle or starve but that they rarely arm themselves with the same legal weapons that others use. Until you attain the kind of affluence that allows you to rely on a battery of lawyers, accountants, and other advisors, this book will show you how to defend yourself with the legal artillery available to you.

The strongest weapon in that artillery is the written contract. This is the foundation of all business relationships; a strong, enforceable contract provides you with solid protection because

the courts will back it up if necessary. Hence this opening chapter on the basics of contractual law. (Specific contracts, such as commission agreements and gallery contracts, are discussed in later chapters.)

What is a contract?

Before a definition of the word *contract* is set out, it may be useful to get rid of any preconceived ideas you may have about it. Many people think of a contract as a lengthy, formal document drawn up by a battery of lawyers. A contract may be just that, but it can also be an oral deal, an exchange of letters, or just one short letter signed by two or more people. If you're one of those people for whom the word *contract* triggers visions of a twenty-page legal document, you might want to substitute the word *agreement* and remember that a contract is any legally binding agreement.

A contract can be defined as a voluntary agreement between two or more persons. Both parties promise, either orally or in writing, to do something (or *not* to do something), and both have the right to demand that the other carry out his or her side of the bargain.

When do artists make contracts?

You make oral contracts all the time. When you buy art supplies, for instance, you make an oral agreement to exchange money for canvas. The contracts generally referred to in this book are agreements that are somewhat more complicated: contracts you make when you consign or sell work to a gallery; when you sell or rent work directly to a collector; when you accept a commission; when you sell reproduction rights to a publisher; when you exhibit your work; or when you lend work to a museum.

When is a contract enforceable by law?

Four conditions must be met before any contract can be enforced by law: (1) competence of the parties involved; (2) legality of purpose; (3) mutual agreement; and (4) consideration.

What does competence of parties mean? Competence of parties refers to mental competence. This means that you can forget about making binding contracts with people who are senile, under the influence of alcohol or drugs, or certified insane.

What does legality of purpose mean? There must be nothing illegal about the agreement, nor can anything in the agreement be interpreted as being against public policy.

For example, if you and a publisher agree to make an edition of reproductions produced by a photomechanical process and then to sell them as original prints, your purpose is to defraud the public. In the event that you sue the publisher for some reason—say nonpayment—the defense could be that the contract was invalid because its purpose was illegal.

You might also find yourself tied into a contract with an illegal purpose if your product can be construed as obscene or libelous. Suppose that a magazine asks you to draw a politician and emphasize his drinking habits. If the publication reneges on payment and you sue, the court might find that the drawing was libelous and rule the contract void. In that case, you would not get paid.

Or you might accept a commission to paint a mural, realistically portraying nudes embracing, for a public place and later need to sue to recover an unpaid fee. In your eyes, the nude figures may express the joy of love, but a judge might decide your mural is obscene and void the contract.

The problem is that there aren't any legal definitions spelling out exactly what libel and obscenity are. Each case is interpreted on its own merits. So proceed carefully before making a contract that looks dubious to you on these grounds.

What does mutual agreement mean? In every contract, both parties must agree on the same set of terms. For example, if you offer to sell four paintings for $2,000 and a collector accepts, you've got a contract. But if she says she wants five paintings for $2,000, there's no contract because the two of you haven't agreed to the same terms.

What does consideration mean? Whoever makes a contract must get something for it. Consideration is the money or object or whatever you must give to get what you want. Both parties must give consideration. In other words, if you offer to sell a painting for $500 and your client agrees, you've made a contract. Your contribution to the contract (your consideration) is the painting; your client's is the cash. But if you merely promise to *give* a painting to a friend and then change your mind, he can't force you to hand it over because he would be getting something for nothing.

Must consideration be explicitly stated? Yes, consideration must be clearly spelled out. A contract must state, "I will paint your portrait for $500," not "I will paint it if you will pay me," or "if you will pay me a reasonable sum." The last two examples don't qualify as valid statements of consideration.

Should a contract be in writing?

Not all contracts must be in writing. In the course of an ordinary day, you make dozens of oral agreements. You may order groceries or supplies over the phone, or you may hire a model. Naturally, these agreements don't need to be confirmed in writing—if they did, you would drown in paperwork. But as soon as a situation arises where it's important to prevent misunderstandings, put the deal in writing. Arrangements made with galleries, clients, publishers, and museums demand written agreements.

Sure, oral contracts are enforceable *in theory*. But when it comes down to your word against someone else's as to the terms of a contract—or even whether one exists—you'd better have some mighty reliable witnesses to back you up, as well as the money to finance a lawsuit. The failure to get a written contract has deflated many high hopes and inflated the wallets of those in the legal profession.

Why are artists reluctant to press for written contracts?

Many artists are afraid that prospective clients, galleries, and other business contacts will think of a written agreement as a hassle—and far be it from artists to create any unpleasantness! Instead, they're often willing to perpetuate their own weaknesses by not standing up for their rights.

But why? Most clients and dealers wouldn't think of operating without contracts themselves. Why should an artist be any different? If you don't respect your work enough to hold out for the best deal you can get—and to get it in writing—you're doing yourself a disfavor.

When is a written contract required by law?

According to the Uniform Commercial Code (a set of laws for commercial dealings and sale of goods that has been adopted by the District of Columbia and all the states except Louisiana), you must have a written contract if: (1) the contract states that the agreement cannot be completed within one year from the date of the contract (called the one-year rule); or (2) the contract is for the sale of goods priced at $500 or more. In both cases, oral agreements won't stand up in court.

What exactly is the one-year rule? This is most easily explained by an example. If a publisher plans to buy one print from you each month for the next eighteen months, the transaction cannot be completed in one year. And even if you contract to sell him one

print each month for the next twelve months beginning next month, that cannot be completed within one year. Both of these contracts must be in writing to be enforceable in a court of law.

Would commissions fall under the Code rule? No, commissions to make artwork refer to services, not goods, and thus don't fall under this law. They do not have to be in writing.

What terms should always be stated in written agreements?

It is wise to put in the names and addresses of the parties who sign the agreement; the date the contract was made; delivery or completion dates; and the consideration—price and quantity. For instance, "I will sell two paintings for $1,000"; or "for $5,000 I will sell five paintings plus all reproduction rights"; or "I consign twenty works to you and in return you will pay me the price you receive for each work sold, less a 40 percent commission" will suffice.

After you read the other chapters in this book that refer to contracts, you may find more clauses that should go into your own. The subsequent chapters deal with galleries, exhibitors, clients, people who commission your work, publishers, and museums. You won't be interested in every possibility, but you can pick and choose the clauses you want to include in a written contract.

Are any oral contracts enforceable?

Theoretically, if a contract involves the sale of goods worth less than $500 and will be fulfilled within less than a year, an oral agreement is as valid as a written one and is enforceable by law. But *realistically,* an oral agreement is only as good as the witnesses who hear it, so why take the chance? Write it down. If you've already placed yourself in jeopardy by making an oral agreement, however, see below for what you can do if it falls apart.

What is the simplest type of contract?

Someone makes an offer and someone else accepts the offer.

This can be as simple as a brief dialogue followed by a handshake, which people do all the time. One person says something like, "I'll sell you a painting for $500." The other says, "Agreed." And the next thing you know, they're shaking hands.

Exactly the same thing can be done by an exchange of letters, one person making an offer and the other accepting it. Or both parties can sign the letter that makes the offer—so just one letter will do.

Can I take back an offer once I've made it?

Yes, but only if the offer hasn't been accepted. If your offer is in writing, take it back in writing—and do it soon! If your offer has been accepted and you revoke it, you can be sued for breach of contract.

Is a gallery display of my work with a price tag an offer?

Yes. You can't raise the price.

What if the other party wants time to think an offer over?

You have two choices.

Suppose a client drops into your studio one afternoon, and you offer to sell her a piece. She says she'd like to sleep on the matter overnight. You'll probably agree to extend the time as a courtesy.

But suppose you're having a show, and a number of prospective buyers are present. Giving one client 24 hours to think about the purchase *may* mean that you'll have to turn down other offers. So you'd give the first prospect an *option* on his offer.

What is an option? An option is a special agreement to keep an offer open for a certain period of time. The option is usually separate from the final contract, and consideration must be present to protect both parties to the agreement.

Suppose you put your studio up for sale for $15,000. A prospective buyer is interested but wants a month to see if she can raise the money. In the meantime, you might have to turn down other offers—offers that may not come your way again for some time. Your wisest course of action would be to offer her an option on the studio in which you promise not to sell it for a month if she will give you a percentage of your asking price for that waiting period. Then, even if she rejects the offer, you've been compensated for delaying the decision. If she accepts the original offer when the option expires, you write up a purchase contract, deducting the option fee from the purchase price.

If the offer has been made and accepted orally, what's next?

Offers are frequently made and accepted in conversation, but while you're talking, you should make one of the conditions of the deal be that it will be put into writing later. If the agreement is relatively simple, your next step would be to summarize its terms in a letter of agreement. You should do this whether you made the offer or accepted it. Here's an example of a letter of agreement couched in plain, everyday, nonlegal terms:

Dear John Dealer:

This letter confirms the details of the agreement we made over the telephone this afternoon.

Between January 15 and February 2, 19__, you will mount a one-person exhibition of twenty of my paintings at your gallery at 2 South Broadway, New York City. Your commission on all sales will be 50 percent of the retail price, which we will mutually determine.

You will prepare and pay for one ad in *American Artist* and one ad in *The New York Times*. You will also have designed and printed and will pay for a postcard announcement showing my painting *New Dawn* on the front in color. You will mail the announcement to 2,000 people and pay all postage. You will insure the twenty paintings for 50 percent of retail price, and you will pay for wine and cheese for an opening on January 15 for 200 people.

I will arrange and pay for the framing of all twenty paintings and help with the installation of the show.

If you are in agreement with these terms, please sign at the bottom of both this letter and the attached copy, return this letter to me, and keep the copy for your records.

What if he doesn't return my letter but replies with his own letter outlining the terms? Providing that the terms are the same, a letter bearing his signature would be the equivalent of signing and returning your letter. Make sure that you file both his letter and a copy of yours.

What if his reply letter outlines different terms? If the terms are substantially the same as yours and/or you decide to agree to them, you don't have to do anything. If, however, you don't agree with his terms, simply reply in writing that the deal is off and give the reason. And remember, always keep a copy of all correspondence for your files.

What if he doesn't answer at all? Your oral agreement is theoretically valid, but before you carry out your end of the deal, it's best to insist that he sign and return your letter. His refusal to do so might indicate unwillingness to fulfill his side of the bargain.

How do I back out if I don't get a reply? Write another letter saying that he failed to fulfill one of the conditions of the oral agreement—that the contract was to be put in writing—and that therefore you consider the deal finished.

If I make an oral agreement with someone and he confirms in writing, can I back out?

According to the Uniform Commercial Code, an oral agreement

made between "merchants" and followed by a written confirmation can be rejected in writing within ten days after it was received. Even though there aren't two signatures on the written confirmation, the receiver's lack of response means that he or she accepts the offer. For example, suppose you agree to sell six etchings for $800 to a dealer, who confirms the terms of the sale by letter. If you change your mind but don't respond in writing within ten days, the etchings are hers.

Am I considered a merchant? The Code says, "A merchant means a person who deals in goods of the kind or otherwise by his occupation holds himself out as having knowledge or skill peculiar to the practices or goods involved in the transaction." This is an ambiguous statement, so there's no way to be sure whether or not a court would decide that you are a "merchant." But why bother to take a chance? Play it safe—behave like a merchant and reject the offer in writing. You may save yourself a lot of grief later on.

When should I get a lawyer to help draft a contract?

The only way to answer this question is to use your common sense. Anytime you hire a lawyer, you're going to run up a substantial legal bill—maybe $100 or $200 for a few hours' work. So you've got to figure out if you'll make enough money on the deal to justify the fee. If the deal is a $1,000 commission and it's a perfectly straightforward arrangement, a $100 or $200 legal bill might not be worth it.

On the other hand, if a lot of money is involved; if a number of steps are involved in the commission (sketches, models, and so on); if you have to please more than one person; or if you want to know what to do about selling a copyright or reproduction rights, then getting advice from an attorney may be worth it to prevent headaches later on. Besides, if the contract involves tough negotiation, a lawyer may be a better bargainer than you and may be able to secure a better agreement. Only after weighing all these factors can you decide if you need legal advice.

However, you may be eligible for some free legal advice. A number of art-conscious lawyers around the country have banded together to form groups of "Volunteer Lawyers for the Arts." They give free legal aid to artists unable to afford legal fees.

How can I find a volunteer lawyers' group in my area?

Up-to-date information on the volunteer lawyers closest to your location can be obtained from one of the following established groups:

If I sign a contract but later decide it isn't fair, what can I do?

You can't do anything, unless you can prove there's something illegal about it. If you mean it's "unfair" because you think you're not getting a fair shake, it's too late. Suppose the rules of a juried exhibition state that reproduction rights for the winning work must be transferred to the sponsor in exchange for the prize money. When you entered the exhibit, you agreed, but later, when you won, you felt that you were being taken. Too bad. The time to make that decision was before—not after—signing the entry form, which *is* a contract.

What if the other party doesn't fulfill his or her part of the contract?

If the other person doesn't live up to his or her side of the agreement—or in legal terms, breaches the contract—you can *threaten* to sue. Sometimes a little "persuasion" can turn the trick and the other party might fulfill the contract.

If this doesn't work, you'll have to bring in the heavy artillery: hire a lawyer and sue.

What can I sue for?

You can sue for specific performance, recision of the contract, an injunction, and/or money damages.

What is specific performance? Theoretically, this means that you can sue to force someone to perform or carry out the specific terms of the agreement. But in *reality,* it works only in a few special cases. The courts don't want the job of overseeing the fulfillment of

contracts, so they limit this kind of legal action to the sale of land and certain personal property that is so unique, like a Rembrandt painting, that it can't be obtained readily in the market. So forget about specific performance and look to the other ways to satisfy your claim.

What is recision? Recision restores you and the other person to where you were *before* you made your bargain. In other words, recision undoes the contract. Suppose you discover that your dealer, with whom you have a written contract, hasn't been living up to his agreement to insure your work while it is on his premises, to furnish you with names of collectors, and so on. You can simply sue for recision, get out of the whole arrangement, and get your work back.

What is an injunction? An injunction is a court order preventing one party from doing something injurious to the other. Imagine that you have a contract with a publisher to make an edition of original lithographs, but you discover that he's been producing cheap reproductions of the same work on the side. An injunction will stop him because it isn't part of the contract.

Looking at a legal suit from another point of view, suppose you have a contract with a dealer but refuse to consign any more work to him. Though it's impossible to force someone to do something—specific performance won't apply—he *could* ask the court for an injunction to prevent you from consigning work to anyone else.

What sort of money damages can I sue for? You can sue for either the amount actually due you or compensatory damages. Compensatory damages are paid when you sustain a loss because someone breaches the agreement. Let's say that a corporation commissions you to create a large outdoor sculpture. Since you know that this will take six months, you turn down several other lucrative offers because you won't have the time for them. The corporation then reneges on the deal, and you're out of work for six months. Even though you haven't started the commission, you've sustained a loss, and you should be compensated for it. Of course, the court won't be sympathetic to demands for substantial damages if you do have the opportunity to substitute another commission for the one you lost (and the corporation will try to prove this).

If I don't have a written agreement and can't prove the terms of an oral one, must I suffer a total loss if the contract is breached?

Not necessarily. Fortunately, some help is available to legal innocents under the doctrine of "unjust enrichment," which holds

that one person cannot be unjustly enriched at the expense of another. So if you agree to paint a series of murals for a restaurant for $5,000 and the owner refuses to pay you on completion, you can take him to court. But now it's the court's job to put a price tag on the work, since there's no written agreement. That price might not be as high as yours, once more proving the value of a written contract.

COPYRIGHT AND OTHER RIGHTS

PUBLICATION
COPYRIGHT NOTICE
REGISTRATION
DURATION
INTERNATIONAL PROTECTION
TRANSFER
FAIR USE
SUING FOR INFRINGEMENT
PATENTS

Many years ago, the Museum of Modern Art in New York bought *Christina's World* from Andrew Wyeth for a few hundred dollars. Since that time, the museum has earned over $1,000,000 from reproductions, but not a dime in royalties has found its way to Wyeth.

How could it happen that an artist wasn't compensated for the money his work generated? This is only surmise, but based on the copyright law then in effect, it could have come about in a number of ways. Naturally, Wyeth might have willingly given the museum the copyright. But he might also have unknowingly sold it along with the painting itself. Or he might have unwittingly "published" (an ill-defined term explained below) the painting without copyright notice, a fatal error which gives to anyone who wants it the right to copy the work.

Today, the Copyright Revision Act of 1976, effective January 1, 1978, goes a long way to protect artists against the accidental loss of copyright and furnishes them with a good defense in court against infringers. The best defense, however, is to secure copyright properly.

Money isn't the only issue. Royalties and other fees may be small compensation for a tarnished reputation. As a reputable fine artist, your name will hardly be enhanced by the appearance of one of your paintings on a sleazy greeting card or cheap liquor advertisement.

So you should know your rights under copyright law. This knowledge, coupled with what you learned about contracts in Chapter 1, should arm you well in the world of business.

What is a copyright?

A copyright gives its owner the exclusive rights to reproduce, sell, distribute, display, and publish artwork and to make other types of work from it, such as reproductions from a painting or a sculpture from a drawing. Conversely, copyright prevents anyone else from doing these same things.

What can I copyright?

Anything that's artistic (two- and three-dimensional works of fine, graphic, and applied art) and original. The law doesn't mean that a work has to measure up to any aesthetic standard to be considered artistic; even a minimally artistic work, such as a child's drawing, can be copyrighted. The law also doesn't define originality in aesthetic terms. You may equate originality with imagination and creativity, but as far as the law is concerned, as long as you don't copyright someone else's work, it's original.

Can ideas be copyrighted?

People ask this question all the time, but the answer is no. Suppose you have an idea for a cartoon. If you want to hold on to it, don't mention the idea to a fellow cartoonist. Or suppose you have a new idea for painting in egg tempera, and you approach a publisher about the possibility of writing a book on it. You'll just have to take your chances that they won't steal your idea. Ideas aren't copyrightable—only the product, which in these cases would be the cartoon or the completed book.

Can I copyright subject matter or themes?

No. Subject matter, themes, and ideas don't belong to anyone. So there's nothing you can do if another artist chooses to use the same source material.

For example, nearly every artist who goes to Rockport, Massachusetts, immediately sets up his or her easel in front of two picturesque fishing shacks at the end of a wharf. It's one of the

most frequently painted scenes in the world; in fact, as a joke, it's called Motif No. 1. Thousands and thousands of paintings have been done of this view, and it wouldn't be surprising if many were similar, even almost identical. Nonetheless, every painting is original; each was painted from a subject accessible to everyone. No one can claim that anyone stole anything from anybody else. The only way that you could be accused of copyright infringement would be if you copied someone's painting directly.

What kind of artwork can be copyrighted?

Almost anything you can think of: paintings, sculpture, drawings, photographs, graphics, jewelry, models and maquettes, book illustrations, cartoons, reproductions, mixed media objects, and videotapes.

You cannot, however, copyright solely utilitarian objects, even though they may be so attractively shaped as to be considered artwork by some.

What is a "solely utilitarian" object?

Furniture, flatware, dishes, and tools would be examples that fall into this category.

Can I copyright artwork that's also useful?

Yes, as long as it's not solely utilitarian. This subtle distinction allows you to copyright artwork that is also an article of utility—like a stained-glass window—or that is embedded in a useful article. For example, you can't copyright a decorative shopping bag, but you can copyright the design painted on it.

Can I copyright crafts?

The same rules apply to crafts as to fine arts. Therefore, you can copyright wall hangings, ornamental pots, and so on. You can also copyright designs painted on utilitarian objects, such as cups and bowls.

Can I copyright my handmade cups and bowls?

No. Despite the fact that they may be beautifully shaped, you can't copyright them, although it may be possible to obtain a design patent (see below) on them.

Can I copyright titles of artwork?

No. We may associate *Christina's World* with Andrew Wyeth, but

he can't copyright the title to prevent anyone else from using it.

Can I copyright material that might be considered obscene?

The courts have taken the stand that obscene material is not eligible for copyright. But the Copyright Office has publicly declared that it won't refuse registration (defined later) on these grounds, for the simple reason that it isn't going to get into the business of defining obscenity. So you can copyright and register such a work with the Copyright Office. But problems may arise if you bring legal action to stop someone from illegally reproducing the work. The infringer may argue that the material is immoral, which, if proven, will render your copyright invalid. The issue then becomes what's obscene and, in some cases, how much of the work is obscene. One scene in a videotape could, depending on how much footage it consumes, destroy the validity of the copyright of the whole tape. It's up to the court to decide the issue.

What happens if I don't copyright my work?

If you don't copyright your work as explained below, it falls into the public domain, which means that anyone is free to copy it.

How do I get copyright protection?

At first, you don't have to do anything. Your work is automatically protected from the date of completion until the date of publication (see below). At the time of publication, you should protect your work by placing copyright notice (also described below) on the work. Before publication, you don't have to put a notice on your work or file papers or anything unless you want to, but, as explained below, there are some very good reasons why you may choose to do so.

What is publication?

Publication occurs when a work has been made public, that is, when you have made it available to the public in some fashion. The copyright law defines publication as follows:

> 'Publication' is the distribution . . . to the public by sale or other transfer of ownership, or by rental, lease, or lending. The offering to distribute . . . to a group of persons for purposes of further distribution, public performance or public display, constitutes publication. A public performance or display of a work does not of itself constitute publication.

All of which makes the definition of publication as clear as mud.

So let's look at the possible ways in which you can publish work, how to protect yourself against inadvertent publication, and what to do if you have already published by mistake.

Does publication occur if my work is offered for sale?

Maybe. If you offer a client a work in your studio, publication doesn't occur because you're not making the work available to the public at large. But if a dealer offers it for sale in a gallery, the answer is yes.

What if a reproduction of my work appears in promotional material or in publications?

Any reproduction you authorize will publish your work. The smart thing to do, therefore, is to place copyright notice (explained later in the chapter) on the work as soon as it's completed.

If a reproduction that you did not authorize is printed, it will not be considered "published." For example, if a reproduction you didn't authorize accompanies a critical review of your work, you're safe because this falls under the category of "fair use," described later.

Does publication occur when I exhibit in a gallery or museum?

Yes.

Does publication of a final work occur if a model of it has been published?

Maybe. This situation is not spelled out in the law. So play it safe—put a copyright notice on the model.

If I publish an edition of reproductions, will this publish the original painting?

Probably.

How can I protect myself against accidental publication?

This question and the one about what you can do if you've already published inadvertently should logically be answered here. But you need some more information before you can understand the answers, so hold on a bit.

What is proper copyright notice?

Copyright notice is something you put on the work of art. It is not

something you send to the Copyright Office for purposes of registration (see below).

What does copyright notice include?

Copyright notice consists of the word "Copyright," its abbreviation, "Copr.," or its symbol "©"; the full name of the copyright owner (not just your initials); and the year of first publication (or year of completion).

Which form of copyright is best?

There isn't any best form, but since you'll want to keep visual clutter to a minimum, © will probably be your choice. Furthermore, it's wise to use the © because that's the accepted symbol both in the United States and abroad.

Where is copyright notice placed?

The law demands that notice be placed where the public can see it if the public looks for it. The safest course dictates placement on the front of a two-dimensional object. Down in the left-hand corner, for example, is perfectly all right, providing the frame doesn't cover it up.

An equally obvious placement on a three-dimensional object would also be wise, as long as you don't put the notice on a base that isn't permanently attached to the object.

Can I put notice on the back or bottom of a work?

Yes, you can put the notice on the back of a painting or the bottom of an object—provided it can be seen if someone were looking for it. In other words, you can put it on the back of a two-dimensional work if it isn't covered by a backing or a frame. The bottom of a three-dimensional work is also acceptable, provided it can be picked up easily. So while you can get away with putting a copyright notice on the bottom of a five-pound sculpture, you can't with one weighing fifty pounds.

Is copyright notice on artwork reproduced in printed form sufficient notice?

It may be adequate, but chances are the reproduction will reduce the size of the notice to the point where it can't be seen clearly. So don't take a chance—insist in writing that whoever is publishing the reproduction insert another copyright notice under the picture.

Must I register my work to secure copyright protection?

No. Your rights are automatically protected by the law from completion until publication. After the publication date, all rights are secured by putting the copyright notice on the work.

The only time you *have to* register your copyright with the Register of Copyrights is if you're planning a legal action against an infringer of your copyright. In other words, if you open up a magazine one day and see an identical version of a painting of yours being offered for sale as a cheap reproduction, you can sue immediately if you have a Certificate of Registration. If you don't, you'll have to delay your suit until you get the certificate.

When can I register?

You can register artwork either before publication—as soon as it's completed, if you want—or anytime afterward.

How do I register copyright?

Write to the Copyright Office (Library of Congress, Washington, DC 20559) for Class VA forms for visual arts.

After filling out the form, return it to the Copyright Office with a fee of $10 and one photograph of an unpublished original work (paintings, sculpture, original graphics), or two photographs if it's published. If the work is a reproduction, you'll have to send one actual reproduction if the work is unpublished, two if it is published. The Registrar then issues a Certificate of Registration.

Do I have to register every work separately?

Not always. For unpublished work, you can make a group deposit of as many works as you wish. The deposit materials should be arranged in an orderly format with a single title, such as "Six Illustrations by Jane Artist, 19__." For published contributions to magazines and newspapers, there is a special group registration provision that may be available to you, but you must meet the following requirements: (1) the contributions must all have been published during a one-year period (not necessarily a calendar year); and (2) all the contributions must have had copyright notice in your name.

Why should I register copyright before I discover infringement?

First, according to stringent legal provisions, a Certificate of Registration issued before publication or within five years of publication represents far superior evidence that your claim to

copyright is valid than one dated after five years of publication. In fact, if you discover you're being ripped off six years after publication and you haven't either registered or placed copyright notice on the work, you'll probably have a difficult time proving your case.

Second, registration is essential if you expect to be awarded certain damages from a lawsuit—if your unpublished work is infringed before the date of registration (the date your application, deposit, and fee are received by the Copyright Office), you won't be entitled to attorney's fees or statutory damages (see below). The same holds true if a published work is infringed before the date of registration, unless registration is made within three months after publication of the work.

So if you think your work is the kind of art that is susceptible to infringement—your landscapes make ideal calendar pictures, for example—register right away.

Must I reregister after publication if I've registered before publication?

No, unless you've changed the work and aren't sure the original copyright will still apply to the altered work.

If I make an edition of reproductions from a copyrighted painting, must I copyright the reproductions?

Yes, you have to go through the whole procedure—copyright and registration—all over again for the reproductions.

If I forget to put copyright notice on my work and it's published, do I lose my copyright?

No. You can omit the name or date, or omit the entire notice, without losing your copyright, if:

1. The notice has been omitted from no more than a relatively small number of works. Keep in mind that copyright law is primarily directed toward printed material and records. So exactly what a "small number" of works means to the artist is unfathomable at this time. Since most artists make one-of-a-kind objects or small editions of works, leaving copyright notice off an original work or a few graphics might be construed as omitting a "relatively small number." But we'll have to wait for the courts to straighten out the semantics. Anyway, the next two circumstances have much greater impact for you.

2. Registration for the work is made before publication or within

five years after publication without notice, and you make a reasonable effort (another phrase awaiting interpretation) to add notice to all copies.

3. You sign a contract with someone, and, in the contract, he or she agrees to attach copyright notice as a condition to your allowing him or her to publicly distribute the work, then fails to do so. In other words, if you have a written contract with a publisher requiring him to place copyright notice on all copies of an edition of reproductions and he fails to fulfill this condition, your copyright is still valid.

What if I publish accidentally without copyright notice?

If it's within five years of publication, register it immediately and add the copyright notice to the work. If the work is out of your hands, ask the new owner to put copyright notice on it for you.

What if I make an error in the date?

If the wrong date is more than a year later than the actual date of publication, the same rule applies to the error that applies to the omission of copyright notice.

If the date is earlier than the publication date, the copyright is valid from that date even though it's in error.

Now let's get back to the question of protection.

What is the best way to protect my copyright?

As soon as the work is completed, place a copyright notice on it, using the year in which it's completed as the year of publication. Then register it with the Copyright Office. Even if you accidentally publish the work, you'll be completely covered.

What if the date of completion is different from the year of publication?

No problem. This is considered an error in the date, and since it's earlier than the actual publication date, the copyright is still valid and the copyright term is computed from the earlier date.

How long does copyright protection last?

The copyright on any work created on or after January 1, 1978, lasts from its completion for the lifetime of its creator plus 50 years. If two or more people own the copyright, it endures for the life of the last survivor plus 50 years. For example, if you're commissioned to create a work of art and by special agreement

you and your client jointly own the copyright, it will last until both of you die and then for another 50 years.

Under the old copyright law, protection lasted from date of publication for 28 years, and then—if you remembered to renew—for another 28 years.

What if I published and copyrighted a work before January 1, 1978, and plan to renew it after January 1, 1978? Because you obtained the original copyright under the old law, your first term remains the same: 28 years from the date of publication. But when you go to renew the copyright, you are entitled to a second term of 47 years—provided you register with the Copyright Office within one year prior to the expiration date of the original term.

What if I created a work before January 1, 1978, but did not publish before that date? The same rules apply that would if you created the work after January 1, 1978. In other words, the copyright will last for your life plus 50 years. But since this might create a hardship for the heirs of deceased artists, the law says that no copyright on unpublished work created before January 1, 1978, can expire before December 31, 2002. It also says that if the work is published on or before December 31, 2002, the copyright can't expire before December 31, 2027.

Does my U.S. copyright give me international protection?

There are three major copyright organizations in the world that govern international copyright: the Universal Copyright Convention (UCC), whose members include most industrialized countries; the Buenos Aires Convention, composed of most South American nations; and the Berne Convention. The United States belongs to the UCC and the Buenos Aires Convention. Therefore, your U.S. copyright protects you in all the countries that belong to these two conventions.

How do I get copyright protection from the Berne Convention?

It's difficult, so first figure out if you need it by deciding in which countries you want a copyright. It could be that the Berne Convention countries you're interested in also belong to the UCC, so there would be no need to subject yourself to the procedure. To find out, write to the Copyright Office.

If you find you do want protection in a country governed only by the Berne Convention, you must publish your work in a Berne Convention country at the same time it's published in the United States.

What if I want copyright protection in a country that doesn't belong to any of these conventions?

The United States has individual copyright treaties with other countries. Check with a lawyer or consult the Copyright Office to determine what agreements we have with the countries you're considering.

Is copyright notice the same all over the world?

No. The UCC demands that you use the symbol ©, your full name, and the year of first publication. Other conventions and individual arrangements may have different regulations, so ask the Copyright Office.

If I'm not a U.S. citizen, can I obtain copyright protection here?

You'll acquire copyright protection for a work published in the United States if: you lived in the United States at the time of first publication; you're a national of a country participating in the UCC; or you're a citizen or national of another country with which the United States has a reciprocal agreement or treaty.

Unpublished works are protected no matter what your national status is.

How long does international protection last?

Protection of a lifetime plus 50 years is common throughout the world; one of the reasons the Copyright Revision Act extended the maximum term beyond the old term of 56 years (two terms of 28) was to conform to this international standard.

Am I entitled to the copyright on works created for my employer?

No, the copyright belongs to your employer unless you have a written agreement that specifically gives you the copyright.

Can I copyright work I create for a fine arts commission?

Yes, unless you agree in writing to give up your rights.

Can I copyright illustrations commissioned by books or magazines?

Yes, unless you agree in writing that the commissions fall into the category of "work-for-hire." Unfortunately, most people who commission illustrations will demand that you sign a statement saying that you are an employee doing work-for-hire. Some hope may be in sight for freelancers, however. A bill has been introduced in Congress that would restrict the category of work-for-hire to employees having federal taxes withheld from their pay by their employers. This would eliminate the copyright problem for freelancers.

Do I retain copyright after a work is sold?

Yes. When the work is sold, the new owner acquires the rights to sell, give, rent, loan, and display the work. But—and this is very important—sale of the work doesn't bestow on the new owner the rights to reproduce the work and to make other types of work from it unless the original owner specifically transfers these rights by a written document, such as a sales contract, memo, or letter, to the new owner. However, if you retain copyright, make sure the sales contract states that you'll have "reasonable access to the work" so you'll be able to reproduce it. If the owner refuses to allow you access to the work to photograph it, after you have written in advance and offered a choice of dates, the courts will probably uphold your demand.

Better yet, make high-quality transparencies before you deliver the work to its new owner. Then you'll be sure that you can sell or grant reproduction rights anytime you want.

What happens to my copyright after I die?

It's passed on to your heirs through your will (or if you don't have a will, to whomever the law considers your legal heirs), and it's their job to renew copyright on a work created and published before January 1, 1978, if they wish to benefit from it. If it's published after January 1, 1978, the term is automatic and not renewable.

Can I sell my copyright, but not the original artwork?

Certainly; it's done all the time. You can sell your copyright to a greeting card company, keep the painting for yourself, and then sell it to someone else.

You can even sell parts of your copyright. For example, you can sell the exclusive serial rights to an illustration to a magazine and

then turn around and sell exclusive rights for its reproduction as a greeting card to another company. Both types of sales are called transfers of copyright.

What is a transfer of copyright?

A transfer of copyright occurs when you sell or give or trade your copyright or grant someone an exclusive license.

What's an exclusive license? An exclusive license is a transfer usually limited to time or place or form of reproduction. For example, if you're an illustrator, you might sell a magazine first serial rights (serial refers to the fact that periodicals are published in a serial, or continuing, manner). First serial rights entitle the magazine to publish your illustrations for the first time. Or you might grant one license to a magazine stating no other magazine could ever reproduce a certain work and another to a greeting card publisher giving them the right to be the only greeting card company to reproduce that work. Another possibility is to limit a license to a geographical area as you would do if you sold first U.S. serial rights or first U.S. rights (if it's a book).

A nonexclusive license means you're letting a number of people do the same thing. For example, you could sell rights to a number of greeting card companies to reproduce the same painting.

If a magazine or book reproduces an unpublished work, am I protected by the publication's copyright?

Yes. It is assumed that you have granted only nonexclusive rights to the work and that you retain the copyright.

Does such a reproduction constitute publication?

Yes.

Even though I am protected by the magazine's copyright, should I insist that my copyright notice accompany the reproduction of my work in a publication?

Yes, for two reasons. First, if copyright notice does not appear with your work, it won't be eligible for group registration. Second, copyright notice will probably limit the publisher to the right to reproduce the work only once. Otherwise, unless you have a written agreement detailing the specific rights you're granting them, they may be able to use it again in a revised edition of the publication without paying you. That is all right, if it is what you want. But if it isn't, the copyright notice will protect you. In any

case, the best course of action would be to put in writing exactly what rights you're transferring.

What should I do when I transfer my copyright?

You don't have to do anything, but the new owner should file a written document, or a notarized copy of it, with the Copyright Office, along with $10, within one month of transfer (or two months, if executed outside the United States). Once this has been accomplished, the Copyright Office will furnish him or her with a Certificate of Recordation.

The transfer document doesn't have to have any particular form, except that it must be signed by you. For example, suppose you sell the copyright on an oil painting to a friend who's in the greeting card business. He might ask you to write a letter saying something like this:

"I, Henry Artist, sell to John Hallmark, for a fee of $1,000, all rights of reproduction to my oil painting *Winter Storm,* which bears copyright registration number 240951." (Registration must precede the filing of a transfer.)

To transfer a nonexclusive right of copyright, there is no need for a written document. But to avoid later disputes, it is still best to have transfers in writing. For example, you may sell one-time rights to a magazine, i.e., you are letting them reproduce your work only once. But suppose they want to reprint the work in some other form—such as an advertisement or a book. If you haven't clearly stated in writing what rights you sold them, they may think they can use it again.

Must the new owner record the transfer?

No, but it's very foolish not to. The reason the new owner should record the transfer is to prove ownership of the copyright in case someone else should also claim to have bought it.

The new owner also needs a Certificate of Recordation before initiating any legal action against an infringer.

Can my work ever be used without my permission?

Yes, under the doctrine of fair use.

What is fair use?

Fair use gives others the right to use copyrighted material without permission of the copyright owner for such purposes as criticism, comment, news reporting, teaching, scholarship, or research. It also allows the copying of a certain amount of the copyrighted

material. But, as you might expect, the law doesn't spell out exactly how much or what percentage of the whole work can be legally copied.

What is an example of fair use? The reproduction of an artwork accompanying a newspaper review or an article describing an art competition.

If I make some drawings based directly on parts of copyrighted material, can I claim fair use?

No formula or guidelines spell out the specific amount of work that can be safely duplicated without permission. If you plan to use only a small portion of the material, the fair use doctrine may cover you. If you're uncertain whether the portion represents a substantial or unsubstantial amount of copying, ask a lawyer. Use of a substantial part of it demands that you seek permission from the copyright holder.

A suit brought against artist David Salle illustrates what can happen if you appropriate someone else's image thinking you're entitled to it because of the fair use doctrine.

In the summer of 1984, Mike Cockrell and Judge Hughes, two Brooklyn artists, learned that David Salle had used one of their drawings in his painting titled *What Is the Reason for Your Visit to Germany?* They brought suit for copyright infringement while the work was on display at the Leo Castelli Gallery.

The image in question was already widely known. Cockrell and Hughes had made a drawing from Robert H. Jackson's Pulitzer Prize–winning photo of the shooting of Lee Harvey Oswald; Salle considered it public property. "I didn't think about it," he said. "I just did it, as they say, in the heat of creative passion. I just wanted that image for my painting." Cockrell and Hughes won a $2,000 out-of-court settlement (Castelli and Salle each paid half).

How can I locate the copyright owner?

Tracing the owner and determining whether a copyright is still in effect may not be easy, but the Copyright Office will do for a fee. Write the Copyright Office, giving it as much information as you can, and it will send you an estimate of the cost of the search.

Can I incorporate photographs and other copyrighted material in my collages without infringing?

Technically, you may be infringing. But in reality, this kind of case is unlikely to come to court.

Will reproduction of my work under the fair use doctrine publish my unpublished work?

No, unauthorized use of unpublished work under the fair use doctrine does not constitute publication.

Can anyone else use my work without authorization?

Yes, a special provision in the Copyright Revision Act of 1978 allows noncommercial broadcasting systems (i.e., public television) to use pictorial and graphic work without permission of the owner. These systems are supposed to pay royalties for such use, however, and an organization called the Copyright Royalty Tribunal was created to determine what the rates were to be.

How does this work?

It doesn't. The Copyright Royalty Tribunal set very low rates for the royalties to be paid when such works are used. It also established rules under which records must be kept of compulsory licensings, but to date almost no fees have been paid to visual artists. It has been such a disaster that the Copyright Royalty Tribunal has recommended to Congress that it repeal this part of the law.

If infringement occurs, what can I sue for?

First, you can sue for an injunction. This means you can stop the infringers from any further reproduction.

Second, money. You can sue for actual damages and/or the infringer's profits, or you can sue for statutory damages. Actual damages are often hard to determine. You would have to prove, for example, how much money you really lost because of the competition between an infringer's reproductions of one of your works and your own reproductions. So people frequently sue for statutory damages, which are amounts arbitrarily determined by the courts according to certain limits set down by the Copyright Revision Act. That's why it's so important to register early—if you register after an infringement occurs, you won't be able to sue for statutory damages (unless you register within three months of publication).

Third, you can sue to prevent the infringing material from being distributed for the duration of the legal action and to destroy the infringing copies and plates, if you win.

Finally, the court may force the defendant to pay your court costs and attorney fees (although you won't be able to sue for attorney's fees if you register after infringement).

Here's an example of a successful infringement suit brought by an artist. Some years ago, New York artist Alan Sonfist went to Alain Resnais's film *Mon Oncle d'Amérique*. In the closing sequence, Sonfist realized that the camera had photographed his mural *An American Forest*. The mural was clearly marked with his name and the copyright symbol, but the filmmakers never asked permission to reproduce the painting. Nor did they pay the artist or give him credit. Sonfist sued and received a cash settlement in the thousands and an acknowledgement in the credits of the film.

If the infringement occurs because I didn't put copyright notice on the work, can I sue?

Yes, you can sue to stop the infringer from infringing. But in such a case, if the person *innocently* infringed your copyright because notice wasn't there, the court won't give you either actual or statutory damages, although it may force the infringer to pay you the profits from the infringement.

Do I have the right to demand that my work be credited to me or that it not be destroyed or altered?

Only in three states. These rights are called "moral rights." More than 60 nations recognize varying versions of the moral rights. In France, *droit moral* formally became law in 1957, although court cases dealing with such issues go back to the nineteenth century; Italy encoded its moral rights laws in 1941, and Germany did so in 1965. The principle is also recognized in international agreements and conventions, notably the Berne Copyright Convention, to which the United States is not a signatory. No U.S. moral rights law exists on the federal level, but such laws have been passed in New York, California, and Massachusetts.

What does the New York state law say?

It prohibits the display or reproduction of artwork in "altered, defaced, mutilated or modified form" without the consent of the artist who made it and allows the artist to sue for damages and to disclaim authorship if the alterations are likely to detract from the artist's reputation. The law also gives artists the right to require notice of authorship whenever their work is displayed or reproduced. It covers painting, sculpture, graphics and photographs, and multiples in editions of up to 300 copies, regardless of quality.

What does the California law say?

It differs from the New York law in four ways: It does not include

prints or photographs; it extends the moral right to 50 years after the artist's death; it applies only to artworks that possess "recognized quality"; and most important, it forbids the destruction, alteration, and defacement of works of art.

What does the Massachusetts law say?

It is similar to the California law but its scope is broader, applying to crafts, drawings, film, painting, photography, prints, video, and sculpture.

Is there any criticism of these laws?

Yes, there has been criticism, particularly of the New York law. It lacks bite in that it doesn't prevent destruction, defacement, or alteration. In New York, all an artist can do if the work is defaced or altered is deny authorship. And as Gilbert S. Edelson, secretary-treasurer of the Art Dealers Association of America, says, "If you destroy a work, the artist denies authorship. So what?" Even if the artist sues for damages, that won't stop the destruction of the work.

Do I have the right to a royalty on the profit made from reselling my work?

The right to profits from resale, known as *droit de suite* in France, is available only in California. This state law provides that whenever a work of fine art is resold and the seller resides in California or the sale takes place in California, the seller must pay the artist 5 percent of the amount of sale within 90 days. It applies, however, only when the gross resale price (gross resale price includes the commission a dealer will charge the seller to sell it) exceeds $1,000 and represents a profit to the seller.

If the artist can't be located within 90 days, the money is deposited in a special fund while the California Arts Council tries to find him or her. If the attempt fails after seven years, the proceeds are used to acquire fine art for the Art in Public Buildings program.

If the seller doesn't comply with the law, the artist may sue for damages within three years of sale or within one year of discovery of sale, whichever is longer.

In states where no such laws exist, some artists have inserted this or similar provisions into their sales contracts.

Is there a federal law that gives artists these rights?

Not as of this writing. But Senator Edward Kennedy introduced

a bill in Congress in 1987 to include some of these rights. Check on its progress.

What is a patent?

A patent protects the invention of machines, devices, processes, substances, and designs of articles of manufacture. The big difference between a copyright and a patent is that a potentially patentable invention must be totally new and novel, while copyrightable material need be original only to you. This means that the Copyright Office doesn't check to see if you're duplicating someone else's idea. The Patent Office, on the other hand, sets rigid standards for meeting the test of newness and searches its records prior to issuing a patent to make sure the process, design, or whatever is indeed unique.

How long do patents last?

Patents protect devices, machines, processes, and substances for 17 years. Design patents last for 3½, 7, or 14 years, as the applicant elects.

How do I get a patent?

Filing for a patent is a complicated and expensive process. While you're permitted by law to prepare and file your own patent application, only the foolhardy would do so. And patent attorneys aren't inexpensive. The simplest procedure could run at least $1,000.

Why would I want a patent?

You probably wouldn't. Because of the utilitarian nature of patentable objects, visual artists aren't usually potential applicants. Occasionally, however, the two areas overlap. The designer of a novelty watch bearing a caricature of Spiro Agnew applied for and received both a copyright for the caricature and a design patent for the watch some years ago.

What if I have other questions about copyright?

To ask questions, call the Register of Copyrights, (202) 287-8700. You might also want to write for a free Copyright Information Kit from the Copyright Office, Library of Congress, Washington, DC 20559. This kit will be particularly helpful in the future as new regulations are promulgated. If you want to request registration forms, write the Copyright Office or phone (202) 287-9100.

Three

THE ARTIST AS SELLER AND EXHIBITOR

PRICING
CATALOGING
DISCOUNTS
SALES INVOICES
RESERVED RIGHTS
RENTALS
EXHIBITIONS

Most artists reading this book are probably reading it because they're exhibiting and making money from their work or are planning to do so. So, right off the bat, let's get into the questions about the two ways to make money—selling and renting—and exhibiting.

How do I decide what is a fair price for my work?

The strategy of pricing is really a *marketing* problem, and therefore outside the scope of this book, but there is an excellent book that deals with the question—Calvin Goodman's *Art Marketing Handbook* (gee tee bee, 11901 Sunset Boulevard, 102, Los Angeles, CA 90049).

Suffice it to say here that prices should cover all costs—both direct and indirect (see below)—and provide some profit. At the same time, your prices must be competitive in the marketplace. To evaluate whether they are or not, check what others, working in the same style or similar subject matter, with similar experience, education, and talent, are getting at dealers in your area.

How do I calculate direct costs?

Begin by getting a set of file cards. Assign a number to each work of art when you start to work on it, and write the number on one of the cards. Keep the card where it can be seen while the work is in progress (perhaps on a bulletin board) to remind you to record details on it.

What details do I record? Record your start and completion dates, plus the number of hours you work on the piece each day, including time spent *thinking* about it. Also jot down all materials you use—both amounts and costs—and record any other directly related expenses. If you hire assistants, mark down names, addresses, wages, and the hours they work. Figure out your own labor costs by multiplying the number of hours you work by what your labor is worth.

How do I decide what my labor is worth? If you have another job—as an art teacher, an illustrator, a framer—you can simply divide your weekly salary by the number of hours you normally work at that job. Even if you don't work at anything art-related—say you drive a cab—you can still make the same computation.

If you don't have another job, you can figure out what your labor is worth by determining what you need to survive. Suppose you're just out of art school, you've rented a cheap living/work space, and your needs are small. Take into consideration your rent, food bills, and other basics. If you decide, for example, that you can't get along on less than $125 a week, which is an amount you could earn by working on a job 35 hours a week, divide $125 by 35. You'd estimate your hourly wage, then, at about $4.

Later, as your market grows, you'll want to give yourself a raise to reflect a higher value for your labor. Obviously, your estimate has to be reasonable.

What are indirect costs?

Indirect costs can be lumped into three groups—material costs that you can't allocate to any one work (for example, you may only use a fraction of a tube of paint in a painting); overhead like rent, utilities, insurance, and so on; and selling costs, such as advertising, postage, framing, crating, shipping, entertainment, travel, and printing.

How do I figure out indirect costs? If you keep a yearly record of all expenses—as you must for tax purposes (see Chapter 13)—all you have to do is total these costs and divide by the number of hours you work per year, according to your file cards. So, if you spent

$2,000 a year on selling expenses and work 1,000 hours, your selling costs are $2 an hour. Similarly, if your overhead is $2,000, your overhead costs are $2 per hour. And if incidental materials are costing you $1,000, this becomes another $1 per hour.

How do I put these cost figures together?

Simply add up your direct costs and indirect costs. Let's say that it takes you 20 hours to complete one canvas. You've decided that your labor is worth $5 an hour. You spent $30 for canvas and stretchers. Your direct costs, therefore, are $130. Now, using the figures determined above, let's say your hourly selling cost is $2, your overhead is $2, and your incidental materials are $1. Just multiply them by the number of hours spent creating the work. This is another $5 an hour, which you multiply by 20 hours for a total of $100 in indirect costs. Your total costs (direct and indirect) would be $230.

Is this total the price I charge?

No, you wouldn't break even if you charged that price. This amount doesn't take into consideration the fact that you, like most artists, probably won't sell all of your work. If you have a history of sales—even two or three years will give you an idea—you know about how many works you do sell each year.

Suppose, therefore, that you paint 20 oils each year and manage to sell about 10 of them. Just to break even on costs, you'll have to double the amount you charge for each work. While the total cost involved in *each* piece is $230, you'll have to get back at least $460 for each piece you sell, just to recover the cost of all 20 pieces.

Once I make this price adjustment, is this what I charge?

You could charge this amount, but you're still not making a profit. What you've done is cover costs and pay yourself for your labor. But this won't put any money in a savings account or help you take that trip to Europe you think is necessary for the development of your art. You've got to think of yourself as a business—and businesses are in operation to make a profit.

How much should I charge then?

Most small-business owners try to make a minimum profit of 20 percent. At the very least, if it costs you $400 to make and sell a painting, you would add on 20 percent of $400 and charge about $500.

Must I always figure costs this way?

The calculations I've just outlined represent the ideal situation. Practically speaking, of course, they don't always work. Suppose, for example, that you're fresh out of school; you figure your labor is worth $5 an hour; and you do large, meticulous egg tempera paintings. Every painting takes you 200 hours. In this case, as a beginning artist, you can't expect to charge and get $1,000 for each painting in the marketplace just yet.

Nor will you feel that it's *always* necessary to price paintings this way. If you have another job and you don't depend on income from your art for support, you may feel that you can afford to be more flexible in your pricing policies.

But the fact remains that too many people ignore cost factors altogether. They price their work too low and end up using income from other sources to support their art. In the beginning of your career, you might expect this to happen. However, you should begin to recover costs very quickly, and you won't be able to recover costs unless you figure out exactly what they *are*.

Are file cards the only records I should keep of my work?

A more elaborate system is needed if you want not only to calculate costs but also to keep track of where your work goes, to protect yourself for insurance purposes, and to prove that the work has been copyrighted.

What sort of record-keeping system should I use?

A good cataloging system includes the file cards described above, a record book, and photographs. The record book contains more long-range sales and exhibition data. And the photographs have a variety of uses, discussed below.

How do I organize this system? When you begin a work, assign a number to it. Write the number both in the record book and on the file card. Later, when the work is complete, photograph it and put the same number on the back of the picture.

What information do I put in the record book? Record your start and completion dates and the price you hope to get. When the work is sold, add the name and address of the purchaser, the *actual* sales price (in case you give a discount), and the date of sale. Leave room for other information about when and where the work is exhibited and prizes it wins. You'll also want to record changes in the purchaser's address and any data about new purchasers if the work is resold and this information is available to you.

What is the significance of the photograph? A photograph provides a record for insurance purposes in case of loss or damage, proof of its original state in case alterations are made by purchasers, and, if you have placed a copyright notice on it, a record for copyright protection. In addition, you'll want the photograph for publicity purposes.

When do I give discounts?

Museums and other educational institutions sometimes expect discounts. So does the collector who buys more than one or two expensive works.

How much should the discount be?

Museums frequently ask for 10 percent, as do collectors, but this isn't to say that they won't ask for more—perhaps as much as 20 percent.

Do I have to give discounts?

If the sale is to a museum, chances are you'll find it worthwhile to discount a work in exchange for the boost to your reputation. But with collectors, every case differs. Naturally, if they buy five or ten works, they're entitled to a discount because they're buying in quantity. But if it's just two or three works, you'll have to decide how much you value them as collectors.

Should I ever give a discount to a collector on just one work?

It's done all the time, because many collectors automatically ask for a 10 percent discount. But it's a lousy idea, because pretty soon the word will get around that your work can always be had for less.

When I make a sale, what written forms must I fill out?

A sales invoice (also known as a bill of sale) and possibly a separate contract reserving certain rights.

Where do I get sales invoices?

Most stationery stores carry standard invoice forms. Or you could design one to fit your needs and have it printed (see Figure 1).

What is included on a sales invoice?

Some or all of the following items:

JOHN DOE, ARTIST
1234 W. FIRST STREET
MIDDLETOWN, OHIO 23456
Telephone: (312) 435-9222

SALES INVOICE

Terms
Net

☐ Cash Sale

☐ Visa #
☐ Master Charge #

Ship to:_____ Bill to: _____ Date: _____
_____ _____ Via: _____

Item No.	Description: Medium, Title, Dimensions (HT X Width)	Price

All sales subject to terms and conditions on reverse of this invoice.

Received in good condition:

Net | $
Sales Tax | $

Client's Signature Date

Total | $

Figure 1. This particular invoice was designed by Calvin Goodman for his book, *Marketing Art.* You can design one to fit your own specific needs based on this form and have it printed. Or you can select one of the many standard invoice forms carried by most stationery stores.

TERMS AND CONDITIONS OF SALE

Payment for all works herein shall be in United States currency, net, on presentation of this invoice. Works may also be charged on valid Visa/Mastercharge credit accounts.

The buyer may return any work acquired herein for full credit against the purchase of any other works available at that time, provided only that said work shall be returned in good condition and within 30 days from the date herein.

Unless otherwise specifically indicated, all works herein are originals, executed by the artist and are certified to be free from all defects due to faulty craftsmanship or faulty materials for a period of twelve months from the date of sale. If flaws should appear during this period and be due to such causes, said works shall be subject to repair or replacement, at the option of the seller. Buyer is cautioned, however, that the seller cannot be responsible for fading, cracking, and other damage to these works caused by improvident exposure to sunlight and weather.

All shipments are fully insured by the shipper against damage or loss. If works are not received in good condition, please notify the seller within ten days of receipt.

All shipments are F.O.B. the seller's place of business and will be transferred via freight collect, unless prepaid by the buyer. Crating methods and charges are per art object freight company standard procedures and rates.

The original works described herein are copyrighted by the artist. The sale of such copyrighted work does not include the sale of rights to reproduction in any form unless specifically granted in writing by the artist.

1. Date of sale.

2. Name and address of client.

3. Your name and address.

4. Description of the work sold (title, dimensions, medium, and date of completion).

5. Price.

6. Discount, if any.

7. Sales tax, if any (see Chapter 15).

8. Down payment and balance due, if any.

9. Payment dates.

10. Delivery date.

11. Provision regarding insurance and risk of loss.

12. Warranty.

13. Statement about ownership of reproduction rights.

14. Signature of the client indicating that the work was received in good condition.

What do you mean by the payment date?

The date—usually the first of the month—when payment is due if payments extend over a period of time. For example, it is not uncommon to allow a client up to twelve months to pay for work.

What do you mean by delivery date?

The date when the client can take possession of the work, meaning the date when he or she can either come to your studio to pick the work up or have you deliver it.

What if a sold work is stolen before being picked up?

If the work is stolen from your studio before the delivery date, that's your problem. You'll either have to replace it with another work or refund the client's money. If it's stolen after the delivery date but before the client picks it up, the law in many states says you're no longer responsible for it.

What happens if a work is stolen after an attempted delivery?

If you try to make delivery on the *arranged* delivery date and fail

because the buyer wasn't there to take possession, you've fulfilled your end of the bargain legally in many states, and it's the buyer's loss. That's why it's important to have the delivery date as well as the payment date on the invoice, particularly if they aren't the same.

What should the invoice say about insurance and risk of loss?

It should state who has to pay for a work that is lost or damaged during shipping. If you're responsible and it gets lost or damaged before it gets to the client, you're the person who has to provide a replacement or a refund. So terms of sale might read: "Shipment is fully insured by the shipper against damage or loss. If work is not received in good condition, notify us within ten days."

Who pays for shipping?

This is a tossup. In these days of rising prices, more and more artists and galleries try to pass these costs on to the buyer, particularly if they have given a discount. Therefore, the invoice might read: "Purchaser pays for shipping."

What is a warranty?

Many collectors, usually those buying art for investment, want documentation stating that the work they buy is authentic, i.e., that it was really created by the artist who claims to have made it. (Documentation of prints is another matter and is taken up in Chapter 8.) Obviously, this sort of documentation has more relevance for works of dead or very famous artists, but it should not be overlooked by those of you who are alive and well and working at being famous.

Furthermore, it's good business to offer clients a limited guarantee that the work will last. By this I mean a promise that materials won't fade or crack under normal conditions. Your warranty should guarantee both authenticity and durability.

What would a typical warranty say? Typical isn't an operative word in the art world, but an example is given in Figure 1.

What about reproduction rights in a sales invoice?

If you plan to sell them along with the work, the sale must be spelled out in the invoice. Otherwise, according to the law, you retain the copyright, which means you have the opportunity to sell the reproduction rights to someone else, if you like.

Despite the fact that the law says that you retain copyright in the

absence of a written agreement to the contrary, it is still a good idea to emphasize your ownership on the invoice to avoid confusion later on. So you might state on the invoice, "All reproduction rights to the work are reserved to the artist." This provision might also be included in a separate contract for reserved rights, also known as moral rights, if you plan to use one.

What are reserved or moral rights?

A number of terms that you could impose as conditions of sale that allow you to exert some control over the work after sale. The most common ones are:

1. Reproduction rights.

2. The right to restore and repair the work yourself, or the right to approve any restoration or repairs.

3. The right to display the work at reasonable intervals (two months every five years would be considered reasonable).

4. The right to be properly credited as the creator of the work.

5. The right to prevent the work from being altered or destroyed.

6. The right to be notified before the owner commits the work to a show and to be given the details of the show.

What else can I ask for?

You could ask for royalties. If so, you might write into your sales contract: (1) the right to 15 percent of the gross profit each time a work is sold in the future; and (2) the right to demand that each seller sign a contract with each new buyer and send a copy of it back to the artist. These rights are found in The Artists Reserved Rights Transfer and Sales Agreement by attorney Robert Projansky. This was a pioneering document in the seventies, when artists began to work for more control over their artwork.

Is it practical?

Not really. First, it's hard enough to sell art without complicating the procedure. After all, a buyer may think twice about purchasing a work of art if he or she will only be able to resell it to someone willing to accept the same conditions. Second, there is no feasible way to force the seller to pay royalties; sales can easily be made that will escape the artist's attention. Third, since most artwork never changes hands, and when it does, it rarely resells at great increases, the contract may be an exercise in futility.

Don't some states guarantee a royalty on resale?

Only California. See Chapter 2 for a description of this law.

Do some states safeguard moral or reserved rights?

Yes, New York, California, and Massachusetts have moral rights laws. Again, see Chapter 2 for a discussion of these laws.

Does the federal government guarantee any of these rights?

As I said in Chapter 2, Senator Kennedy sponsored such a bill in 1987. Check on its progress.

What kind of contract will I need to rent artwork to clients?

You'll probably rent through an art rental outlet—usually a museum shop, but possibly a gallery—that gives borrowers the option to buy. So you'll sign a contract with the outlet, and it will make a deal with the person who plans to rent. Or you might want to rent directly. Either way, the terms of the contract will be pretty much the same.

What kinds of terms should be in the contract?

Most museums have standard rental contracts. But before signing, check to see if the following points are included (or, if you're planning to rent directly to a client, make sure the following provisions are in your contract):

1. Selling price. This is the price on which rent will be based, and you should set it.

2. Rental fee. This is usually about 5 percent of the sales price per month.

3. Rental period. There is no set time on this, but many museums prefer a two-month period with a one-month renewal.

4. Percentage of the rental fee going back to you. Bear in mind that you may actually not get any of the fee. Some museums operate on the theory that most rental works are eventually purchased and the rent they charge just covers handling and shipping. Other museums may deduct handling and shipping fees and remit the balance, leaving you very little.

5. Museum's commission. If the museum sells the rented work, its commission should be about 30 percent, from which it deducts the rental, because the customer who buys a work pays the purchase price minus rental fees.

6. Shipping and insurance. You'll probably be responsible for arranging for these, and you'll probably have to pay the costs to and from your studio to the museum. Be sure, though, that this is spelled out. If you're renting directly to a client, either one of you can make the arrangements, but the client should pay the costs.

7. Loss or damage. If the work is lost or damaged in the museum or on the borrower's property, the museum or client should pay. Again, spell it out or you might get stuck.

8. Termination of the agreement. Rental agreements are usually terminated by written notice from either the artist or the museum, which ends the agreement within a short period of time, such as five days from the date of the notice. Should the borrower decide to buy within that period, he or she may do so.

9. Cleaning and repairing. Your contract should stipulate that your approval on whether a work is to be cleaned or repaired if damaged must be in writing.

10. Copyright protection. Your contract with the museum should have a clause requiring a provision in the museum's agreement with the borrower that forbids any reproduction of your work without your consent. You might also forbid the use of the work for any commercial purposes, such as exhibition in a restaurant.

Can corporations deduct art rentals from their tax?

Yes, as long as they only lease the artwork and never buy it. Occasionally, artists and dealers try to interest corporate collectors by tempting them with tax deductions on rentals. They claim that the corporation can pay off the purchase price through monthly rental payments that are tax-deductible. Unfortunately, this isn't quite so, because if the corporation buys the work, the IRS will reject the previous deductions.

Should I sell work through charitable sales or auctions?

That depends on what sort of commission they plan to take. Prices at charitable auctions or sales rarely equal prices made from studio or gallery sales, so a 50–50 split would probably not make your entry worthwhile. Only when the charity sponsors plan a commission of 20 to 25 percent would such a sale make sense.

Should I deal with charities at all?

Everywhere I go, artists complain to me about the constant pressure they are under from charitable organizations to donate

artwork for sales or auctions. It's about time artists began to say no to this practice instead of submitting as soon as the sponsor says, "Well, everybody else is giving us something." Remember, you can't deduct the price of an artwork from your income tax—only the cost of the materials that went into it. So while you're giving up income, it's illegal for you, unlike the collector, to compensate for this loss with a substantial tax deduction. If you can afford to be charitable, fine; otherwise, you're losing valuable income.

Before I enter a juried show, what should I look for in a contract?

Since contracts vary, all the terms you might come across that must be checked out before you sign can't be anticipated. But in general, when you read the description of a show and the contract, look for the answers to these questions:

Who is sponsoring the show? An art organization? A museum? An art school? A group of professional fund-raisers? Or someone you've never heard of before? Check the credentials of the organization and find out about other exhibits they have sponsored.

Who are the jurors? Don't accept the promise of a "jury composed of eminent art specialists." This may indicate a tacky, if not downright dishonest, fly-by-night entrepreneur. And if the prospectus does name names, check on them in *Who's Who in American Art* (available in most sizable libraries) to see if they are indeed eminent.

How much are the prizes? Make sure a description of the prizes includes a breakdown in amounts for first, second, and third prizes in the various mediums. "Many valuable prizes" or "$25,000 in prizes" is too vague and may suggest the show is less than what it seems.

If purchase prizes are awarded, how much are they? Purchase prizes should correspond to your own sales prices and, at the very least, should not be less than two-thirds of the price you sell your work for on the retail market.

Is there to be a catalog? Sponsors sometimes charge higher entry fees because they say they plan to publish a catalog. Find out what they mean by "catalog." Not infrequently, catalogs turn out to be nothing more than price lists that hardly justify a high entry fee.

Will the sponsor charge a commission, and, if so, how much? If the sponsor does charge, a 30 percent commission is not unreasonable.

What is the entry fee? When deciding whether the entry fee is

reasonable, remember that a stiff fee plus a high shipping charge may outweigh the chancy possibilities for sales or prizes.

Who will assume responsibility for the safety of work while at the show and for its return? This is an important consideration. The sponsors *should*—if they won't, don't send your work.

Who will own the reproduction rights on a work that wins a prize? Some sponsors may require that you assign them the copyright on award-winning works. The time to decide if you want to give up these rights is *before,* not after, you sign the contract.

Is there a prospectus? The larger, well-known institutions that sponsor competitions put out prospectuses that detail all the above information—jurors, prizes, conditions of entry. When such information is not forthcoming in the form of a prospectus, check the exhibition yourself, if you can, and think carefully before entering.

How many entrants will be chosen? The fewer people chosen, the smaller your chance of being picked and the more likely you'll lose the entry fee and shipping charges. So find out in advance how many entries will be selected for exhibition and figure out for yourself whether it's going to be worthwhile to enter.

What should I look for in a contract before I enter a nonjuried outdoor festival?

Many of the same things mentioned above for juried shows. In addition, ask if the grounds are secured at night; how you'll be protected from rain; and how you'll get your location—is it on a first-come, first-served basis or by assignment? If there is a rental fee involved, weigh the advantages of the possibilities for publicity and sales opportunities against the size of the fee.

Is there a publication that lists exhibitions?

Yes, the *Exhibition Directory* put out by The Exhibit Planners, Box 55, Delmar, NY 12054. *American Artist* magazine also publishes monthly lists in its "Bulletin Board" column.

How do I pick appropriate shows to enter from an aesthetic point of view?

There's no surefire way to match your aesthetics with those of the different exhibitions without actually going to the shows, which can represent a considerable investment in time and money. But there are two other ways to research exhibitions. First, send for

the exhibition prospectus, which will list the jurors. Look them up in *Who's Who in American Art* to see if their biographical entries give any clues to their aesthetic preferences, or try checking out their names with your local museum. Second, write for last year's catalog—most of the national shows publish them.

Four

COMMISSION AGREEMENTS

PROPOSALS

BUDGETS

COMMISSIONS

TERMS OF COMMISSION AGREEMENTS

Back in the fifteenth century, when most art was custom-made, client and artist entered into a legal agreement in which the latter was committed to deliver exactly what the former had requested. The client tolerated no deviation from the original drawing and demanded in writing that only certain colors be used to insure the finest quality. Not for him any inferior grades of gold or ultramarine, the most difficult colors to get and apply at that time. These patrons left little to chance even though they were dealing with the likes of Botticelli and Fra Angelico.

Today, a great deal of art is still made to order. There's a lot of opportunity and money out there for artists to do monumental pieces for public spaces, portraits of public and private citizens, collections of works depicting industry or other human endeavors, and paintings and drawings for record and book jackets, among other types of regularly commissioned works.

A commission may be very satisfying to you as an artist, particularly if it gives you the chance to do something you wouldn't ordinarily have the funds or facilities to do.

Nowadays, despite both the volume of work and the amounts of money involved, artist/client relationships are generally characterized by looser arrangements than those between such teams as Filippo Lippi and Giovanni di Cosimo de'Medici.

Many modern-day contracts consist of a single paragraph that leaves out more about a project than it puts in. As a result, the client has one idea of what's going to happen and the artist has a different idea. When commissions go sour, it's usually because there wasn't a real meeting of the minds.

To mention just one example, Robert Morris, a well-known New York artist, signed a contract with the Veterans Administration for a sculpture proposal for the Bay Pines Hospital on Tampa Bay, Florida. VA officials were less than pleased with the design they received the following year. Said Lenore Jacobs, the VA's program officer, in *ArtNews:* "Morris proposed a project that was in such bad taste, it was just inappropriate and callous."

Morris said, "I did some research and found that some of the casings for the Nagasaki- and Hiroshima-type atomic bombs still exist." His plan called for mounting the casings, inscribed with the dates of the atomic blasts and the bombs' sobriquets—"Fat Man" and "Little Boy"—on pedestals in front of the hospital. Morris said he was surprised at the reaction. "Cannons seem to be okay. They've put them up outside their hospitals all over."

But the VA stood by its decision to deny Morris the $50,000 commission for the hospital, which houses mainly psychiatric patients from World War II.

Morris then sued the VA for a $12,500 advance that he claimed was guaranteed him on the submission of his proposal. The VA replied that Morris failed to conform to his contract, since his proposed sculpture varied greatly from the slides of current work he had originally submitted.

In Morris's case, however, there was an additional problem. The contract stipulated that he was to supply the materials for the sculpture. Instead, he asked the VA to furnish the government-owned bomb casings. This violated the contract and the VA won the suit.

So much for a meeting of minds. When it does take place and is written into a contract to the best of everyone's ability, however, most problems will vanish.

How do I find out what the client needs?

This can be done by some judicious probing during the initial interview. However, analyzing what a client wants a piece of artwork to accomplish isn't always easy. Even if you've been chosen on the basis of past work, he may have something very definite in mind that he has difficulty communicating to you. Or maybe he has only the foggiest idea of what he needs. In either case, you might ask him a series of questions such as:

What does he need? The client may know only that he needs something large to hang on his lobby walls. You can help him decide whether he wants a large canvas, a mural, a series of smaller paintings, or whatever.

What kind of mood and colors does he need? A bank president may want something warm to take the chill off the coldness and sterility of an impersonal interior. In this case, he probably needs some red or earth tones, not blues or greens. So if you're showing slides of your work, pick two slides that express different moods through varying colors and ask which he prefers.

Where will the work hang or be installed? If your client wants a portrait of himself, for instance, find out what kind of space he plans to hang it in, since this will affect size and shape. Also ask what other art it will compete with.

What does he want the art to communicate? A bank president may want the artwork to project a feeling of strength, security, progress, or even serenity, but she may not be able to articulate these concepts. Again, you can help her crystallize her thinking through the use of slides that describe these feelings.

Does he want a regional flavor? If it's a company in New Jersey, for example, perhaps an industrial scene would be appropriate.

How do I find out if he will be receptive to my ideas?

You can determine this by tossing out some ideas of your own. For example, "Instead, Mr. President, of a large, impersonal abstract design, how about a series of paintings depicting the workings of your industry or a history of the town?" Whether or not he finally accepts the ideas doesn't matter. Just find out at this stage whether or not he's willing to consider them.

What if I don't like his ideas?

Now's the time to back out graciously. I recently heard about a talented abstract artist who was recommended to a record company executive looking for someone to paint a scene for the cover of a recording of Caribbean music. The executive said he wanted a realistic Caribbean cityscape. The artist replied that if that's what he wanted, that's what he would get.

But the painter couldn't deliver. His style was abstract; he wasn't happy working any other way. The preliminary sketches revealed this. Dissatisfied with the results, the executive paid him for his efforts and terminated the relationship, making a mental note never to consider his work again. Had the painter said right away that it wasn't the job for him, the executive might have kept him in mind for future, more appropriate work.

So if you can't perform, say so. If a potential portrait subject wants you to trim 30 pounds off his beefy frame, decide if this is

going to go against your aesthetic grain before you waste any time on the project.

What else should I ask in the initial interview?

Be sure to ask how much money will be allocated for a commission. If the work is to be included in an overall design budget, the architect or designer usually knows what percentage he or she wants to spend on artwork. This is particularly true if it's a public building in a geographical area that has passed legislation that demands a certain percentage (usually 1 percent) of the construction costs be spent on art.

If no such exact information is forthcoming, at least get a rough estimate so you can operate within the right price range. There's no point in slaving over a design for a $15,000 masterpiece when only $10,000 is available. Give them a design for a $10,000 masterpiece instead.

After the interview, what is the next step?

The next step is submitting a proposal, which usually consists of a visual aid or aids; a written description of the work, detailing sizes, shapes, materials, and so on; and a budget. It may also include a résumé of your career, any pertinent publicity, and examples of your work. In other words, it's a package showing what you have done and, more importantly, what you'd like to do for this project.

What kind of visual aids should I include?

The visual aid might be as simple as a rough sketch for a painting. Or it might be a maquette for a piece of sculpture. If the client wants something more elaborate, a series of drawings showing the relative scale superimposed on photographs of the actual site or a mockup of the site, complete with miniature people and trees, may be in order.

Do all clients demand a proposal?

Most clients will ask for a proposal, but should this not be the case, it's up to you to take this step to clarify the project. Here's an example that illustrates why this step is so important. Several years ago, I received a letter from a painter who had been commissioned by a company in the Midwest, on the basis of previous work, to paint 100 watercolors for its executive offices. After agreeing on a fee and signing a contract, he found himself in a head-on confrontation with a number of fussy executives,

COMMISSION AGREEMENT FOR DESIGN OF ARTWORK

The Collector _____ residing at

_____, acknowledges sufficient familiarity

with the style and quality of the work of the Artist _____

residing at _____
The parties have made and entered into this agreement on this

_____ day of _____, 19 _____.

1. **Description.** The Artist in consideration of the covenants and agreements herein contained, agrees to design _____

(hereinafter "Work") as preparation for its creation by the Artist for an approximate production budget of between $____ and $____

 a. Approximate size of finished Work:

 b. Material & construction:

 c. Scope of the Artist's work:

 d. Collector is responsible for:

2. **Design Agreement.** The receipt of good and valuable consideration of $_____ on this day for the design work to be provided by Artist after signing of this agreement is hereby mutually acknowledged.

 a. Artist agrees to provide reasonable study, sketch or mockette of the Work to the Collector on or about _____ (date). Upon receipt of design, the Collector shall notify Artist within ten (10) days of any proposed changes in design.

Figure 2. This commission agreement for the design of work was created by northwestern Minnesota artists P. Richard Szeitz and Patricia McGowan Szeitz. They have found it very helpful in clarifying their relations with clients.

b. Artist will provide a maximum of _____ designs or revisions for this Work. Additional designs or revisions shall cost an additional design fee of $_____ per hour.

c. If Collector decides not to proceed with creation of the Work, all designs must be returned to Artist, Artist shall retain the design fee, and this agreement shall be terminated.

d. If Collector determines to proceed with creation of the Work pursuant to a selected design, the WORK OF ART COMMISSION AGREEMENT must be completed and signed by both parties, and the first one-third progress payment will be paid at that time.

3. **Copyright.** It is agreed that all designs are instruments of service and shall remain in the possession of and the property of the Artist, and thereby Artist retains the exclusive right to use and create Works according to the designs. Collector agrees to make no public display or commercial use of the designs, or any copy or facsimile thereof, without the Artist's consent. It is agreed that if consent is granted for commercial use, the Artist shall be entitled to a minimum of ten percent (10%) of any and all consideration paid or exchanged for such commercial use.

IN WITNESS WHEREOF the parties have hereunto set their hands.

By_____
 Artist

By_____
 Collector

some rejecting work outright, others demanding revisions, and all driving the poor guy mad. His letter was a cry of help, but it was a little late.

First, he should have offered a proposal based on, perhaps, ten paintings. Had he tested out his audience's reaction before taking the plunge into a full-scale project, he might have considered one or more of the following alternatives: revising his overall fee upward to account for the additional time he would have to spend satisfying his group of clients; charging for each and every revision; asking that the number of decision-makers be reduced; or bowing out before an ulcer attack.

A proposal is a must, no matter what the project. Even a portrait painter benefits from preliminary sketches. A rough charcoal sketch of a company president might reveal the absence of his beloved pipe, which he feels is part and parcel of his self-image. Better to find that out now than when the portrait is complete.

How do I estimate the budget for the project?

It all depends on what expenses you plan to pay for. Let's suppose that you opt to pay for the major ones—materials and outside labor. You'd total these costs, add in the costs of your own labor, operating expenses, and selling costs, and then mark the fee up to make a profit.

How do I figure out the cost of materials?

If it's a relatively simple project, like the commission awarded to the watercolorist, you would simply add up the cost of the paper and paint. A more complicated project might demand that you figure out just how many yards of concrete you need, how much scaffolding, how many forms for pouring concrete are necessary, and multiply by their unit costs. Previous similar projects recorded on the file cards mentioned in Chapter 3 will give you an estimate of prices—but in these inflationary times, recheck them or you may underestimate. And after you have totaled these items, add in an additional 10 percent of the total for wastage.

How do I figure outside labor expenses?

Again, your file cards will enable you to estimate the approximate number of man-hours necessary to complete the project. But check hourly rates of outside labor, especially if you're dealing with unions, which may have negotiated wage increases for their members.

How do I figure my own labor?

How much your time is worth depends on what you make, or could make, on another job, plus your reputation as an artist (see Chapter 3).

How long it will take you to complete the job will be based on your records and on some preliminary work, which may reveal all sorts of unexpected, time-consuming problems. The watercolorist I mentioned above ordinarily spent three hours on a half-sheet. Had he taken the time to make a preliminary study of the working conditions prior to submitting a proposal, he would have revised his hourly estimate considerably.

How do I calculate overhead and selling costs?

Just as you did in Chapter 3. At this point, however, you might want to give your client a break. If you're selling many works instead of one, you might want to trim your selling costs. Taking the example of the watercolorist once again, he sustained fewer selling costs by making one sale of 100 works than he would have if he had had to sell 100 works individually. Therefore, he would give his client a discount of 5 to 10 percent of the total fee.

What would my total fee be?

After costs have been covered, to make a minimum 20 percent profit (see Chapter 3), you would have to raise your fee by at least 25 percent. So if the project costs $10,000, charge $12,500.

If I am a portrait painter, isn't there an easier way to arrive at my fee?

Sure. In advance of any commission, you would simply make up a table of prices based on content and size. For example:

	9″ × 12″	18″ × 24″	2′ × 3′	4′ × 6′
Head and shoulders				
Full bust				
Half figure				
Full figure				

And you could make several tables for oils, charcoal, or pastel. But you'll still have to do some preliminary work to make sure

problems aren't going to arise that might double or triple your time on the project.

Will I get paid for the proposal?

Sometimes you do get paid, and sometimes you don't. If it's a competition for a commissioned work, you'll know right away. Announcements appear periodically in art magazines and newspapers saying that some organization wants to commission a work. The organization invites artists to enter the competition and states at the outset whether a fee will be included.

If it's not a competition, your client may tell you immediately if he or she is prepared to pay a fee. But when payment isn't mentioned, it's up to you to decide whether or not to ask for one.

How should I decide to ask for a fee?

A rule of thumb used by Calvin Goodman—West Lost Angeles consultant to artists—in advising his clients on the appropriateness of charging a fee may help you decide. He says that where direct costs for materials and labor for the preliminary work represent over 5 percent of the total fee, an initial fee is justified; when they run less than 5 percent, it is not.

Therefore, if your preliminary costs run over $100 on a relatively modest project of about $2,000, ask for payment. On the other hand, it would not be unreasonable for you to absorb the $500 or $600 spent trying to secure a $20,000 commission yourself.

How do I charge for preliminary work?

The answer depends on what you're selling—a work of art itself, part of the final commission, or a design that is without value unless the commission is executed—for example, a crude maquette made of impermanent material or rough drawings that you can't sell later.

How do I charge for a separate artwork? Price it as if you were selling an already complete work. For example, suppose you made a maquette of a large-scale sculpture that cost $500 for fabrication costs and the cost of your time. If the piece is a finished work of art that you would sell for $1,000 elsewhere (after you added in overhead and selling costs plus a markup), by all means charge $1,000.

What if it's part of the final commission? If the preliminary work is actually part of the commission, you might charge a percentage of

the total fee. In the case of the watercolorist, for example, had he done 10 paintings preliminary to the 100-work commission, he would have been justified in charging 10 percent of the commission fee.

What if it's only a rough model or drawing? When the design work is not artwork or part of the project, your fee should be based on the cost of your time spent researching the project, thinking about it, and executing the model or design.

Will this initial fee be included in the total project fee?

Most likely the preliminary fee will be included in the total cost of the project if you are awarded the commission, unless it is a separate piece of artwork. But, and this is an important but, make sure that your agreement states that if the client decides not to go ahead with the project, you keep the preliminary fee.

Can the client use my preliminary work as the basis for future work?

If the client does not give you the commission, he cannot use your preliminary work as a basis for future work even if he pays for it. By law, the creator retains the reproduction rights and the right to make derivative works (work based on the original work) from it. But don't expect your client to know the Copyright Law. Get the issue clarified right away. Then, when you sell the design, place a copyright notice on the piece and mark on the sales invoice that all rights are reserved to you, the copyright owner.

Should a contract accompany the proposal?

Yes. A simple letter will suffice, stating what's being sold (the design, model, or sketch), the price, that you will copyright the work, and that you will retain the fee in the event that you don't get the commission. Or you could use a more formal document, such as the design contract shown in Figure 2.

Will my dealer expect a commission when I am asked to create a work of art?

He certainly will if he did the work to get it for you. And even if you got the commission yourself, he may still ask for his fee, reasoning that the work he put into developing your reputation and visibility enabled you to get the job. Many dealers, however, don't require the same fee they collect for work sold on consignment (see Chapter 5).

In any case, sort out with your dealer in advance of any such projects what he is to get or not get when you're commissioned to do artwork. Of course, when you work with several casual dealers where you leave art on consignment from time to time, you won't owe any of them anything except the one who actually helps you to get the commission. And if your gallery or anyone else charges a commission, make sure you adjust your fee to accommodate it and not let it bite into your profit.

Who else might expect a commission?

If you're awarded a contract to create a work of art, interior designers and art consultants may expect a commission. An interior designer who comes to your studio or gallery and, after looking at your work, recommends you to a client, will expect a percentage.

The same holds true of art consultants. Art consultants are individuals who make a living by searching for works of art for corporations. These people also recommend artists for special projects.

How much will interior designers and art consultants expect? Some expect nothing if their clients are paying them a fee for the project. Others, not paid by their clients but earning a living by working on commissions, may charge from 10 to 40 percent of the total project fee, depending on the selling effort made on your behalf and whether or not they have to split their fee with your gallery. If the latter is true, 10 to 20 percent of the total commission project fee will probably go to the designer or consultant. So if your dealer's usual commission is 50 percent, the designer might receive 15 percent and the dealer 35 percent.

Of course, there are always designers and consultants who take from both ends, charging a commission while on the client's payroll. This is considered somewhat unethical, but it's a rather common practice.

Do galleries always split the commission with designers and consultants?

No, occasionally you'll run into a dealer who expects you to pay his or her full fee plus that of the designer or consultant, leaving you with very little. Art advisors, however, do not take commissions.

What is an art advisor?

According to the Association of Professional Art Advisors

(APAA), they are people who are qualified to provide professional guidance to collectors—usually corporations—on the purchase, installation, placement, and maintenance of works of art. In order to belong to APAA, art advisors must also abide by the following guidelines: (1) they must not have an inventory of art to sell to clients and cannot sell art as dealers or artist's representatives, and (2) they must be compensated by the client only, not by artists or dealers.

For a list of APAA members, write: Association of Professional Art Advisors Inc., 342 Madison Avenue, New York, NY 10017.

Do architects charge commissions?

Although architects frequently perform the same role as interior designers or art consultants, they shouldn't charge a fee if they recommend your work to their clients. The leaders of the architectural profession consider this an unethical practice.

What should go into an agreement for a commissioned work of art?

Clauses describing the following should go into such an agreement: the scope of work; obligations and duties of artist and client; fee and schedule of payments; cancellation, cancellation fee, and a release if work is rejected; ownership of copyright; reserved rights; starting and completion dates; delivery of work; death and disability; and arbitration.

All of these are mentioned in Howard Thorkelson's "Commission Agreement between Artist and Client" (see Figure 3). Many of them should be included in any standard contract; your project, however, may entail other situations that should be covered in an agreement, and some of these will be mentioned below.

What is the scope of work?

The approximate dimensions of the piece and the mediums and materials used. The physical, as opposed to the creative, aspects of the work come into play here.

What will a clause about duties and obligations say?

It will spell out who's responsible for what, particularly with respect to who is to arrange and pay for certain materials and services. A number of these obligations are listed in Clause 3 of Figure 3. You should supplement this list with others that are pertinent to your project or eliminate those that are unnecessary.

COMMISSION AGREEMENT BETWEEN ARTIST AND CLIENT

1. **Agreement.** This is an agreement between

Name_____ Address_____
(hereinafter referred to as the "client") and

Name_____Address_____
(hereinafter referred to as the "artist") for the creation and transfer of the work. All rights and liabilities of either party in the work shall be governed by this agreement.

2. **Description of the work.** The work, to be created by the artist, shall be (a portrait, a mural, or whatever . . .) (. . . of the approximate dimensions of . . .) (. . . in medium or materials).

3. **Obligations of the artist and client.**
a) The artist/client shall designate and purchase materials necessary for the creation of the work.

b) The client shall bear the expense of any transportation or living costs incurred by the artist away from his home or studio, long-distance telephone calls or telegrams, sales taxes, or customs duties, insofar as such expenses are reasonably incident to, or entailed by, the artist's creation, delivery or installation of the work (or supervision thereof).

c) The artist shall create the work.

d) The artist/client shall provide for the framing and installation of the work, at the artist/client's expense, subject to the artist's right to supervise any such work.

e) Artist/client shall hire and compensate any additional labor services necessary for the creation and installation of the work.

f) The artist/client shall secure any building permits necessary for the lawful creation and execution of the work.

g) The artist/client shall hire and compensate any consulting engineering services necessary to the creation and installation of the work.

h) The artist/client shall obtain (fire, casualty, and personal injury liability) insurance on the work to be in effect until the (delivery) (completion of installation).

Figure 3. This contract was drafted by Howard Thorkelson, Esq. It isn't meant as the ultimate commission contract; it is merely a guide to help you think out what you should put in your contract.

i) The artist/client shall provide for the workmen's compensation coverage for any employees of the artist during the creation or installation of the work.

j) The client shall bear the rental expense of any new and additional work space necessary for the artist's creation or installation of the work.

4. **Start and completion dates.** The artist shall undertake the creation of the work on approximately _____ and shall complete the work by _____.

5. **Fees and schedule of payment.** The client shall pay to the artist the sum of $_____ in total payment for the work. This amount shall be paid in equal one-fourth installments as follows: $_____ upon the execution of this agreement (or the start-up date, if later); $_____ on _____; $_____ on _____; and $_____ on _____ (completion date).

6. **Cancellation and cancellation fee.** The client shall not unreasonably withhold acceptance of or payment for the work. If prior to the work's completion, the client observes or otherwise becomes aware of any fault or defect in the work or noncomformance with the design plan, he shall notify the artist promptly. However, the client's objection to any feature of the work (not specifically indicated by the design plan but) attributable to the exercise of the artist's esthetic judgment in the creation of the work on the basis of the design plan shall not justify the client's withholding acceptance of or payment for the work. In the event that the client (unreasonably) rejects the work after having made one or two installment payments, the artist shall be entitled to keep any monies so paid. In the event that the client rejects the work after three installment payments and before the completion date, the artist shall be entitled to be paid such additional sums as will raise the total amount of payments for the work to 85% of the amount of the entire fee. Notwithstanding the rejection of the work and the payment of any cancellation fee, all rights in the work shall vest in the artist, who shall be entitled to complete it, without regard to the design plan, and to make appropriate identification of the subject matter in connection with any display or exhibition of the work. In the

event that the client fails to pay the fee or any portion thereof for thirty days following the relevant date specified in the schedule of payments, the artist may terminate this agreement and, thereby, have the right to keep all amounts theretofore paid and to collect any amounts then due.

7. **Copyright.**The artist shall copyright the work in his own name (and such rights shall not be affected by the transfer of the work itself) (but the artist shall assign all such rights to the client effective with the transfer of the work itself).

8. **Exploitation of the work.** Notwithstanding the assignment of any copyrights to the client, the artist shall retain certain rights relating to the use and maintenance of the work. The artist shall be entitled to reasonable advance notice of any temporary public exhibition or display of the work so that he may advise on the physical circumstances and esthetic manner of its exhibition or display. In connection with any proposed commercial exploitation of the work, the artist shall be entitled to advance notification so that he may authorize or deny identification of himself as the artist and, in the case of proposed photographic reproduction, may veto it. In the case of any noncommercial or authorized commercial use or published writing or publicity featuring the work, the artist shall be entitled to customary and appropriate identification as the creator of the work. Upon giving reasonable advance notice to the client, and at his own expense, the artist shall be entitled to borrow the work, for (a) period (s) not to exceed ____weeks cumulatively in any continuous ____-year period, for the purpose of public exhibition; and the client shall be entitled to customary and appropriate identification as the owner.

9. **Maintenance of the work.** The client shall notify the artist promptly in the event of the need for any maintenance or restoration services so that the artist may have a reasonable opportunity either to perform such work himself or to supervise or consult in its performance. The artist shall be reasonably compensated by the client for all such maintenance or restoration services. In the absence of any need for restoration or maintenance, the work shall remain free of alteration by the client, who shall take reasonable precautions to protect it against damage or destruction by external forces. (In the event of possible alteration or destruction of the work due to proposed renovation or demolition of a structure to which the work is affixed, the artist shall be entitled to notification, by the client, affording the artist a reasonable opportunity to reclaim the work by removing it whole at his own expense.)

10. **Warranty.** The artist warrants that the completed work will be fit and suitable for use and exploitation in the manner (and to the extent/and for the duration) for which it is to be created, but this warranty is conditioned upon the client's compliance with the provisions hereof relating to installation, maintenance and exploitation.

11. **Delivery.** The artist shall prepare the work to be ready for delivery to the client on _____. Delivery and physical transfer of the work shall be accomplished (by the artist's notification to the client that the work is ready for pick-up at the artist's studio) (by the artist's causing the work to be sent, insured and shipping charges prepaid, to the client).

12. **Title of ownership.** Title of ownership in the work shall pass from the artist to the client upon the client's payment of the fourth installment of the artist's fee for the work.

13. **Death and disability.** In the event of an incapacitating illness or injury of the artist and a delay arising therefrom in the execution of the work, the artist shall notify the client of such delay and the client's obligation to make payments shall cease until such time as the artist notifies the client he has recovered and is ready to thereupon resume. The death of the artist shall terminate this agreement, and the artist's estate shall be entitled to retain any payments already made by the client and to be reimbursed for any payments which the client would have been obliged to pay the artist; the client shall be entitled to claim the work and any unused materials acquired for its execution (and to have the work completed by another artist without regard to the original design).

14. **Other delay.** If the execution of the work is delayed by the act or neglect of the client, by labor disputes, fire, unusual transportation delays, or by other external forces or natural calamities outside the artist's control, the artist shall be entitled to extend the completion date, by notification to the client, by the time equivalent to the period of such delay.

15. **Arbitration.** Any dispute hereunder between the parties (not involving money claims by either party in excess of $_____) shall be resolved by resort to arbitration (in accordance with the standards and procedures of the American Arbitration Association).

16. **Construction.** Construction of this agreement shall be governed by the laws of the state of _____.

Who pays for materials and labor?

In many cases, it might seem more advantageous for the client to assume the responsibility. Otherwise, you might find yourself staying up nights paying bills and keeping accounts. On the other hand, to avoid any disputes over the quality of labor and materials, it might be wise to arrange and pay for them yourself.

Can I protect myself against inflation if I pay for materials and labor?

When the project looks as though it will take a long time, you can protect yourself in three ways—first, by carefully assessing each and every possible expense so your initial estimate will be accurate; second, by including the 10 percent allowance for wastage mentioned above in the budget; and third, by making the contract good only for a certain length of time—perhaps 90 to 120 days— after which the contract would have to be renegotiated.

Who pays for expenses other than materials and labor?

Again, that's up to you and your client. The client will probably pay for such items as public liability insurance (see Chapter 12), for example, but you may decide to pay for travel expenses. The point is that to avoid misunderstandings, each and every expense should be spelled out. Both you and the client must know not only what he's paying for, but what he's not paying for.

And finally, if your client picks up the tab for expenses you've incurred, he'll expect you to keep accurate, accessible records.

If I don't pay for the framing or installation, can I control them?

The effectiveness of any artwork can be destroyed by shoddy installation or a cheap framing job, so make sure your contract contains a clause stating that you are to be consulted on or to supervise installation or framing.

How do I provide for changes in the size of the project?

Insert a price revision clause into your contract that deals with compensation for increases and decreases in the scope of work on a square-foot or hourly basis. For example, suppose before signing a $7,500 contract for the execution of a 75-square-foot mural you inserted a clause saying that payment was to be based on a $100 per square foot charge and total payment would depend on final size. Then, if the 75-square-foot mural grows to 85 square feet, you can raise your fee by $1,000.

What do you mean by a schedule of payments?

A schedule of payments is a clause in your contract indicating when each of a series of payments is to be made. In other words, as soon as the agreement is signed, you should receive your first payment (which might also include the fee for your preliminary work). If you plan to pay for labor and materials, this payment should be sufficient to enable you to start buying materials and hiring labor. Thereafter, your fee might be paid in periodic installments or at various stages in the creative process (perhaps as every third is complete).

Proof of the work's progress can be ascertained by a visit by your client to your studio or wherever the work is being made. If this is impossible, however, you could take photographs to show its status.

Your client, if he's smart, will withhold 10 percent of the total fee until installation is finished and he's totally satisfied. So if you are awarded a $10,000 commission, you might ask for $1,000 to begin with, followed by two interim payments of $3,000 and another of $2,000, with your client holding back $1,000 until the project is cleaned up.

Why is a schedule of payments important?

Each payment indicates approval or satisfaction and gives the go-ahead to the next phase. More important is its negative aspect—since each payment is an advance payment for the next work period, your agreement should state that if the client withdraws at any stage, you'll retain all payments received up to that point.

A schedule of payments is warranted even for a small commission, such as a portrait. You might ask for a payment when the preliminary sketch is approved, when the preliminary blocking-in is finished, and then when the portrait is complete.

What if my client won't agree to a schedule of payments?

If for some reason—usually because you're just not in a strong enough bargaining position—you can't force progressive payments out of the client, the contract should stipulate that he approve the work at various stages by initialing it (for example, "approved 9/1/87, B.D."). These okays are evidence that the client was happy up to a certain point in case he reneges on payment. In other words, suppose your client rejects your finished portrait of her, claiming it doesn't satisfy her, and she refuses to pay your agreed-upon $1,000 fee. If you take her to court, these initialed and dated approvals indicating that she was satisfied for a while

would probably persuade the court to award you a percentage of the fee.

Can I prevent a client from cancelling a commission?

No. If the client is dissatisfied, you can only hope to cut your losses. Commissions for artwork are one instance of the customer being just about always right. Court after court has ruled that when a contract states that payment depends on the client's satisfaction—no matter how many artists, curators, or critics would testify to the satisfactoriness of a work—it is up to the client alone to decide this.

Of course, you could try to prove that his dissatisfaction is fake—that the real reason why he rejected the portrait you painted of his wife was that he was getting ready to divorce her. But convincing the court of his state of mind would be very tricky.

But don't let this discourage you. You can do a pretty good job of protecting yourself with a schedule of payments, a cancellation penalty, and a clause reserving the right to sell the rejected work.

Can a client cancel a project because I deviate from the original design?

Yes, but only if this is a term in the contract. Some clients won't allow any deviation from an initial concept, but others will. If your client agrees that you need a certain amount of latitude in your creative activity, get this agreement in the contract. You might word the clause in the terms Thorkelson used in Clause 6 of his commission agreement. He says that "the client's objection to any feature of the work (not specifically indicated by the design plan, but) attributable to the exercise of the artist's esthetic judgment on the basis of the design plan shall not be a basis for withholding acceptance of or payment for the work."

Spelling out artistic freedom or defining the fine line between acceptable and unacceptable deviations, however, isn't as easy as outlining the scope of work or duties and obligations in a contract. So use your common sense. Major changes will be rejected by all but the most lenient of clients.

What if a client refuses to pay for work permanently attached to his property?

If he does nothing to remove it after rejection, you can sue him under the doctrine of unjust enrichment (see Chapter 1)—no one can enrich himself unjustly at someone else's expense.

But if he attempts to get rid of the offending piece, not only won't he have to pay your full fee, but you may end up paying

him. Suppose, for example, you painted a mural on his wall. If he doesn't like it and gets a housepainter to paint it out, he can sue you for damages and perhaps force you to pay the housepainter's fee.

Can I protect myself against the client suing me for damages?

Yes. Any time you create a work that will be permanently attached to property, such as a mural on a wall or a large-scale sculpture in a permanent installation, ask that your contract include a clause saying that you won't have to pay damages to have the piece removed if the client is dissatisfied.

What is a cancellation penalty?

A cancellation penalty insures you a percentage of the total fee even if the client rejects the completed work. Such a clause should state that if the work is rejected, the client will still have to pay you a substantial amount, perhaps 85 percent of the total fee. Going back to the example of the $10,000 commission, suppose you receive the initial payment and the two interim payments for a total of $7,000. Then, when the work is completed, the client rejects it. If your contract contained a cancellation penalty of 85 percent of the total fee, you'd still be entitled to another $1,500.

Why should I have a clause that allows me to sell a rejected work?

If a commissioned work is rejected, you'll naturally want to sell it to someone else if you can. And usually this won't be a problem—if your client doesn't want the work, he or she is not going to object to your selling it to someone else.

But the portrait artist should take note—selling or exhibiting the rejected work might invade the subject's right to privacy, particularly if he or she is someone famous. So get a release in writing before—not after—rejection, when the client may not feel too kindly toward you. The release should be included in the contract and would read something like this: "If the client is dissatisfied and rejects the final work, the client waives all rights in the work and consents to its sale or exhibition by the artist."

Is there anything else I should do to protect myself?

Yes, make sure you have a title of ownership clause stating that the client can't become the owner of the work until all payments have been made. A contract with a title of ownership clause will also serve notice on creditors if the client goes bankrupt that

you—not the client—are the owner if the work isn't completely paid for.

What reserved rights can I ask for?

Any of the reserved rights discussed in Chapter 3. The most important of these is the right to maintain the integrity of a work. Alterations, for example, can be prevented by a clause like this: "The client may not alter the work in any way without permission of the artist." Or to prevent total destruction, which could occur if the building containing the work was to be torn down or renovated, you might insert a clause reserving the right to remove the work at your own expense. See how other rights are handled by Thorkelson in Clause 9 of his contract.

Can I insist on the right to exhibit my work? You can't *insist* on anything, but you *can* bargain for it. Ask your client for the right to exhibit the work for certain periods of time. Two months out of five years is considered a reasonable amount of time to borrow a work for exhibition.

How do I arrange for ongoing maintenance? You can do this by inserting a clause requiring continued maintenance, and, if possible, designating you as supervisor of it.

You might also withhold your warranty guaranteeing the durability of the piece if it's not properly maintained. In other words, it isn't reasonable to guarantee a piece if your client isn't going to take proper care of it—for instance, placing a fragile piece of sculpture meant for indoor display outdoors, exposing it to the elements.

At the same time, you might suggest a yearly maintenance contract, offering for a fee to take care of necessary repairs and upkeep to keep the work from deteriorating.

Is it important to demand proper credit in publicity material? Certainly. If an article appeared in the media about your work but failed to credit you as the artist, you'd probably be very upset. But what can you do if a credit clause isn't in your contract? Ask for a clause saying that any publicity material dispensed by the client must give you proper credit. Bear in mind, however, that when the media gets hold of the material, that's the end of any control the client has over it. So you might still open up the newspaper and see a picture of your work without your name attached.

Should starting and completion dates be in the contract?

Yes, approximate dates are essential to the well-made contract and will prevent misunderstandings.

What happens if I am late meeting the deadline?

A few clients may demand a penalty clause for lateness; most won't. In fact, if you bring the project in more or less on time, chances are nothing will happen. Nevertheless, you should protect yourself in the contract with provisions covering sickness or injury and other events over which you have no control.

What should I say about sickness or injury in a contract? Read Clause 13 in Figure 3. Thorkelson advises bargaining for a clause stating that once the client has been notified of your disability, he or she will extend the deadline by the amount of time it takes you to recover. The client, of course, will be given the right to suspend payments until you resume work.

What should I say about an event that is out of my control that holds the project up? Once again, you should ask for a time extension equivalent to the delay. A clause like this might read:

If the artist is delayed at any time in the progress of the work by the act or neglect of the client or by changes ordered in the work or by labor disputes, fire, unusual transportation delays, strikes, unavoidable catastrophes or casualties, the client will extend to the artist the time equivalent to the time lost by reason of any of these circumstances.

What if I don't complete the work at all?

Most likely the client will insist on a clause stating that after a certain length of time—say 60 days after the promised completion date—if the project has not been finished, you'll have to return all payments you received. However, you might try to modify the harshness of this clause to read that, if failure to complete the project is caused by permanent disability, you won't have to return payments received up until the time of disability.

What if I die before the project is completed?

Although death terminates the contract, your efforts up until that time should be compensated. So a provision should be included in the contract similar to the one in Clause 13 of Figure 3. It provides for your estate to retain all payments paid to you and to be entitled to any repayment of any expenses incurred that the client would have been obliged to pay.

What if the client dies before the project is completed?

The contract should provide for this eventuality as well by stating that you can keep all fees already received and collect from his estate any others due you for expenses.

What if the client doesn't pay me on time?

If the payments are only a few days behind schedule, it will be to your advantage to bear with the client. But if the payments are very late, you may want to terminate the contract. In this case the agreement might say:

If the client does not pay the artist within 30 days of the dates described in the schedule of payments, the artist shall have the right to terminate the contract, in which case, the artist shall be entitled to retain all amounts received prior to termination and collect any sums still due.

What is arbitration?

If any dispute over the project should arise, such as if the client does not repay you for expenses, you can settle it in one of two ways: either by going to court or by arbitration. Arbitration means that a neutral third party imposes a decision that is binding on both parties.

Where do I find arbitrators?

Neutral third parties are available from the American Arbitration Association in over 1,300 cities in the United States. To locate one in your area, write the association at 140 West 51 Street, New York, New York 10020.

What are the advantages and disadvantages of arbitration?

Arbitration is less expensive and quicker than formal litigation. But it's binding on the parties, so if you think you received an unfair decision from the arbitrator, you cannot appeal it in any court of law.

How is arbitration written into a contract?

Clause 15 of Thorkelson's contract in Figure 3 illustrates how arbitration is written into a contract. But consider this clause carefully—if you think you'd rather sue than arbitrate a controversy or claim arising from your commission agreement, don't put this clause in. If you do and then try to sue, your dealer will claim you're breaching the contract.

What state and local governments have Percent for Art Programs?

Contact your state arts council or city and county arts commissions to find out if a program exists in your geographical area.

Five

THE ARTIST
AND THE DEALER

DEFINITION OF DEALER

VANITY GALLERIES

ADVANCES AND STIPENDS

OUTRIGHT PURCHASES

CONSIGNMENT SALES

TERMS OF CONSIGNMENT AGREEMENTS

Stories about the terrible deals artists get from their dealers get a lot of press. No one hears much about the honest, fair-minded, even generous, business arrangements that unite the majority of artists and their dealers. But there's no denying that some artists do get skinned: A dealer goes bankrupt and disappears, leaving the artist holding neither the work nor the money for it; a gallery cancels a promised exhibition after an artist has invested time and money and turned down other offers.

Less dramatic, but certainly equally frustrating, are the following examples.

A painter in Utah told me how he had been locked into a three-year exclusive contract with no termination clause with a gallery in Salt Lake City. The dealer refused requests from out-of-state galleries interested in showing the painter's work, effectively stunting the growth of his reputation throughout the West during this period.

And a painter from Ohio, after sending a number of paintings to a New York gallery he knew very little about, heard nothing from them for two years until a check arrived for the sale of two works. Neither the check nor subsequent inquiries revealed how much the individual works sold for, who bought them, or the status of the other paintings.

These situations and others of a similar nature could have been avoided if the artist had known at the outset what he was getting

into. Parties to the best artist-dealer relationships, like those in the best marriages, suffer no delusions about what to expect from each other.

The object of this chapter is to alert you to the terms you should clarify before entering into a deal with a dealer. Of course, a number of them won't be relevant to your particular situation—who's responsible for shipping costs won't mean much if your gallery is within easy reach by car; insurance will be less important if you use a private dealer who doesn't have a gallery in which to show and store work. But you can pick and choose those terms that are most important to you and then try to hammer out the most favorable agreement you can in relation to these terms.

Obviously, the bigger your star, the better your bargaining power. And it's important to assess just how much clout you do have, a step many artists fail to take. All too often I hear of totally unknown artists—with no selling or critical records—making outrageous demands, or, conversely, recognized artists failing to negotiate the kinds of deals they could easily demand.

How do you define the term "dealer"?

Anyone who sells fine art, except auctioneers. Included in the definition are people who run large galleries and small frame shops, as well as those who operate without public sales facilities but rather sell from their houses or apartments. The latter are sometimes referred to as private dealers, artists' agents, or art consultants. Whatever title they go by, if they buy work or take it on consignment from you, they're dealers, though there is a distinction between retail and wholesale dealers.

What is the difference between a retail and a wholesale dealer?

Ten years ago, almost all dealers were retailers. In other words, they sold to the collector, the person who bought artwork for display in his or her own home or office. The increasing demand for art, however, has changed the nature of the art market, resulting in a proliferation of wholesalers: businesses that buy art outright to sell to the trade—retail galleries, interior designers, architects, department stores, and so on.

How can I check on the reliability of a dealer?

The Better Business Bureau, the Chamber of Commerce, curators of local museums, and art groups—such as local chapters of Artists Equity Association—are possible sources of information. Another way is to ask the dealer in question for a list of the artists

he or she handles and contact some of them. Find out if they're pleased with the financial arrangements, if they're supplied with details of each sale, and if they receive prompt payment.

If you're unable to get any information on a dealer who approaches you about the possibility of representing your work, don't take the chance on trusting work to him or her. And if it's a vanity gallery, think long and hard before agreeing to a show.

What are vanity galleries?

Galleries that invite you to mount a one-person show in return for which you pay all or almost all expenses are called vanity galleries. In other words, you rent the gallery to put on the show.

Would I want to show at a vanity gallery?

Occasionally, vanity galleries perform useful functions in nonmetropolitan areas. But in a major city, exhibiting in a gallery that every knowledgeable person in the art world knows is a vanity gallery is not going to bring you fame or glory. In fact, if you have any reputation at all, it will be rendered somewhat suspect by an exhibition at a vanity gallery.

Are vanity galleries reputable?

Many are perfectly honorable in their dealings, but others are not. In fact, you might get royally taken. A not atypical case goes like this:

A gallery in New York City calls or writes, inviting you to show at their prestigious address on Madison Avenue. They promise to handle the details—placing ads, sending out invitations, providing the champagne and hors d'oeuvres, and so on—in return for a 10 percent commission on sales. All you have to do is put up $300. And these galleries don't ask just anyone—if they've done their homework properly, you're probably the wife of a successful doctor or lawyer on Long Island or Westchester County.

And then comes the kicker. Sometime after the invitations have been mailed and all your friends and your husband's business associates have announced plans to attend the opening comes another call or letter from the gallery, this time asking for the other $2,700 they need to pay expenses.

So you're left with the choice of recalling the invitations and retreating in embarrassment, or paying up.

Does a dealer ever support struggling artists?

Yes, but with decreasing frequency. It's a risky business, and these

days few dealers can afford to gamble on the future success of a favorite artist. Nevertheless, some dealers will support artists during their early years either by paying them an annual stipend or by giving them money advances against the time when they can generate more sales. Stipends and advances sound highly desirable from an artist's point of view, but they should be carefully considered before acceptance—they can destroy a good business relationship.

What's wrong with advances and stipends?

There's nothing wrong with advances or stipends themselves; it's how they are to be repaid that can be a problem. Will the dealer want cash or some of your work? If you're not selling well and he wants cash, how will you be able to repay him? If sales are strong and he opts for work, will he demand the cream of the crop? And if so, how many will he think are justified? These prickly problems can sour an otherwise successful relationship.

Repayment may not be the only thorn in your side. Your dealer may try to influence your stylistic and aesthetic development. If, for example, your lyrical landscapes are starting to sell well, she might not be pleased to see you change directions and embark on something that may not be as salable.

What sort of business arrangements do dealers offer?

You can sell work outright to a dealer who acts as a retailer or a wholesaler, or you can consign work to a retail dealer. Wholesalers almost never get involved in consignment sales. In a consignment arrangement, described in more detail below, you retain ownership of the work until the dealer sells it for you.

If a dealer buys work, how much will he or she pay?

It's impossible to generalize. A retailer buying one or two works might pay you the same amount you would get from a consignment sale—the retail selling price minus the dealer's commission. For example, suppose your work sells through retail galleries for $500 and dealers in the area usually take a 40 percent commission, leaving $300. A dealer buying one work might also offer you the $300. But if he buys a number of pieces, an additional 10 to 15 percent on top of the 40 percent would not be out of order.

A wholesaler's discount will be far greater—and with good reason. Look at the economics of it. He must buy cheaply so he can resell at a profit, and, at the same time, allow the retailer to do the same. This means that he will probably buy your work for half

(or a little more or less) of what he plans to sell it to the retailer for so the retailer can buy the work at half (or a little more or less) of what she plans to sell it for in her gallery. So if you sell a work to a wholesaler at $100, he may sell it to the retailer for $200, and the retailer may charge the customer $400. In other words, each person who buys the work just about doubles the price.

This may seem outrageous to you, but it's a perfectly acceptable fact of life in any merchandising business.

What are the benefits of direct purchase?

Immediate cash is the greatest benefit. Emotional gratification isn't too far behind.

What are the disadvantages of outright sales?

If you sell a work cheaply and the dealer can sell it for more than you anticipated, you won't benefit from the increase in value.

What would I include in an outright purchase arrangement?

You and the dealer would spell out how much work he or she is to purchase. For example, he may want: (1) to buy all of your work, in which case—if you agree—you must sell him everything you produce; (2) to purchase a specific portion; (3) to have first refusal rights (in this instance the agreement should state that you may sell work he rejects to anyone you like); or (4) to buy only occasional works.

Other terms would be similar to those included in the sales agreement explained in Chapter 3 concerning, for instance, copyright, delivery dates, and payments.

When I consign work, how is the dealer compensated?

The dealer is compensated in one of two ways: either profit earned over the net price or a percentage of the sales price, which is the more common method.

What is a net price?

A net price is an agreed-upon amount that you'll be paid no matter what the work sells for. For example, you might say to your dealer, "I want $700 for this work. You can sell it at whatever price you want as long as I get my $700." Under this method, you would probably determine what you think is a fair net price by first figuring what your work should retail for and then deducting the going commission in your area from the retail sales price. For

instance, if you think certain works of similar size will sell for $1,000, and most dealers in your area are charging a 40 percent commission, you would ask for a net price of $600.

What are the risks involved in the net price system?

Obviously, if your dealer is able to charge more than you expected, he—not you—will make a bigger profit. Less obviously, if your dealer thinks he might have to lower prices to sell your work, he'll be less interested in selling them at all.

If I have several dealers, should I use the net price system?

No. Since the dealer, not you, sets the prices, chances are prices will vary—and they'll vary a lot. (The same thing will occur if you make outright sales to a number of dealers.) It isn't difficult to imagine the ensuing chaos. Dissatisfied clients will soon demand to know why work sells for more in one gallery than in another in a different city. They'll also wonder what its real value is.

What exactly does the term "consignment" mean?

When you consign work to a dealer, you set up an agency relationship with him. Under the law, as an agent, he must take care of your work and pay for any loss or damage the work suffers while it is in his possession if he hasn't exercised reasonable care to protect it. In other words, if work is stolen from an unattended, unlocked gallery, the dealer would have to repay you for the work.

Consignment also means that while your dealer has the power to sell your work, you own it until you have been paid in full for it.

This sounds good, but in actuality, a dealer-agency relationship is fraught with a certain amount of danger. If the dealer goes bankrupt, consigned work may be seized to satisfy the claims of his creditors.

How can I prevent my work from being seized by creditors?

It's difficult unless you live in certain states (see below). If you don't, under the Uniform Commercial Code (UCC), which governs commercial transactions, you can protect your work only if, before consignment, you either fill out UCC Form No. 1, which guarantees your right to your work, or make sure that the gallery prominently posts a sign stating that artwork is on consignment, an action that is very hard to enforce.

What does a UCC Form No. 1 do?

It prevents consigned work from being subject to the claims of creditors. In essence, it allows you to place a lien against the work. This means you have first claim on it and will get it back if and when creditors descend on the dealer.

What's wrong with filing this form?

It's a cumbersome procedure, and one that most dealers are reluctant to agree to. When you file a UCC Form No. 1, your dealer cannot sell the work until the lien is removed by you. This means he or she must contact you and you have to remove the lien on the work in writing, a process not designed to expedite sales. Nevertheless, if you consign a number of works and each is worth a lot of money, you should consider asking your dealer to allow you to file a UCC Form No. 1 on the work.

Figure 4. The Uniform Commercial Code form shown here should be filled out if you're consigning work of considerable value to a gallery. If you don't use the form and the gallery goes bankrupt, your work may be seized by creditors unless you live in a state that prevents seizure of artwork by creditors.

Where do I get and file this form?

Most legal stationery stores carry them or can get them for you. To file the form, check with either your county clerk's office or the secretary of state for the proper procedure; they'll tell you where to file the form and how much it will cost to file—usually a few dollars.

Which states protect my work from creditors?

Arkansas, Arizona, California, Colorado, Maryland, Massachusetts, Michigan, Minnesota, New Mexico, New York, Oregon, Texas, Washington, and Wisconsin protect your artwork against creditors of a gallery without your having to file a UCC Form No. 1 or post a sign in the gallery.

New laws may have been enacted since this writing, so be sure to check out the legislation in your state.

SIMPLE CONSIGNMENT AGREEMENT

Smith Galleries, Inc. (date)
2404 State Street
New City, New York

You hereby acknowledge receipt of the following painting created by me:
 "Sea Storm," an oil painting, 40" x 60".
I am consigning to you this painting at the retail price of $1,000.
 You shall deliver to me within ten (10) days after the date on which you make delivery under a sale or contract of sale the purchase price of the painting less your commission of _____%. Title to the painting is reserved in me until sale of the painting.
 Any time prior to the sale of the painting, you will deliver the painting to me immediately upon receipt of instructions from me asking for its return.

 Artist

The foregoing is confirmed and agreed to by _____
 Smith Galleries, Inc.

Figure 5. This is an example of the simplest form of a consignment agreement. It might be used when you consign only one or two works to a gallery.

What other legal rights do I have when I consign work?

Under contractual law, you have the right to be paid. Your offer of the work and the dealer's acceptance represent a valid oral contract. When the work sells, it is implicitly understood that he must pay you the purchase price, minus his commission, and you can sue him if he doesn't. But that's all you can expect under this minimal type of contract.

What sort of contract should I have with my dealer?

You should have a clearly worded written document that spells out all the terms, such as insurance and exhibitions, that are relevant to your arrangement with your dealer.

Do I need a contract to consign only a few works?

Yes, but if you occasionally consign a few works to a dealer or dealers, none of whom promises you an exhibition or any long-term arrangements, you could use the simple form of consignment contract shown in Figure 5.

What would be the format of a more complicated agreement?

In most cases, this will depend on your status. A big reputation demands protection from a good lawyer, who, to earn his or her fee, will probably set forth the terms in a multitude of clauses starting with "herewiths" and "wherefores."

If you're less established or unknown and don't have a lawyer, you can use one of the model contracts shown in this chapter (see Figures 6 and 7). Rather than adopt one of these verbatim, however, a wiser choice would be to adapt one to your particular needs by eliminating some clauses and modifying others.

For example, Clause 11 of the Bay Area Lawyers for the Arts (BALA) "Artist-Gallery Agreement" (Figure 7) states that, "The division of financial responsibility for the costs of exhibitions and other promotion efforts shall be mutually agreed in advance." This could be changed to state your exact arrangements, such as, "Dealer agrees to pay for two half-page national magazine advertisements. Any further magazine advertising must be paid for by the Artist."

Can't I just write a letter?

Yes, you can protect yourself by writing a letter in your own language stating what you think the terms of your agreement are and asking the dealer to initial and return it to you.

ARTISTS EQUITY ASSOCIATION, INC.
MINIMUM ARTIST-DEALER AGREEMENT

Prepare this agreement in duplicate. N.B. This agreement should not be considered the last word in artist-dealer contracts. Artist Equity's National Board holds that the best agreements are carefully tailored to meet the specific needs and interests of the artist and dealer involved. Therefore please feel free to adapt and modify the terms set down here to meet your own needs, interests and opportunities. You may also find it wise to enlist the assistance of an attorney skilled in drafting contracts.

Artist Equity's National Office receives many requests for advice regarding appropriate trade discounts to dealers. Such discounts vary widely, depending entirely upon the services performed by the dealer for the artist and no general rules can be established. For example, a dealer who absorbs the entire cost of an exhibition may well be entitled to a better discount than one who shares such costs with the artist. Obviously, a dealer who purchases works outright is entitled to a better discount than one who sells consigned works.

It is hereby agreed between _____ , the artist, address:

and _____ , the dealer, address:_____

that the dealer shall exhibit the artist's work at the dealer's premises under the following conditions:

1. The works hereby consigned for exhibition and sale by the dealer as agent for the artist are enumerated, described, and priced at retail on the attached list. Such works are warranted by the artist: to be free of inherent vice, to be his/her own original creations, and to be the unencumbered property of the artist. They shall remain the property of the artist unless and until they are purchased by collectors or by the dealer.

2. The works here listed shall be exhibited by the dealer from _____(date) to and including _____ (date). These works shall constitute a solo/part of a group (*choose either term*) exhibition. Such exhibitions shall be held approximately every _____ months.

3. Approximately _____ works on the attached list shall be hung during the exhibition period. The remainder shall be available for inspection by prospective purchasers. After the exhibition period, the artist's consigned works may be retained by the dealer for sale for a term of _____ months. At the end of that period, they may be individually removed by the artist providing five days prior written notice has been given. Other works may be supplied as additions or replacements for works sold or removed from time to time by mutual written agreement of artist and dealer. The term for retention of works may be thereafter extended annually by mutual written agreement.

4. The artist will assist the dealer by: (*select appropriate responsibilities/eliminate inappropriate items*)
 a) crating and shipping works to the dealer,
 b) framing the works for exhibition,
 c) furnishing advice, cooperation, and assistance in advertising and publicizing the artist's work,
 d) furnishing data regarding prospective and existing collectors.

5. The dealer will pay the artist _____ % of the retail sales price on any works sold. Notice of all sales, including the name and address of purchaser will be given to the artist at the conclusion of each month and payment of all monies due shall be made not more than thirty days after the receipt of payment by the dealer. The dealer assumes full risk of non-payment by the purchaser. However, if a work is returned in good condition by a client for credit, the dealer will make appropriate pro rata adjustments in future payments to the artist.

6. During the term of this agreement or any extension thereof and during the shipment to the artist of works from the dealer, the dealer shall cause all of the artist's works consigned to the dealer to be insured to the benefit of the artist against any and all loss in an amount equal to the artist's portion of the retail sales price.

7. No unsold works shall be removed from the dealer's premises and no discounts shall be permitted except by specific permission of the artist.

8. The artist shall have the right to inventory all consigned works at reasonable times and to obtain a full accounting for any works not present at the dealer's premises at such time.

9. The artist reserves all rights to the reproduction of works in any manner. This restriction shall be indicated by the dealer in writing on all sales invoices and memoranda. However the artist will not withhold permission for the reproduction of such works for promotional purposes.

Figure 6. A number of organizations have prepared artist-dealer agreements. Artists Equity Association drew this one up.

10. During the term of this agreement, the dealer will exclusively represent the artist in the following geographical area:

However, the artist takes the following exceptions to such exclusive representation* (e.g.: *The artist reserves the right to sell works from his/her own studio. In this case, the artist will remit* _____ *% of the proceeds of such sales to the dealer*)

11. Costs of crating and shipping shall be absorbed as follows: (*Indicate responsibility of artist and/or dealer*) _____

12. Promotion and advertising costs shall be absorbed as follows: (*Indicate responsibility of artist and/or dealer*)

13. Costs of an exhibition opening in conjunction with the exhibition provided above shall be absorbed as follows: (*Indicate responsibility of artist and/or dealer*) _____

14. In the event that a dispute arises under this agreement involving the interpretation of any of the provisions herein which cannot be resolved by discussion between the artist and the dealer, both parties will submit such dispute to an arbitrator appointed by the American Arbitration Association, who shall decide the issue in accordance with the terms of the agreement and the laws of the State of _____. Costs in such cases shall be borne equally by both parties.

_____ _____
Artist **Dealer**

_____ _____
Date **Date**

*Eliminate if not appropriate

What should my contract with a dealer contain?

Many of the following points are issues that crop up in relation to consignment sales, the most common arrangement between artists and dealers in the United States: exclusivity; scope of work; title and receipt; sales prices; discounts; commissions; payments; approval sales; accounting; sales contract; rentals; copyright; delivery and return costs; loss or damage and insurance; exhibitions; duration of agreement; assignability; termination; and arbitration. And attached to your agreement should be a "Consignment Sheet" (see Figure 7), listing all work consigned to the dealer.

The list is not meant to be definitive; only you can supply the full list of issues relevant to your situation. Nor would you want to include all of these issues in a contract. But many of them are musts and are explained below in detail, including the problems involved with each and how you might resolve them in a contract.

Each point or issue has almost limitless negotiating possibilities. In most instances, the most favorable arrangement to the artist is given, but compromise will usually be the name of the game. If you discover you cannot agree on enough points, it's far better to find that out before you consign any work, so you can look for a better deal elsewhere.

Will a dealer want exclusive geographical rights to my work?

Maybe. Many dealers will want geographical exclusivity. For example, a New York City dealer will probably not allow you to sell through other dealers in many parts of New York state, New Jersey, and Connecticut—areas where he or she would compete with local dealers.

How will this be put into a contract?

A clause might read: "Artist appoints Dealer his sole and exclusive agent for the sale and exhibition of his works of art in (city, state, or region)."

This clause also establishes your agency relationship, so, at the very least, your dealer must exert reasonable care to protect your work and act in your interests. It does not, however, insure that your work will be protected from creditors (if you live outside those states with consignment laws) in case of bankruptcy.

What do you mean by scope of work?

When referring to consignment sales, scope of work means the amount and kind of works you want the dealer to sell for you. For

example, you might want to consign your paintings and sculpture to one dealer and your graphics to another. To make sure there is no misunderstanding about who gets what, specify the scope of work each one can handle in your contract (see Clause 2 in Figure 7). Ask yourself the following questions:

Do you want him to represent all your work even if you create in different mediums and styles? If not, say so specifically.

Do you want him to represent the work produced prior to your agreement? This, of course, depends a lot on what the dealer wants, too.

Do you want to give him your entire output or a specific number each year? If it's the latter, your dealer will probably want to reserve the right to choose what he wants.

Will you want to reserve certain works for gifts, bartering, bequests, or studio sales? Unless you're in a strong bargaining position, most dealers won't let you hold back work for these purposes, particularly if it's some of your best.

What do you mean by title?

The dealer has the right to expect that the work you consign is owned by you or, put in legalese, that you "possess unencumbered title" to it. In other words, he expects that you aren't trying to pass off works of others as your own and that you haven't already sold the work to someone else or given it as collateral on a loan or whatever. And he'll want this in the contract. To protect your interests, you'll want the agreement to state that you retain title until the work is sold and paid for in full.

What do you mean by receipt?

You should make sure that you get a receipt for all work consigned to the gallery both initially and every time you bring in more. The way to do this is by writing this condition into the contract and attaching a consignment sheet (see Figure 7) to it. A consignment sheet lists every work turned over to your dealer, along with sizes, mediums, and retail prices, and a separate consignment sheet should be filled out and attached to the contract with every new delivery. Each sheet should be signed by both artist and dealer.

How do I write a title and receipt clause into a contract?

A good example can be found in Clause 4 of the BALA contract in Figure 7.

Who establishes the sale prices of my work?

The best price policy is one mutually determined by you and your dealer. And prices should be reviewed once or twice a year to bring them into line with your growing reputation and what the market will bear.

Will I be expected to discount my work for anyone?

Yes, museums usually ask for and get a 10 percent discount or sometimes more, as do clients who buy in quantity. Some galleries also discount work for valued clients—although this is by no means standard practice—and for architects and interior designers. The latter groups usually receive a 15 percent discount, although architects and sometimes designers pass the discount on to their clients.

What kind of discount does a dealer give other dealers?

Dealers frequently give other dealers, such as out-of-town galleries and private dealers (those people who operate without galleries), a discount that amounts to half of their own commission. In other words, if your dealer charges a commission of 50 percent, he may give the other dealer a 25 percent discount and take 25 percent for himself.

Some dealers, however, expect their full commission after discounting the work, forcing the artist, in essence, to pay two commissions. This sort of deal can be prevented if you can negotiate a clause stating that discounts must be deducted from sales commissions.

Can a dealer discount my work without my permission?

Not if you don't want him to, but this must be made clear in the agreement. As a rule, you'll want to give him some leeway in discounting work, so you and he should decide whom he can discount work for and how much he can reduce prices without consulting you—10 percent would be reasonable. Any time he wants to increase this discount, he must consult you.

How do I write sales prices and discounts into my consignment agreement?

You might say something like this:

Sales shall be made at a price no less than the sale price agreed to in writing on the consignment sheet. The Artist authorizes the Dealer to give a customary trade discount (which shall not exceed X percent of sale price,

except with the artist's prior written consent) on sales to museums, other dealers, decorators, and architects. In the case of discount sales, the discount shall be deducted from the dealer's sales commission. Dealer and artist agree to review sale prices every _____ months.

How are commission fees established?

By the kind of services offered. A dealer who absorbs the costs of an exhibition, for example, may be entitled to a larger commission than one who shares the costs with you.

A private dealer or artists' agent (if your sole dealer) may sometimes take a smaller commission because he or she doesn't have to pay rent or other expenses for a gallery. On the other hand, an aggressive private dealer or agent stumping the countryside for you or otherwise doing a bang-up selling job should earn as big a commission as a dealer with a fancy gallery.

Does a dealer charge all artists the same commission?

Not necessarily. The more successful you are, the better financial deal you can bargain for. I know superstars in New York giving up only 33⅓ percent to dealers who charge other artists 50 and 60 percent.

Lower commissions are also charged sometimes if an artist makes a large investment in his or her work. Suppose you're a sculptor whose costs represent a significant portion of the selling price. Suppose further that costs run as high as 40 percent, leaving only 60 percent profit to be split by you and the dealer. A dealer ordinarily charging 50 percent might reduce his or her commission to 30 percent (or 50 percent of 60 percent).

Will a dealer charge the same commission in all situations?

Not always. A dealer may have a policy of charging different commissions for different media: 40 percent on paintings, for example, and 50 percent for graphics.

His commission policy may also depend on whether a sale is made by him or by you from your studio.

Why do I have to pay the gallery any commission on studio sales?

Collectors often try to buy directly from artists—figuring they can get a bargain by avoiding dealer commissions—if the artist is willing to lower the retail selling price. Artists sometimes go along with these sales because they get a bigger share of the profits.

Dealers resent this practice both because it places them in competition with the artist and because they feel they are not

being fairly compensated. After all, they reason, an artist's selling prices and popularity may be primarily due to the dealer's selling ability. Therefore, a dealer may insist on being paid the regular commission on all sales no matter where they are made. One who is willing to compromise may ask for a commission but reduce it for studio sales. Of course, if you have real clout, you can exempt studio sales altogether in the Scope of Work clause.

How do I write commissions into an agreement?

A sales commission clause might state:

The gallery shall receive the following sales commission:
 (a) ____ percent of the agreed sales price for works in the following medium: _____;
 (b) ____ percent of the agreed sales price for works in the following medium: _____;
 (c) ____ percent of the amount paid for studio sales made directly by the artist.

Will the dealer expect a percentage of commissioned projects?

That depends on whether you secure the commission or he gets it for you, and on his attitude toward commissioned work in general. If he takes the approach that only through his efforts at enhancing your name and reputation could you have been awarded the commission, he'll ask for his full commission no matter who actually obtains it. Many dealers, however, will have two different rates.

How would fees for commissioned projects be stated in an agreement?

If the commission award represents a fee for your services only, a contract might read:

The Dealer shall receive (a) ____ percent of the price of any commissioned projects awarded to the Artist when such commissions are obtained for him by the Dealer, and (b) ____ percent of any such commissions the Artist obtains directly during the term of this agreement.

Or if you have enough bargaining power, "The Dealer shall receive no commission if the Artist obtains the commission himself." If you are responsible for paying for materials and/or labor costs for the project, you would want to word the agreement differently. For example:

The Dealer shall receive ____ percent of the net balance of the Artist's commission after deducting expenses for materials and/or labor actually

*used in executing the project when such commissions are obtained for him
by the Dealer.*

How soon after sale of work should I be paid?

The most businesslike arrangement is to insist on payment within
30 days of the purchaser's payment to the dealer.

When should I receive my share if the client pays in installments?

The same principle should hold true. You should receive your
share of each installment payment within 30 days of the receipt of
payment by the dealer.

How do I protect myself against a client's failure to pay?

It should be the dealer's responsibility to find out how financially
stable his or her clients are. Therefore, your consignment agree-
ment should read that the dealer assumes the full risk of default
of payments by a client.

How do I put terms of payment and default into a contract?

The BALA contract handles payment and default terms very
nicely in Clause 8.

How should approval sales be handled?

There are several ways of approaching the issue of approval sales,
i.e., the practice of allowing a client to take work home to see if he
can live with it. Actually the crux of the issue is whether or not the
client pays for the work before taking it home for a certain time
period. If he or she does not pay first and then fails to either
return the work or pay for it, the dealer is confronted with the
tricky job of getting the work back.

How is this handled in an agreement?

Dealers confident of their clients' reliability may insist on a clause
similar to Clause 9 in the BALA contract to permit approval sales.

On the other hand, both you and your dealer might feel
somewhat reluctant to pursue this lenient policy. In this case, your
agreement might state:

*No unsold works shall be removed from the dealer's premises. However, if
a work is returned in good condition within 30 days by the client, it may
be exchanged for cash or work. If returned in good condition after 30 days,
the work may be exchanged for other work.*

What if the client wants his money back?

If your dealer has already paid you, he shouldn't ask you to return your share of the sales price. Instead, he should deduct the amount of the credit from payments he makes to you in the future. So your contract might read something like this: "If a work is returned within 30 days in good condition for a cash credit, the dealer will make appropriate pro rata adjustments in future payments to the Artist."

Can I inspect my dealer's financial records?

Yes, it should be your privilege to inspect those records that pertain to transactions involving your work—and if you sell a lot of works from your studio, your dealer may demand equal rights and want to inspect your records. You should also ask for an accounting from your dealer at regular intervals, usually once every three months, in the form of a statement of account. A typical Statement of Account is shown in Figure 7, and Clause 13 of the BALA contract demonstrates how to write this demand into a contract.

Will my dealer tell me whom he sold my work to?

Many dealers prefer not to, believing that you'll be tempted to sell to customers directly. Therefore, you should state in your contract that he must either list names and addresses of clients on your quarterly Statement of Account or attach to the Statement copies of sales receipts showing this information.

Can I ask my dealer to use my own sales contract?

Yes. As mentioned in Chapter 3, you may want to reserve certain rights in your work after it is sold, such as the right to borrow work back for exhibition, the right to approve or supervise repairs, or even the right to a royalty on resale. The place to reserve these rights is in a sales contract. Thus, one of the terms of your consignment agreement should require your dealer to insist that all purchasers of your work sign a contract reserving these rights to you. To write this into the agreement, use Clause 14 of the BALA contract.

Do dealers ever rent work?

Not very often. Unless there's a good chance that the renter will become a buyer, rentals offer few advantages for the dealer—they take work out of circulation for little gain to either him or the artist.

BAY AREA LAWYERS FOR THE ARTS
ARTIST-GALLERY AGREEMENT

This Agreement is made the _____ day of _____ 197__ between:

NAME: _____
ADDRESS: _____
PHONE: _____ ("the Artist")

and

NAME: _____
ADDRESS: _____
PHONE: _____("the Gallery")
which is organized as a ·_____

The parties agree as follows:

1. **Agency.** The Artist appoints the Gallery his/her agent for the purpose of exhibition and sale of the consigned works of art in the following geographical area:_____

2. **Consignment.** The Artist shall consign to the Gallery and the Gallery shall accept consignment of the following works of art during the term of this Agreement:

☐ All new works created by the Artist (in the following media: ____
_____)

☐ All works which the Gallery shall select. The Gallery shall have the first choice of all new works created by the Artist (in the following media: _____)

☐ Not less than ____ new works per year (in the following media: _____)

Figure 7. Another version of an artist-dealer agreement was drawn up by the Bay Area Lawyers for the Arts (BALA) in California. Note that clauses 8 and 12 refer to certain protections guaranteed under California law. You can guarantee yourself the same rights by including these two clauses in your contract.

Clause 16 refers to another protection provided by California law. Unfortunately, unless you live in California or another state (see above) that protects your work while under consignment, the only way you can guarantee yourself the same protection is by filing UCC Form No. 1.

☐ All new works created by the Artist excluding works reserved by the Artist for studio sales and commission sales made directly by the Artist

☐ The works described in the Consignment Sheet (Schedule A of this Agreement) and such additional works as shall be mutually agreed and described in a similar Consignment Sheet

The Artist shall not exhibit or sell any consigned work outside the Gallery without the prior written approval of the Gallery. The Artist shall be free to exhibit and sell any work not consigned to the Gallery under this Agreement.

3. Delivery. _____ shall be responsible for delivery of the consigned works to the Gallery. All costs of delivery (including transportation and insurance) shall be paid as follows:

(a) _____% by the Artist
(b) _____% by the Gallery.

4. Title & Receipt. The Artist warrants that he/she created and possesses unencumbered title to all works of art consigned to the Gallery under this Agreement. Title to the consigned work shall remain in the Artist until he/she is paid in full. The Gallery acknowledges receipt of the works described in the Consignment Sheet (Schedule A of this Agreement) and shall give the Artist a similar Consignment Sheet to acknowledge receipt of all additional works consigned to the Gallery under this Agreement.

5. Promotion. The Gallery shall make reasonable and good faith efforts to promote the Artist and to sell the consigned works as follows: _____

_____ .

6. Sales price. The Gallery shall sell the consigned works at the retail price mutually agreed by both parties and specified in writing in the Consignment Sheet. The Gallery shall have discretion to vary the agreed retail price by ____% in the case of discount sales.

7. Sales commission. The Gallery shall receive the following sales commission:

(a) _____% of the agreed retail price for selling works in the following medium:

_____ .

(b) _____% of the agreed retail price for selling works in the following medium:

_____ .

(c) _____% of the amount paid for studio sales or commission sales made directly by the Artist.

The remainder shall be paid to the Artist. In the case of discount sales, the amount of the discount shall be deducted from the Gallery's sales commission.

8. Payment.

(a) *On outright sales,* the Gallery shall pay the Artist's share within 30 days after the date of sale.

(b) *On deferred payment sales,* the Gallery shall pay the Artist's share within 90 days after the date of sale.

(c) *On installment sales,* the Gallery shall first apply the proceeds from sale of the work to pay the Artist's share. Payment shall be made within 30 days after the Gallery's receipt of each installment.

As provided by California law, the Gallery shall hold the proceeds from sale of the consigned works in trust for the benefit of the Artist. The Gallery agrees to guarantee the credit of its customers, and to bear all losses due to the failure of the customer's credit.

9. Approval sales.
The Gallery shall not permit any consigned work to remain in the possession of a customer for the purpose of sale on approval for a period exceeding 14 days.

10. Rentals.
The Gallery may not rent any consigned work without the prior written consent of the Artist. The rental period may not exceed ____ weeks unless a longer period is approved by the Artist. The Gallery shall receive _____% of the rental fees, and the remainder shall be paid to the Artist within 30 days after the Gallery's receipt of each rental fee.

11. Exhibitions.
The Gallery shall arrange, install, and publicize at least ____ solo exhibitions of the Artist's work of not less than __ weeks duration each, and shall make reasonable efforts to arrange other solo and group exhibitions thereafter. The Artist's work may not be included in any group exhibition without his/her prior written approval. The division of financial responsibility for the costs of exhibitions and other promotional efforts shall be mutually agreed in advance, and neither party may obtain reimbursement for such costs without the prior written approval of the other party.

12. Loss or damage. As provided by California law, the Gallery shall be responsible for loss of or damage to the consigned work from the date of delivery to the Gallery until the date of delivery to the purchaser or repossession by the Artist. The Gallery shall insure the consigned works for the benefit of the Artist up to ____% of the agreed retail price.

13. Statements of account. The Gallery shall give the Artist a Statement of Account (similar to Schedule B of this Agreement) within 15 days after the end of each calendar quarter beginning with _____19___. The Statement shall include the following information:

 (1) the works sold or rented
 (2) the date, price, and terms of sale or rental
 (3) the commission due to the Gallery
 (4) the name and address of each purchaser or renter
 (5) the amount due to the Artist
 (6) the location of all unsold works (if not on the Gallery's premises).

The Gallery warrants that the Statement shall be accurate and complete in all respects. The Artist and the Gallery (or their authorized representatives) shall have the mutual right to inspect the financial records of the other party pertaining to any transaction involving the Artist's work.

14. Contract for sale. The Gallery shall use the Artist's own contract for sale (a copy of which is appended to this Agreement) in any sale of the consigned works.

15. Copyright. The Artist reserves all rights protected under the Copyright Law of 1978 in all works consigned to the Gallery. No work may be reproduced by the Gallery without the prior written approval of the Artist. All approved reproductions in catalogues, brochures, advertisements, and other promotional literature shall carry the following notice: © by (name of the Artist) 19___ (year of publication).

16. Security. As provided by California law, the consigned works shall be held in trust for the benefit of the Artist, and shall not be subject to claim by a creditor of the Gallery. In the event of any default by the Gallery, the Artist shall have all the rights of a secured party under the Uniform Commercial Code.

17. Duration of Agreement. This Agreement shall commence upon the date of signing and shall continue in effect until the _____day of _____ 19__. Either party may terminate the Agreement by giving 30 days prior written notice, except that the Agreement may not be terminated for 90 days following a solo exhibition of the Artist's work in the Gallery.

18. Return of works. _____shall be responsible for return of all works not sold upon termination of the Agreement. All costs of return (including transportation and insurance) shall be paid as follows:

(a) _____% by the Artist
(b) _____% by the Gallery

If the Artist fails to accept return of the works within ____days after written request by the Gallery, the Artist shall pay reasonable storage costs.

19. Non-assignability. This Agreement may not be assigned by the Gallery to another person without the prior written approval of the Artist. The Gallery shall notify the Artist in advance of any change in personnel in charge of the Gallery or of any change in ownership of the Gallery.

20. Arbitration. All disputes arising out of this Agreement shall be submitted to binding arbitration. The arbitrator shall be selected in the sole discretion of the Executive Director of Bay Area Lawyers for the Arts, Inc. If such arbitrator is not available the dispute shall be submitted to arbitration in accordance with the rules of the American Arbitration Association. The arbitrator's award shall be final, and judgment may be entered upon it in any court having jurisdiction thereof.

21. Entire agreement. This Agreement represents the entire agreement between the Artist and the Gallery and supersedes all prior negotiations, representations and agreements whether oral or written. This Agreement may only be amended by written instrument signed by both parties.

22. Governing law. This Agreement shall be governed by the laws of the State of California.

IN WITNESS WHEREOF the parties hereto have executed this Agreement on the day and year first above written.

The Artist	For the Gallery

CONSIGNMENT SHEET (SCHEDULE A)

RECEIVED FROM: _____ DATE: _____

THE FOLLOWING WORKS OF ART:

TITLE:	MEDIUM:	SIZE:	RETAIL PRICE:	MAY BE RENTED:
1.				
2.				
3.				

SIGNED BY:

_____ _____
 The Artist For the Gallery

This Consignment Sheet must accompany the BALA contract. Furthermore, each time new works are consigned to a dealer, an additional sheet must be filled out and attached to the agreement.

STATEMENT OF ACCOUNT (SCHEDULE B)

ARTIST: _____ DATE: _____

ADDRESS: _____ QUARTER: _____

TITLE:	RETAIL PRICE:	SALES COMMISSION:	DUE TO ARTIST:
1.			
2.			
3.			

NET AMOUNT DUE TO ARTIST: $_____

 For the Gallery

BALA also recommends that this Statement of Accounts be used in conjunction with its contract so the artist is assured an accurate accounting.

If my dealer does want to rent work, how should I proceed?

First, look over the rental agreement your dealer plans to use for clients. Check to see if it basically conforms to the rental terms discussed in Chapter 3, making sure that the commission fee corresponds to what was suggested there. Then bargain with your dealer for the right to refuse the rental of any particular work and to limit rentals to a period of about a month. The resultant clause should resemble Clause 10 of the BALA contract.

How do I protect my copyright in a consignment agreement?

Let's assume that you have already copyrighted by placing proper copyright notice on your work (see Chapter 2). In this case, you don't actually have to do anything further since you automatically retain copyright. Nevertheless, to make sure no misunderstandings arise between you and either your dealer or a client, your consignment agreement should discuss copyright.

What would the consignment agreement say about copyright?

Something like this:

The Artist reserves copyright in all works consigned to the Dealer.

The dealer will not permit any of these works of art to be reproduced except for the purpose of appearing in a catalog or advertisement of the Artist's work or with the prior written consent of the Artist. All approved reproductions shall carry the following notice: © by (name of artist) 19 _____ (year of publication).

The Dealer shall print on each bill of sale in a prominent place the following notice: All rights to reproduction are reserved to the Artist.

What will my dealers get for arranging the sale of reproduction rights?

Dealers usually take a 10 or 20 percent commission on the royalty payments or flat fees you receive when they arrange for or sell reproduction rights. So your contract might read: "If the Dealer sells or arranges for the sale of reproduction rights with the Artist's prior written approval, Dealer's commission will be _____ percent."

Who arranges and pays for the delivery of work to and from the dealer?

The most common arrangement between artists and their dealers is for the artist to arrange and pay for costs of delivery (including

transportation and insurance) and for the dealer to be responsible for arranging and paying for costs of return. Clauses 3 and 18 of the BALA contract illustrate how this can be written into your consignment agreement.

Who is responsible for loss or damage?

Unless you live in Arkansas, Arizona, California, Colorado, Connecticut, Massachusetts, Minnesota, Oregon, Washington, or Wisconsin—where work is protected by state law—you might suffer a complete loss if work in possession of the dealer is lost or damaged and the dealer can prove he or she wasn't negligent. So ask your dealer to promise in the agreement that he or she will be responsible for loss or damage to consigned work from the date of delivery to the gallery until the date of delivery to the purchaser or repossession by you. This means he or she must either insure the work or pay for it if it's lost or must be repaired.

What kind of insurance should the dealer carry?

An all-risk policy that insures against fire, flood, theft, or other damage to work while in his or her possession. It should cover work not only while in his or her place of business but also while traveling to shows.

How much are works insured for?

Most dealers insure works up to an amount equal to the artist's share of the retail sales price. In other words, if the dealer takes a 40 percent commission, he or she will most likely insure the work for 60 percent of the retail price.

Who does the insurance company reimburse for work?

This is a point to bargain for. Ideally, your name should appear on the insurance policy as the "loss payee," or person to be paid, in case of a claim. But this may not always be practical from the dealer's standpoint.

How is loss or damage written into a contract?

You could say something like this:

For the benefit of the Artist, the Dealer will provide at his expense all-risk insurance on all of the Artist's work of art listed on the Consignment Sheets up to _____ percent of the agreed sale price from date of delivery to the Dealer until date of delivery to the purchaser or repossession by the Artist.

What information on exhibitions should be in a consignment agreement?

Before listing the provisions that should be considered for inclusion into an exhibition clause, let me point out that they could form the basis of a separate contract if your sole contact with a dealer is to be a one-time, one-person show. The following points should be covered:

1. Location and frequency. Spell out where the exhibitions are to take place, how many rooms will be allotted to your work, and how often you can expect solo exhibitions. A show every one and a half or two years is average.

2. Choice of work. Determine in advance who will choose the work for the exhibition—the best choice is usually mutual.

3. Hanging and installing. Arrange who will pay for this and who will be in charge.

4. Framing or bases (for sculpture). Again, decide who will arrange for this and who will pay for it.

5. Partitions and painting. Decide the same as above.

6. Advertising. Determine where the show will be advertised and who will bear the expense.

7. Invitations and postage. Spell out how many invitations will be mailed and who will pay for the printing and postage.

8. Brochure or catalog. Will there be one, and if so, who will pay for it; who will decide on its format; and who will have control over its quality?

9. Refreshments. Will there be any, and if so, who will pay?

Obviously, the stronger your bargaining power, the more favorable your arrangements will be, and the more likely you'll be able to persuade the dealer to absorb most or all of the expenses connected with the show.

What should I bargain for concerning group exhibitions?

Some artistic control, such as a clause that permits you to withdraw works from group exhibitions that you don't feel are appropriate for the display of your works. But if your dealer agrees, don't use this power thoughtlessly. Remember, he's got a stake in your career too, and he probably has good reason for wanting to enter your work in certain group shows.

What will an exhibition clause look like?

Clause 11 of the BALA contract is a good example of an exhibition clause (see Figure 7), but, since it's a part of a model contract, it can't spell out all the points raised above. It's up to you to do this based on your particular situation.

What is an arbitration clause in an artist-dealer agreement like?

It is similar to one in a commission agreement, and Clause 20 of the BALA contract illustrates just how arbitration is written into an artist-dealer contract.

How long should a consignment agreement last?

Time limits, like other terms, are usually set by the stronger party in negotiations. A dealer signing on a relatively unknown artist may dictate a one-year contract with an option to renew for two one-year periods. An artist of considerable renown may want to retain the renewal option rather than yield it to the dealer. Indeed, getting the option to renew is a show of power.

Power plays aside, a few practical guidelines should be considered when negotiating the length of a contract. If you're young, tying yourself to a dealer for an extended period may not be a good idea. On the other hand, a dealer will want to be sure you will be around for a reasonable length of time before investing any time and money promoting your work. Most dealers, for example, will want you to remain with them through at least two exhibitions of your work. Therefore, you might consider the advice Calvin Goodman gives. He suggests his clients negotiate five-year contracts with an option open to both parties to cancel every year after the second year.

Can I terminate the agreement before the end of the contract?

Yes, if your contract permits such a release from the agreement. And there are many reasons why both you and your dealer might want such a clause: if the dealer fails to hold exhibitions as scheduled; if the dealer goes bankrupt; if the dealer doesn't sell a certain number of works within a given time; if you fail to create and deliver works as promised; or if gallery personnel changes. You might have a tough time writing the last possibility into a contract. But you should try, especially if you joined the gallery specifically because of a close relationship with an employee or the director and you have great confidence in that person's selling ability. In this case, you may want to terminate the contract if he or she leaves the gallery.

How is termination accomplished?

Termination usually takes place a given number of days (normally 30 to 60 days) after you notify your dealer (or vice versa) in writing that you plan to terminate. However, this may not be easy if an exhibition has just taken place. To protect his or her interests, a dealer may insist in the contract that no termination take place for a given number of months after a one-person show or that you reimburse him or her for the expenses of mounting the show.

How should duration and termination be written into a contract?

A general example is found in Clause 17 of the BALA contract (see Figure 7). But in your own contract, you may wish to specify the situation that will result in termination, such as "Failure of the Dealer to hold at least _____ one-person exhibitions of the Artist's work every _____ months shall entitle the Artist to terminate the agreement."

Can a dealer assign or "sell" me to another dealer?

Yes, but you should try to prevent this in your contract. For one thing, if you joined a dealer because of your confidence in him, you won't want your contract to be transferred to anyone else. The dealer, on the other hand, may see you as an asset he can "sell" to another dealer if he wants to get out of the business. Resist this, and hold out for a clause that reads: "This Agreement may not be assigned by the dealer without the Artist's prior written consent."

Does death terminate the consignment agreement?

Yes, and this is fine for artists who want their agreement terminated with death. Other artists, however, prefer that their dealers sell work on hand and pay the proceeds to the estate. Still others want an ongoing relationship between their heirs and dealers. But unless some provision is made both in your last will and in the consignment agreement concerning a continuing relationship, a dealer cannot automatically go on representing an estate, which could result in some annoying problems. Therefore, you should seek legal advice, not only on writing a will, but also on the phrasing of the death clause in your consignment agreement, since they must dovetail.

Six

COOPERATIVE GALLERIES

ORGANIZATION

DUES AND FEES

COMMISSIONS

FORMING A CO-OP

GALLERY SPACE

COSTS

NONPROFIT CO-OPS

As art schools and colleges continue to churn out more and more fine artists, the demand for exhibition and selling space has far outstripped commercial gallery facilities. To cope with these needs, many artists around the country have taken matters into their own hands and formed cooperative galleries. By running their own galleries, artists give themselves a place to show and sell on their own terms.

What exactly is a cooperative gallery?

While the structure and activities of co-ops vary, generally they consist of a group of artists who have joined together to share the costs of running a gallery in which they can show their work in both one-person and group exhibitions. Occasionally they put on guest shows, introducing the work of artists from other regions or sponsoring performances by dancers and musicians. But the underlying motivation is the artist's need for exposure to the public in a permanent gallery facility.

How many members belong to a co-op in general?

The average co-op is the size of most commercial galleries—20 to 25 members. This allows each member to exhibit his or her work

at least once every two years or eighteen months. But describing what's average isn't particularly helpful. Depending on the priorities of the members, co-ops may include as few as 3 or 4 artists or as many as 36 or more if sufficient exhibition space is available.

Is there any structure to a co-op?

There should be. Some artists take the word "cooperative" literally, believing that everyone should willingly chip in to do his or her share of the work at exactly the right time and that to impose any kind of structure or organization on the group defeats the cooperative philosophy. That's nice in theory, but it rarely works in practice—particularly if there are more than three or four people involved. Someone must be in charge. To make things run smoothly, a co-op should elect a president, vice-president, secretary, and treasurer. Committees should also be set up to handle such responsibilities as installing shows, recruitment of new members, maintenance of the gallery, publicity, and so on. Members with particular expertise in certain areas should be appointed to the appropriate committee. For example, the painter with a flair for writing might be put in charge of publicity.

Who runs the gallery on a daily basis?

The members of a co-op may elect to hire a director to handle sales and promotion, or they can do it themselves. If the latter is the case, members usually rotate the task of "sitting" for the gallery; in other words, each member staffs the gallery one day a week or however often it's necessary. During this time they answer customers' questions and either make sales or refer the customer to the artist in whose work he's interested. The latter is a most inefficient way of promoting sales, for while it is true that an artist is usually able to talk about his work more effectively than anyone else, if the customer has to contact him or wait for the artist to get in touch, he may lose interest.

Another way to staff a co-op is with a part-time director. For example, artists at Soho 20, a gallery in New York City, who do not wish to sit pay the director an hourly fee for the number of hours they should staff the gallery.

How are co-ops funded?

To cover expenses, members commonly pay an initial fee to join the cooperative and yearly or monthly dues thereafter. Initiation fees and dues are determined both by costs discussed below and by the number of members available to share the costs.

How much are initiation fees and dues in general?

Because of the variables, such as rent and the number of services offered, there is no way to estimate an average initiation fee or amount for dues. Some cooperatives, for example, require their members to pay for all costs for a one-person show, including printing, mailing, advertising, and reception expenses. Dues in such a co-op will be less than those charged by co-ops that pay these costs out of the collective pot. When all services are paid for, annual dues can rise as high as $1,200 to $1,500 if the co-op is located in a high-rent district, such as New York City. In general, they'll be much less elsewhere.

How much does a co-op charge in commissions?

Some co-ops charge no commissions at all. Others take from 5 to 30 percent on each sale. Those co-ops with commissions on the high side represent, in most cases, galleries with a paid director who receives a percentage of the commissions plus a salary.

Cooperatives almost never charge as high a commission as commercial galleries in the same area do, a fact that should be pointed out to potential customers. The reason for this, of course, is that the artist is not looking to make a profit on the gallery itself but on the individual sales of his or her work.

What is the director's percentage of the commission?

No hard and fast rules govern commissions. A commission of 25 percent might be divided up, with 20 percent going to the director and 5 percent to the gallery to help defray expenses, or vice versa. Or the co-op may have a policy of giving the entire commission to the director, rejecting any part of that money for itself.

Why would a co-op charge no commission?

It goes without saying that in most galleries certain artists will sell better than others. Therefore, if commissions are used to defray expenses, the better-selling artists would, in effect, be supporting the gallery and subsidizing those who don't sell as well. To avoid this, co-op members may feel that it is more equitable for everyone to support the gallery solely by dues and initiation fees.

On the other hand, if everyone in the co-op sells relatively well, it would be a good idea not only to charge a commission but to make it fairly high. Then, with commissions offsetting costs, dues could be reduced.

Can I expect to sell well through a co-op?

The odds on selling well through a cooperative gallery depend to a great extent on how many commercial galleries operate in your area and how strong they are. If a number exist, but they're all new and haven't done a good marketing job, a co-op stands as good a chance of achieving a respectable sales record as they do—an even better one if it can mount an imaginative and aggressive sales campaign.

But a co-op can rarely expect to make it in an area where commercial galleries are all-powerful. In New York, for example, where commercial dealers maintain a stranglehold on the art market, many artists have ceased to think of the co-op as a profit-making vehicle for its members.

Then what's the point of joining a co-op?

These New York artists insist that the function of a cooperative gallery in New York is to show—not sell—and to give members an opportunity for uncensored exposure. In other words, they feel it's worth paying the price for the freedom to exhibit as they please and not as dictated by dealers.

How do I decide if a co-op is the place for me?

First, decide what it is that you want a co-op to do for you. Are sales your first priority? Or will you be satisfied with the right to show? If sales are your goal, perhaps you should hold out for commercial representation or spend the money saved by not paying dues to increase sales from your studio.

Also consider the demands a co-op will make on your time and decide whether this time could be spent more productively working on your art. Are you willing, for example, to give up a day every now and then to "sit" for the gallery or to keep the books? I know of a co-op in the Southwest made up of five women who operate without a hired director. Each sells well, but each must contribute one out of every five days to minding the store, as well as putting in some extra time delivering work, hanging shows, bookkeeping, and doing other chores. These particular women rate their gallery a success. They believe they've learned a great deal from each other and have benefited from their association in terms of creative efforts and financial reward.

And it may well be. Still, one or all of these members—if they devoted the time spent working in the gallery to painting—might conceivably do better financially in a commercial gallery. With someone else handling all the details, they might be able to

produce enough to more than compensate for higher commissions. On the other hand, not everyone can work seven days a week, and talking to clients might be downright stimulating. So you have to weigh the advantages and disadvantages.

What are the first steps in forming a co-op?

If sales are your objective, assess the sales potential in your area. The first order of business would be to check out the existing commercial galleries and see if you can compete with them. If there aren't many other galleries, the next step is to evaluate the potential market. Are there many known collectors, or other people who could be counted on as possible clients, in your area? Is your community receptive to the arts? Do you have a museum or arts center through which you might be able to promote work? Do your local newspapers and radio and TV stations cover exhibitions? Can you get publicity in these media? After you've made these assessments, you might discover that you'd be better off opening a co-op 30 miles away in a more receptive area.

What's next before actually forming a co-op?

Decide on the approximate number of members you ultimately want in your gallery. Then ask yourself whether you can get certain types of people to join. For instance, you'll need members capable of acting as bookkeepers, publicists, and administrators. If you plan to run the gallery without a hired professional director, you'll also want members who are personable and articulate.

Once you've resolved all those problems, start looking for gallery space.

Where should we look for gallery space?

The best place to set up a co-op is alongside your competitors and other businesses that cater to the sort of clientele you want to attract. If you're looking for well-heeled clients, settle down near the posher antique stores and art galleries. If you see the novice collector in the suburbs as your ideal customer, craft shops or boutiques make good neighbors.

Is a second-floor location as good as one on the ground floor?

No. Most co-ops depend heavily on pedestrians brought into an area by surrounding businesses, so being as visible as possible should be one of your top priorities. After the co-op establishes itself firmly in an area, you might be able to move above street

level or onto a side street. But keeping a low profile when you're starting out could result in an early demise for your operation.

What if we can't afford both the ground floor and the best street?

Compromise, but only after a careful investigation of pedestrian traffic patterns. A second-floor location, advertised by a colorful banner, on a heavily trafficked street might be preferable to a ground-floor gallery around the corner on an often empty street. However, street-level galleries are a must in areas where businesses are more spread out.

What other traffic patterns should we look for?

Make sure pedestrian traffic is heavy during afternoons and Saturdays, and watch out for traffic lights that halt the flow of people before they get to you. Also avoid buildings that are satisfactory traffic-wise but whose tenants have consistently gone out of business in a hurry. Even if you can't figure out the reason for this history of failure, don't tempt fate by trying to break the cycle.

What should we look for in physical facilities?

There are many specific things you'll need, but, in general, be sure to consider the following:

1. Sufficient space. You'll need two showrooms at least—one for solo shows and one for private viewings—and storage space for a sample of each member's work.

2. Watertight building. See if the roof leaks. If you're on the ground floor of a multistory building that has a single-story extension in the roof, check the extension, too. Give the walls a good going over for dampness, and examine windows to make sure they're watertight and not filled with dry rot.

3. Walls made of the right material for hanging paintings. Walls faced with metal are useless, unless you're opening a sculpture gallery.

4. Ample-sized doors. If you are planning to exhibit large-scale works, check to be sure the doors are large enough to accommodate them.

5. Plumbing in good order.

6. Adequate toilet facilities for the public.

7. Floors that are in good condition and able to bear the stress of heavy sculpture.

8. Adequate heating.

9. Adequate ventilation.

10. Air conditioning. Will you need it? Does the building provide it? Is the building wired for it?

11. Humidity. Will you need a dehumidifier to control the atmosphere to avoid deterioration of work?

12. Electric wiring. Consider whether there is enough wiring to handle your lighting requirements or whether you'll have to rewire.

13. Quiet rooms. Check for excessive street noise and fellow tenants who might be noisy during gallery hours.

14. Cleanliness. Will outside conditions or other tenants subject you to dirt and other pollutants?

15. Good security. Will you need some sort of alarm system?

16. Zoning. Is the property zoned for commercial use? If it isn't, look elsewhere.

17. Safe access to the gallery. Check out hallways, stairs, and elevators to make sure they're safe and well lit.

Do we need insurance?

This is a must, so make sure you can get it in the building you're considering. Ask a local property insurance agent if the building is insurable against fire and theft and what the rates are. You might also consider plate glass insurance if you have a large storefront window.

How can we tell if the building is structurally sound?

If you're considering an old loft building or something similarly decrepit, look in the Yellow Pages for a real estate appraiser. He or she will come to inspect the building and give you a written report of its condition.

What do we do once we locate a possible space?

Now is the time to estimate costs. An accurate cost analysis will demonstrate how much money you'll need to start up and maintain the gallery. You might find it's too expensive for the

individual members, or you might discover you can cover costs only by cutting corners. In the latter case, you'll have to decide whether you can compete with commercial galleries with something less than a first-class operation.

How do we estimate costs?

By making a list of all your expenses. Many are listed on the projected costs worksheet in Figure 8. Add to them any others you can think of, and think hard. This isn't the time to leave out an important item.

How do we estimate utilities? Call the local utility company and ask the monthly cost for a similar facility in your neighborhood.

How do we calculate lighting costs? Unless you know precisely what fixtures you want and can take this list to a commercial lighting dealer, ask the dealer to send someone over to discuss your needs and give you an estimate.

How do we calculate costs for renovations we can't do ourselves? Once again, ask the experts—electricians, plumbers, general contractors—for estimates. An honest contractor will furnish you with financial references and the names of previous customers you can check with to see if his or her work has been satisfactory. A reliable contractor will also agree in writing to a firm estimate of the total cost and a definite completion date. And don't stop at one. On any major repairs, you should get at least three estimates.

What costs are usually borne by the members?

Costs of shipping, framing, photography, and insurance of the work itself are nearly always paid for out of the members' pockets. Your group may also decide to require members to pay for their own shows.

Once expenses are calculated, what do we do?

Estimate the dues by dividing expenses by the planned number of members. Since you'll need enough cash to handle starting costs and monthly expenses for at least six months (to give you a financial cushion in case of unanticipated expenses), you might want to collect one year's dues or six months' dues plus an initiation fee in advance. In the beginning, sales will probably be negligible, so don't count on income from commissions to help defray expenses. Now, if these figures don't give you a heart attack, turn your attention to the lease.

PROJECTED COSTS WORKSHEET

ESTIMATED MONTHLY EXPENSES		
	Your estimate of monthly expenses	Your estimate of how much cash you need to start your business (monthly expenses multiplied by six)
Salary of Director		
Rent		
Advertising and promotion		
Telephone		
Legal fees		
Insurance (liability, property, fine arts)		
Accounting fees		
Utilities		
Taxes		
Maintenance		
One-man shows (promotion, refreshments, etc.)		
Miscellaneous		
STARTING COSTS YOU ONLY PAY ONCE		
Renovations (new floor, paint, roof, wiring, partitions, labor)		
Rental equipment (sanders, paint sprayers)		
Rent deposit		
Telephone deposit		
Utilities deposit		
Legal fees		
Advertising and promotion for opening		
Fixtures (lighting and tracks)		
Installation of fixtures		
Furnishings and equipment (desks, chairs, filing cabinets, typewriter, fire extinguisher, storage bins)		
TOTAL ESTIMATED CASH YOU NEED TO START WITH		

Figure 8. Before you sink any money into a cooperative gallery, an accurate assessment of costs is a must. So list all possible starting and ongoing expenses on a worksheet like the one shown.

What should we look for in a lease?

Before going any further, let me stress that this is now the time to consult a lawyer. Let him or her check out the lease. But if you're going to be stubborn and do it yourself, make sure to do the following four things:

1. Get an option clause that will extend the lease at your discretion. Once you've sunk a lot of money and time into renovations and established your location in the minds of clientele, you don't want the landlord to be able to kick you out when the lease expires.

2. If the landlord plans to charge you a monthly rent based on square footage of usable interior space, check the dimensions and figure out your own estimate. Don't rely on his or her figures.

3. Read the fine print in the lease, looking out for escalation clauses. The landlord will try to pass on to you increases in real estate taxes and fuel costs. If you can't get them written out of the lease, they should be calculated in *your* estimated costs.

4. Find out exactly what your rent will include.

What should our rent include?

Your rent should entitle you to expect the landlord to be responsible for proper operation of heating, plumbing, and air conditioning (if there is any) systems, plus repair of the roof. You should also expect him or her to repair the parking lot and pavement in front of the building, when necessary. These are basic needs that should definitely be included in your lease. If they aren't, hesitate before you sign it, unless you don't mind paying these expenses yourself.

Also check to see if the landlord is responsible for keeping the building clean, removing snow from the sidewalk out front, and supplying heat and electricity at all times. Ask questions about each individual item. Will electricity be provided in hallways and stairs? Will the building be heated when you require it? I know of one co-op that discovered that the heat was turned on only on weekdays, not on Saturday, and—you guessed it—they didn't find out until after they signed the lease.

The point is that you must sit down and think through all the possibilities that might affect the way you plan to use the space. Most landlords won't automatically provide each and every service you think you need, so bargain for them. If they refuse, forcing you to provide these services yourself, make sure your budget can handle the costs if you plan to rent the building anyway. ·

Will we need an accountant to keep our books?

No, but unless one of your members has some bookkeeping background, you'll need an accountant to set up a simple set of books and show your more financially inclined members how to keep them. After that, those particular members can probably handle the books themselves. Nevertheless, to insure that the books are kept up to date and tax forms are properly filled out and filed on time, an accountant may be a wise investment.

How do we go into business as a co-op?

First, decide which you want to be—a partnership or a corporation. For information on incorporation, see Chapter 16. There are two reasons to incorporate: limited liability and tax benefits.

What is limited liability? Limited liability means that if your organization goes bankrupt, creditors of the corporation can only claim the assets of the corporation, if there are any—they can't ask you and your fellow members to pay debts out of your own pockets. Under a partnership, your personal assets can be claimed by creditors. Nevertheless, limited liability will probably not offer any real advantage to a co-op. Since co-ops are predicated on the idea that dues and initiation fees should cover costs, it's unlikely that enormous debts will be incurred.

Will the co-op benefit from tax advantages? Incorporation won't bring about any tax advantage unless the business is making a considerable profit, a fact that should eliminate incorporation from your consideration. Co-ops hardly ever make a profit unless they charge relatively high commissions, and even then profits can't be expected for the first few years. If business begins to boom later on, you and the others in the co-op should ask an accountant about the advantages of incorporation. But in the beginning, incorporation seems an unnecessary expense.

Should we investigate incorporation anyway? Yes, it might be wise to check out incorporation with a lawyer. Your particular situation might demand limited liability for some reason. Also, if your co-op is a large one with new members joining and old ones resigning with frequency, the corporate form of business might be more appropriate—partnerships usually dissolve when partners leave, and a new partnership must be formed.

How do we form a partnership?

Find out from the county clerk's office what forms must be filled

out or what applications must be made—they vary from region to region.

Next, work out a written agreement to be signed by all members that spells out the terms of partnership. Basically this means that you'll want to include:

1. The name of the partnership.

2. The purpose for which it was organized, which will probably be to exhibit and sell art.

3. How you want to limit the powers of individual partners. For instance, you might say that all expenditures over a certain amount must be approved by all partners.

4. How dues and fees are to be paid.

5. How profits and losses are to be shared—they'll usually be shared equally between partners.

6. How assets (fixtures, equipment, and so on) are to be divided if the co-op dissolves.

This is a rudimentary outline of what goes into a partnership agreement. It would be far better to get a lawyer to do it properly for you.

Is the partnership agreement enough in itself?

Yes, it is sufficient, but you might want to draw up a contract similar to the dealer-artist agreement discussed in Chapter 5 *in addition* to the partnership agreement. The dealer-artist agreement, which would represent a contract between the co-op and its members, would clarify what each member can expect from the co-op.

Can a co-op be a nonprofit organization?

Yes, co-ops can file as nonprofit organizations, either as corporations or as unincorporated associations (the equivalent of partnerships), in their states. This means that they've been established for purposes other than financial gain and that no part of their assets, income, or profits can be distributed to their members (except in the form of salaries). A nonprofit organization can organize for numerous purposes, but presumably a co-op might be founded as a cultural or educational group. Indeed, many co-ops whose prime purpose is exhibition file as nonprofit organizations because they see themselves as educational institutions.

Does this mean a co-op is eligible for funding?

That depends on what kind of funding you're talking about: public funding from the federal, state, or local governments or private funding. Federal public funders, such as the National Endowment for the Arts, are required by law to fund only nonprofit organizations that have been declared tax-exempt by the IRS. However, this is not always the case on the state or local level. Some state arts councils, for example, can legally fund nonprofit organizations that are not tax-exempt.

Private funders, such as foundations, can give money to anyone they please, but they are strongly encouraged to fund tax-exempt groups by the Internal Revenue Code, which provides that only contributions to tax-exempt groups are deductible for income tax purposes. Because of this, private funders rarely fund nonprofit organizations not declared tax-exempt.

Is it easy for a nonprofit co-op to become tax-exempt?

Unfortunately, it's almost impossible. Despite the fact that the requirements for nonprofit status and tax-exempt status are almost identical, the IRS rarely accepts co-ops as truly nonprofit organizations. While the state simply takes a co-op's word for the fact that it's nonprofit, the IRS investigates. And only those groups not engaged in any selling efforts such as those described in the next chapter qualify.

Once we have formed a co-op, how can we learn to mount first-rate exhibitions?

Everything you ever wanted to know about exhibitions—lighting, security, temperature control, placement of art, and much more—can be found in a book entitled *Good Show: A Practical Guide to Temporary Exhibitions,* by Lothar P. Witteborg, published by the Smithsonian Institution Traveling Exhibition Service (Washington, DC, 1981).

Seven

OTHER ARTIST-RUN ORGANIZATIONS

ORGANIZING

TAX-EXEMPTION

POTENTIAL FUNDERS

PROPOSALS

In the past fifteen years, the growth of artist-run, nonprofit, tax-exempt organizations has exploded. Frequently called "alternative spaces," they began in the early seventies as a sort of guerrilla movement outside the established art support system. They function in a variety of ways: Some provide slide registries or an information network or emergency material funds for artists; others concentrate on exhibitions or educational activities. Some are small in scope, such as storefront workshops; others have enormous spaces, budgets, and prestige. An exhibition at P.S. 1 in Long Island City, New York, for example, can be a major stepping stone in an artist's career. But no matter how they function, they all have the same problem: money and how to get it.

So I'll devote this chapter to fund-raising. But a few words should be said about forming your organization. First, make sure its purpose and goals are valid and not an unnecessary duplication of those of other organizations within the community. Second, reread Chapter 6. Much of the information given there regarding cooperative galleries applies to any artist-run organization. Third, set up a corporation.

Why should we set up a corporation?

For several reasons. Incorporation limits your liability and facilitates efforts to obtain tax-exempt status. Also, many people are reluctant to deal with an unincorporated organization because, rightly or wrongly, they sense a lack of professionalism.

How do we go about incorporating?

First, choose a name not held by any other corporation in your state. Second, form a board of directors, which will elect officers and adopt bylaws. Third, draft the necessary legal documents for a nonprofit corporation in your state.

How can we find out if the name we pick has been used by someone else?

Contact the Department of State in your state to see if the name you have chosen is already in use.

How do we know what documents to file? The Department of State in your state should be able to help you with this.

Can we write bylaws and fill out legal documents ourselves?

Yes, but it might be advisable to get legal assistance with the bylaws.

Then what do we do?

The next step is to apply for tax-exemption.

How do we do this?

Contact your local IRS office and ask for Form 1023. Tell them that you are applying for tax-exemption for nonprofit corporations under Section 501 (c) (3) of the Internal Revenue Code. IRS publication #557 tells you how to fill out the form.

Will we need anything else?

Yes, an employer identification number. This is equivalent to an individual's Social Security number. You can file for an employer identification number with Form SS-4 at the same time you file Form 1023.

Can we fill out these forms ourselves?

Again, yes. But they are complicated, and in order to get it done right the first time, it's better to have a lawyer help you with it.

Why do we need tax-exemption?

To raise funds. Only tax-exempt nonprofit organizations are eligible for grants from foundations, corporations, and government agencies, with the exception of some state councils on the

arts. They may fund you even if your organization hasn't been declared tax-exempt as long as they know you have applied for tax-exempt status and you have been declared a nonprofit organization by your state. Most individuals will donate only if they can be assured that they will be able to deduct contributions from their income tax.

How long will it take to become tax-exempt?

If you do it right the first time, not longer than a year.

Who are our prospective contributors?

Individuals, foundations funded by families and corporations, businesses that do not have foundations but make grants directly, and state and federal government agencies.

What individuals would be potential donors?

Friends, relatives, and other people within your community who have expressed interest in the visual arts, such as collectors and contributors to other art organizations. So be sure to ask colleagues in similar programs about their contributors or others they think might help you.

How can we find out what funding is available from the government?

Write to your state council on the arts and the Visual Arts Programs, National Endowment for the Arts, Nancy Hanks Center, 1100 Pennsylvania Avenue NW, Washington, DC 20506.

What corporations are our best bets?

Local companies and national or international companies with local offices.

If it is a local operation of a major corporation, should we approach the head office?

No. The decision to make a grant to a local arts group is usually made at the head office, but only on the recommendation of the local operation. Therefore, no contact should be made with the head office until local executives give the go-ahead.

How should we decide which local companies to approach?

Study each corporation's patterns of giving. Is your program in

their interest area? Have they funded similar programs? Do your funding needs fit within the range of their average grant size? Also take a look at the activities of the corporate executives. If they are donors to or sit on the boards of museums or other cultural institutions, they could be influential in convincing management of the value of your arts organization.

What specific corporate individual should be approached?

If you or anyone in your organization has a personal friend in the company, contact that person first. If not, and the company is small, write to the president. If the company is large and you have no personal contacts, call and inquire who makes grant decisions. The company may have an executive in charge of contributions. If not, it will probably be the head of one of the following departments: public affairs, public relations, or community relations.

Then what do we do?

Send a letter on stationery printed with your organization's name and address and a list of people officially connected with it, such as the board and/or officers. This letter should never be mechanically reproduced.

What should the letter say?

Explain who you are; outline the organization's program; describe what you plan to do, how you will do it, and how much it will cost; and ask whether the executive is interested in seeing a complete proposal for your program.

What happens next?

Follow up the letter with a phone call requesting an appointment. You will quickly learn whether the company is interested. If they are, arrange a meeting.

What should we do at the meeting?

Find out what their formal grant proposal procedure is, and ask for advice about the proposal's content, format, and length and any other suggestions that may improve your chances of getting a grant. This interview is important. It gives you a chance to establish an ongoing relationship with the company and to get first-hand information about what they like to read in a grant proposal.

What else should we find out?

What do they give grants for? Some companies will only fund capital expenditures such as office equipment; others provide funds with no strings attached. Keep in mind that some businesses won't give money at all but will provide services. An advertising agency, for example, may have no budget for grants but might be willing to produce a brochure for you.

What other organizations, particularly those outside our local area, might fund us?

Foundations are another source of funds. Most large corporations, and many individuals and families, do not give grants directly but funnel funds through their foundations. Even some of your local corporations will have foundations. Unlike governmental grant-making agencies, foundations seldom announce the availability of funds that have been earmarked for particular types of projects. Instead, they have fairly detailed statements that outline their specific areas of interest and the amount of money set aside for grant-making each year.

How can we find out which foundations are most compatible with our interests and needs?

The Foundation Center, a national service organization, provides the most complete source of factual information on philanthropic giving and will help you find out what foundations are most appropriate for you to apply to for funding. By using its publications and its nationwide network of library reference collections, you can identify foundation programs that correspond with your needs.

Where are the Foundation Center reference collections?

There are many collections. For a list of them, call toll-free (800) 424-9836.

What is the next step in applying for a grant?

Make sure you can answer the following questions:

Does your proposal meet a real need?

Does it provide a convincing solution to the problem you are addressing?

Is the scope of your proposed solution appropriate to the size of the problem?

Are you approaching only those foundations and corporations that you have firm reason to believe will be interested in your proposal? That will make grants of the size you require and will fund in your geographic area?

Are you submitting your proposal in the most appropriate format?

Do you have tax-exempt status with documentation?

Do you understand the review process and timetable of the foundations and corporations to which you've applied?

What goes into a proposal?

The format of a proposal varies, depending on whom you are submitting it to. Government agencies usually have long, complicated forms to be filled out, while most foundations and corporations do not use standardized application blanks. No matter what form they take, however, they will want pretty much the same information. This holds true whether your organization is small and new or large and well established. But keep in mind that if you are small and new or you are asking for a small amount of money, a long, elaborate proposal is inappropriate.

What information do funding sources want?

According to the Foundation Center, funding sources will want: a clear summary of what is to be accomplished; a defense of why this plan is needed; a description of the people to be involved; and a realistic financing scheme.

How should the summary be stated?

The major features of the proposed plan should be set forth clearly and logically, and an objective assessment of the importance of the problem being addressed should be made. Do this with a minimum of professional jargon, and avoid broad, sweeping generalizations.

How do we defend our plan?

By answering the following questions:

1. Why aren't others now meeting the need?

2. If a new organization is proposed, is it needed?

3. If others are performing a similar function, how does your proposal differ and why is the difference important?

4. Is the time right for the proposed endeavor?

What information should we give about the people involved?

Brief explanations of positions and duties; a biography for each key individual (this should go in the attachments); a defense of the qualifications of the people in view of the job to be done; and a list of directors and their duties or responsibilities.

What sort of financial information will the funding source want?

A budget for the next year of operations, including projected income (if any) by source and projected expenditures, and a program for eventual self-support or support from sources other than the one to which you are applying.

You may also want to include projections for two, three, or five years as well as documentation of past performance such as balance sheets.

What attachments should we send?

The statement of tax-exemption, biographical material on the staff and board of directors, the budget, newspaper clippings describing or reviewing your activities, and other pertinent support material.

What should we do if we are rejected?

Ask the funding source why they rejected your proposal; this could be a very helpful learning experience. And ask if you can resubmit your proposal at a later date or at a different point in your development.

What should we do if we receive a grant?

Some funding sources require periodic reports. Even if this is not the case, you should still keep them abreast of program activities, staff changes, and any other relevant material such as newspaper clippings. Cultivation of contributors, even small ones, is a must in any fund-raising program.

Eight

PRINTS: ORIGINAL AND OTHERWISE

DEFINITIONS

PRACTICES

LEGISLATION

DOCUMENTATION

A s the popularity of prints has increased since the late 1950s, the aesthetic experience offered by the medium has sometimes lost ground to its investment potential as the motivating factor for buying. Collectors jump at the possibility that they can buy cheap and sell dear, and they frequently leap into the arms of unscrupulous dealers and printmakers selling, for example, signed, limited editions guaranteed to double in value next year and triple the following year. Unfortunately, many collectors buy what they think are valuable lithographs or etchings only to discover they are the possessors of humble reproductions. Because of these and other abuses, the public has demanded laws to protect the unwary consumer.

The purpose of this chapter, then, is to highlight some of the problems involved in the print medium and describe the legislation a few states have enacted to deal with them.

What does "original print" mean?

There are myriad opinions on the subject, but let's take a quick look at the official definition of the United States Customs Department and a definition adopted and later dropped by the Print Council of America (PCA).

The Customs Department—it gets involved because it charges duty on reproductions but not on original works of art—defines original prints as including "only such as are *printed by hand* from plates, stones, or blocks etched, drawn, or engraved by photo-chemical or other mechanical processes."

What is the PCA's definition?

In 1961, the Print Council of America proclaimed that:

An original print is a work of graphic art, the general requirements of which are: (1) The artist alone has made the image in or upon the plate, stone, woodblock or other material for the purposes of creating a work of graphic art. (2) The impression is made directly from that original material by the artist or pursuant to his directions. (3) The finished print is approved by the artist.

Why was it dropped?

Modern technology has multiplied the ways that printmakers make prints, so it's almost impossible to tell what is a pure, unadulterated original print. Even a not-so-recent example will demonstrate what I mean. To create a series of prints known as *Miserere*, Georges Rouault had some preliminary drawings made into plates by a photomechanical process. After the plates were completed, he worked on them with printmaking tools. On the one hand, he violated the requirements of the PCA's definition by allowing his drawings to be reproduced mechanically; on the other hand, he satisfied the requirements by manually manipulating the photogravure plates. With the variety of techniques used by printmakers today, the situation is even more confusing.

Who are considered printmakers?

There are two distinct categories of printmakers. In the first category are those artists who do everything themselves. They perform every step of the process, from creating the image; deciding on the papers, inks, and other materials; and placing the image on the stone or plate; to printing the prints—very frequently—on their own presses.

Artists in the other category rely heavily on the craft skills of professional (master) printers and, many times, on the recommendations of their publishers as to sizes, shapes, colors, and even the images themselves.

Who is a master printer?

A master printer is a professional printer who prints original etchings, lithographs, silkscreens, and so on, for other artists who supply him with a finished plate, stone, or screen. The artist may work with the master printer in developing color possibilities or give the master printer a *bon à tirer* (see below).

What is your definition of an original print?

One workable definition of an original print is a work of art created solely for the print medium and no other. An artist makes an original print to achieve a particular kind of effect that only a particular medium can give.

What is a reproduction?

It's an exact duplicate of a work that already exists in another form. If you take a drawing, for example, photograph it, make a metal plate of the photograph, and reproduce it, you have a picture of a picture—a reproduction.

The essential difference between a reproduction and an original print centers on the word "original." As Carl Zigrosser, author of one of the definitive books on the subject, *A Guide to the Collecting and Care of Original Prints,* put it:

One may ask with reference to a color reproduction: Where is the original? and receive the correct answer that the original is a painting by So and So in the collection of such and such a museum. But one cannot give the same answer with reference to an artist's etching. There is no mythical original of which the print in question would be a replica. One cannot consider the copperplate the original nor the preliminary drawing study with its sketchy lines, granted that the artist has made one (often he has not). These are but the preliminary steps in the production of the finished etching, which is the perfect embodiment of the artist's creative intention. The print itself is the original.

What are the most common abuses that consumers complain about?

The most obvious one—with regard to original prints—is the practice of leading the customer to believe, without actually saying so, that he's buying an original print when he's actually purchasing a photomechanical reproduction. Usually this is done through the use of the words "signed," "numbered," and "limited editions," all of which may actually be applicable to an edition of reproductions but are usually associated with original prints. Other abuses explained below are connected with the practices of signing and editioning.

What is a signed print?

A print that has been signed by its creator in pencil below the printed image. This relatively recent practice was popularized by Whistler, who signed prints with his Butterfly mark.

What is the significance of the signed print?

According to Zigrosser: "The signature has come to stand for, among other things, a guarantee of printing quality, a stamp of good workmanship, similar to the hallmark on silver."

How does signing a print become a misleading act?

There's nothing misleading about signing an original print after it's been printed. The signature attests to the quality, which may vary from one print to another because they are made by hand. Not so with reproductions. By the very nature of the process, all photomechanically produced reproductions are the same. No useless okay by the artist is needed to vouch for quality. When an artist signs a reproduction, therefore, he or she is probably doing one of two things: trying to deceive the public into believing that the reproduction is an original print, because original prints bear signatures; or adding an autograph that by its presence alone will make the reproduction seem more valuable. There's nothing illegal about the latter, as long as the work is clearly marked a reproduction; it's simply a marketing device.

Are there any other misleading signing practices?

Signing the stone or plate so it looks like there is an autograph on each print, and signing blank paper before printing are dubious practices. Both preclude the artist's approval.

If a master printer prints work for me, should I sign it?

Yes, but sign it differently. If you print the work yourself, you should write after your name, "imp." (*impressit*—he printed it). If a master printer executes it, the work should be signed, "John Artist del Peter Printer."

What is a numbered print?

When a print bears a number, the number supposedly indicates when in a series that particular print was printed. For example, the marking 7/35 on a print should mean that it was the seventh print made in an edition of 35.

What's the significance of numbering prints?

There's very little significance to numbering prints. The sole purpose of this fairly recent—yet well-established—practice seems to be to provide a means to increase the marketability of a work.

Collectors often assume that the earliest numbers are the best, but this isn't necessarily so. In a small edition, all impressions may be of equal quality.

Furthermore, numbering may be a meaningless gesture. Printmakers, particularly those making color images, often don't bother to keep track of the order in which they print. And sometimes, with multicolored prints, an artist will print all 40 or 80 prints one color at a time. When that color dries, he'll start printing the next one. It would be the rare printmaker indeed who would be so meticulous as to maintain the proper sequence when making a four-color print, much less one of ten or fifteen colors.

What is a limited edition?

A limited edition is one in which the artist promises to make just so many impressions and no more. Limited editions are still another product of the twentieth century. Historically, artists made prints from the same plate for as long as it held up and a market for them existed. For example, records show that 73,000 impressions of a single Currier and Ives lithograph were sold.

Do artists abuse limited editions?

Yes, sometimes they do. As a general rule, the smaller the edition, the more valuable the print. Some people reduce the numbers in individual editions artificially while actually printing larger editions to make more money in the end. First, there's the practice of producing separate editions of the same image from the same plate. This tactic, while not considered fraudulent, leads to confusion. Suppose, for example, a publisher issues two editions of 40 prints each, using the same plate but two different types of papers. Isn't the total size of the edition 80? Not everyone thinks so. Paper is a crucial factor in printmaking—many reputable people would deem two such editions legitimate.

Second, and less acceptable, are those editions of the same image made from the same plate that differ only by the use of Roman numerals on one edition and Arabic numerals on the other.

Other potentially deceptive acts are associated with the selling of restrikes, artist's proofs, prints made after an artist's death, and other proofs.

What are restrikes?

Restrikes are prints made from a plate, or whatever, after the original edition was issued. They are perfectly valid legally as long

as they aren't sold as prints from the original limited edition. To prevent this from happening, the plate should be cancelled.

What do you mean by cancelled?

An artist cancels a plate by destroying the master design or altering it in such a way that no more prints can be made from it once the original limited edition has been made. For example, an etcher might etch either her name into the plate or a line across the image. Evidence that the plate has been cancelled is given by making a print, called a cancellation proof, from the defective plate.

What is wrong with selling prints made posthumously?

Again, there's nothing fraudulent about making and selling prints after the artist's death as long as the buyer knows that he or she is buying a work that the artist could not approve.

What are artist's proofs?

Artist's proofs are a very small number of prints from an edition reserved for the artist's personal use. They are not numbered but are marked A/P. Because of their personal association with the artist, these prints have added value in the eye of the collector. Unscrupulous artists and publishers have taken advantage of this fact by printing large numbers of prints marked as artist's proofs. They then raise the prices accordingly, and, at the same time, reap the benefits of increasing the total number of prints to sell.

What is considered an ethical number of artist's proofs?

An ethical number would be 10 to 12 percent of each edition.

What other prints might be offered for sale?

Printer's proofs, *hors commerce*, trial proofs, and prints from different states. All are perfectly valid as long as they aren't labeled and sold as something else.

What's a printer's proof? A printer's proof is a proof bearing the artist's signature, indicating that the plate is satisfactory and used as a standard against which other prints from the edition are compared. A printer's proof is also known as a *bon à tirer* (literally, a print good to print).

What's a hors commerce? It's a sample copy for salespeople not counted as part of the edition and not intended for sale.

What's a trial proof? These are proofs pulled before the *bon à tirer* that aren't satisfactory. Trial proofs are rarely preserved or offered for sale, although they may be very interesting because artists frequently draw revisions on them, using them as working notes.

What's a state? A state is any stage in which the plate is altered. Trial proofs are states, as are changes made after a *bon à tirer* is pulled. An artist may print an edition and then decide to rework the plate and make new prints from the altered plate. The new edition would be another state. States are usually indicated by lower-case Roman numerals. For example, i/iv means the first of four states.

Was there ever an attempt to limit the size of a limited edition?

No. No law, custom, or ethic dictates the size of a limited edition. It's up to the artist and publisher.

What states have laws governing printmaking practices?

As of this writing, California, Illinois, New York, Arkansas, Hawaii, and Maryland have such laws.

What does the New York law say?

The New York state print law requires sellers of prints and photographs to state in writing the following descriptive information:

1. The name of the artist.

2. The medium or printing process.

3. When it was produced.

4. The size of the edition.

5. Whether the print is signed.

6. Whether it is signed in the stone or plate.

7. Whether it is estate-stamped or the artist's name is affixed in some other manner.

8. Whether the printing plate was made or printed posthumously.

9. Whether it is a photoreproduction of work in another medium not created specifically for the edition.

10. If the print is unsigned, whether the artist authorized the edition in writing.

11. Whether the print is a restrike.

The law also requires sellers of limited editions to disclose the size of the edition and how it is numbered. In addition, sellers must guarantee that the number of artist's or other proofs does not exceed ten prints or 10 percent of the edition size, whichever is greater. If the number of proofs does exceed this limit, or if the print was produced in separately numbered duplicate editions, they must also state this.

The law is directed toward dealers, but artists must bear some responsibility. Whenever they consign or sell prints or photos, they must provide the above information and can be held liable if they provide false or incorrect information.

What are the penalties for violating the New York state law?

If the sellers supply false information, the consumer can return the print and receive a refund plus interest. If the sellers have purposely failed to provide the required information or knowingly supplied false information, they are liable for three times the price of the artwork plus interest, court costs, and attorneys' fees. For repeated violations or outright fraud, the state attorney general can sue to recover triple damages for customers as well as a penalty up to $500 for each violation.

What does the Illinois statute say?

The Illinois law applies only to dealers and covers fine prints printed after July 1, 1972, and offered for sale unframed for $50 or more, or framed for $60 or more. It also applies both to fine prints and reproductions that are described as signed, numbered, and/or limited editions. The bill requires the disclosure of the following facts:

1. The name of the artist and the year when printed.

2. Whether the print is an etching, engraving, woodcut, or lithograph.

3. Whether the edition is being offered as a limited edition, and, if it is, the total size of the edition (exclusive of trial proofs).

4. Whether the plate has been destroyed, effaced, altered, defaced, or cancelled after the current edition.

CERTIFICATE OF AUTHENTICITY

ARTIST:

Born:

Studied:

Exhibitions:

Awards:

Collections (or comments):

AUTHENTICATION: This is to certify that the print entitled
_____ is an original by _____
numbers of colors _____ paper _____ year printed _____ number of
authorized signed prints in the edition _____ artist's proofs _____
publisher's proofs _____ unsigned proofs _____ number of
other editions _____ size of other editions _____ has plate
been cancelled? _____ Printer: _____

_____ _____

Authorized Signature Date

Figure 9. Whether or not you live in a state that demands print documentation by law, it is a good idea—particularly from a marketing point of view—to furnish a certificate of authenticity to collectors. The example shown gives sufficient information, but if you want to, you can include additional information about the print process itself.

5. The series number of the current edition—if there were any prior editions from the same plate—and the total size of all prior editions.

6. Whether the edition is a posthumous edition or restrike, and if so, whether the plate has been reworked.

7. The name of the workshop, if any, that printed the edition.

If the dealer does not know all the details, he must specifically state which one he is ignorant of. Disclaiming such knowledge eliminates the dealer's responsibility for standing behind his product.

What happens if the dealer violates the Illinois law? If the dealer violates it unknowingly, the purchaser can sue for the purchase price plus interest; if the purchaser can prove that the dealer deliberately violated the law, the purchaser may recover three times the purchase price plus interest. Both actions must be brought within one year of discovery and not more than three years after the print was bought. The dealer, if convicted, can also be fined up to $1,000 by the state.

What does the California law say?

The California law covers prints and other multiples that sell unframed for $100 or more and applies to both artists and dealers.

Information to be disclosed includes:

1. Name of artist and the year when printed.

2. Whether the artist signed the print.

3. A description of the process.

4. Whether the artist was deceased at the time the master image was created.

5. Whether there have been prior editions and in what quantity.

6. The total size of the limited edition.

7. Whether the master image has been cancelled after the current edition.

What are the penalties for violating the California law?

Similar to those for violating the New York State law.

THE ARTIST AND THE PUBLISHER

ORIGINAL PRINT PUBLISHERS
REPRODUCTION PUBLISHERS
FEES
CONTRACTS

Now let's backtrack a little to look at the problems you may run into before your work ever gets off the press. What I'm referring to are the deals you make with publishers of original prints and reproductions (meaning those to be framed and hung on the wall, not those published on greeting cards, for example, or in books). Despite the prestige of original prints, there's no stigma attached to producing high-quality reproductions, as long as they don't pretend to be original prints.

No matter what printing process is used, however, the issues that should be incorporated into publishing contracts are pretty much the same for both original prints and reproductions. In order to avoid confusion, however, they're discussed separately below—original prints first.

After reading this chapter, go back to Chapter 4. Agreements between artists and publishers closely resemble those made between artists and clients commissioning the creation of artwork. Chapter 4, then, should be reread before you sign a publishing contract, to refresh your memory with respect to general contract considerations, such as start and finish dates, death clauses, and so on. This discussion is limited strictly to issues involved in publishing.

Who is a publisher?

A publisher is simply a person who "issues or causes to issue" printed works for sale, according to the dictionary. This means that a publisher doesn't have to be either a printer or a retailer, although both can qualify for the title if they can bring the work before the public.

Who usually publishes original prints?

The artist, the artist in partnership with someone else, or a businessperson who commissions (or sometimes buys) an edition are all publishers.

As publisher, how would I sell my original prints?

You would sell them directly to the public, through galleries, or sometimes through wholesalers.

If I sell original prints to galleries, how much should I charge?

If you sell only a few works, you would charge about 50 percent of the retail price. If you sell the whole edition, 35 percent to 40 percent of the retail price would be equitable, although you may have to settle for less if you're relatively unknown.

If I consign original prints to galleries, what commission will they charge?

You can expect a dealer to charge up to 60 percent of the retail sales price. Commissions on original prints are usually higher than on unique works.

Is it better to sell or consign original prints to galleries?

Because of the fragility of original prints, it's usually a better idea to sell outright. Otherwise you take the risk of getting the work back damaged.

Should I have a contract with a gallery if I consign original prints?

Yes. If you consign work, a contract similar to the artist-dealer contract shown in Chapter 5 would be appropriate.

If I sell original prints to a wholesaler, how much should I charge?

If you sell to a wholesaler, once again the price is based on how many pieces you offer. A few pieces would justify your asking 25 percent of the retail price (50 percent of the wholesale price). If you sell the whole edition, you might have to go to as low as 10 percent of the retail price.

Who do artists usually copublish original prints with?

An artist and his or her dealer often team up to produce an edition. Each makes an equal investment in the project. In other words, the artists will execute the image on the stone or plate and

print the edition or supervise the printing in a workshop, while the dealer provides the money for materials and possibly printing costs, if the artist works in a print workshop. Profits are split 50–50, although some dealers will subtract distribution costs (what it costs them to sell your work around the country) before profits are divided.

Who else do artists copublish with?

Joint ventures are also fairly common between artists and the owners of print workshops. In these cases, you may find no money changing hands at all. What frequently happens is that the artist supplies the image and works on the stone at the workshop. When the edition has been printed, the printer takes half and the artist takes the other half. Both are free to do what they want with their part of the edition, although they should have an agreement promising to uphold an agreed-upon retail price.

Such 50–50 arrangements are less likely to occur with a straightforward wholesale publisher (described below). But if your name is big enough, you could still demand to split the profits evenly after printing and sales costs have been deducted.

Who usually commissions original prints?

Three types of businesses. Their functions frequently overlap, but in general they represent the three basic vehicles for bringing an original print before the public.

1. A print workshop. The owner may plan to wholesale the work through galleries or retail it through advertising. Gemini G.E.L. and Universal Limited Art Editions, which publish the works of such superstars as Robert Rauschenberg and Jasper Johns, are examples of workshop publishers—though they may also be examples of 50–50 joint ventures.

2. A wholesale publisher. Although he may have printing facilities, his major role is to sell prints to galleries and other retail stores. Occasionally, he may sell work directly to the consumer through advertisements in periodicals and by direct mail.

3. A dealer. He will sell the prints through his own gallery and possibly wholesale them to other galleries.

Should my agreement with a publisher of original prints be in writing?

Of course. It might be an informal letter of a couple of paragraphs

setting forth the financial arrangements. A better idea would be to draw up a more comprehensive contract including the usual clauses referring to the scope of work and start and completion dates, plus the following specific clauses: remuneration; artist's proofs; responsibilities; rights and copyright; cancellation; and termination (see below).

If a publisher commissions me to make an original print, how will I be paid?

Payment for work commissioned by a publisher will be in the form of a flat fee or a royalty.

How do publishers arrive at a flat fee?

Everyone has his or her own method. Some publishers may pay a flat fee for the entire edition equivalent to what you would get for a work on paper, such as a drawing. Other publishers will offer an arbitrary sum based on their estimate of your sales potential and the costs of printing and distribution.

How do they work out royalties?

Royalties are payments that are paid after the work is sold rather than when it is done. There are no hard and fast rules here. One wholesale publishing company offers artists one-sixth of a mutually agreed-upon retail price, with half of this amount being paid to the artist on delivery of work and the other half paid as the prints are sold.

Royalties, if an edition sells out, should amount to more than a flat fee. This is only as it should be—after all, by not accepting money up front, you are in essence subsidizing the publisher until sales start coming in.

What are ideal flat fees and royalties?

The whole point of both flat fees and royalties is that ideally they should be roughly equivalent to the same old formula of 25 percent of the retail price. But only big names will be able to command this percentage. If you're an unknown, expect to go as low as 10 percent, maybe even lower. Another company told me they offer a flat fee that would equal a 5 percent royalty, but they supplement this fee with free transportation to and from New York from anywhere in the country plus room and board for two to three weeks while the artist works in their workshop. Don't forget, of course, that percentages will also be lower if you don't do the printing yourself.

Which is better?

Unless you're confident that the edition will sell out, and even appreciate in value, sending prices up before it sells out, a flat fee is probably better than royalties. You'll get your money immediately without waiting months or years for it, or maybe not getting it at all.

In any case, most publishers will offer flat fees rather than royalties, unless they have some pressing reason for not wanting to pay you immediately.

Do I get paid for preliminary sketches for the project?

In any special commission, you should ask for payment for preliminary work, so if the project falls through, you won't be caught short. This sum may represent additional compensation or—more commonly—it will be an advance against royalties, the final fee.

Are advances returnable if the original prints don't sell?

They shouldn't be, so make sure your contract says they aren't returnable unless you fail to complete the work.

When will I be paid a flat fee for a commission?

A flat fee for a commission of original prints should be treated the same way as that for any special project. Therefore, you should request a schedule of payments. It might run something like this: first payment on execution of the contract; second payment when you approve the *bon à tirer;* and final payment when you sign the prints.

Who has artistic control over the print?

You should, since it's your responsibility to sign the *bon à tirer.* To insure that you retain control, put in your contract a phrase such as: "The responsibility for the aesthetic content and quality of the edition is the sole responsibility of the artist."

What if the publisher won't agree to this?

This is where your schedule of payments serves you well. If the publisher refuses to accept the final print, your contract should stipulate that the sum paid you for the design be nonrefundable, to compensate you for the cost of materials and time spent on the work if rejected.

When will I be paid royalties?

Royalties are generally paid every six months, and you should have a clause in your contract granting you the right to inspect the publisher's financial records concerning your work.

How many artist's proofs should I be entitled to?

Whether you're paid a flat fee or royalties, you should also be entitled to a certain number of free artist's proofs—10 percent to 12 percent of an edition of original prints is the general rule.

What responsibilities will the publisher have?

It goes without saying that publishing, promoting, and selling the prints are the publisher's responsibilities. He or she might also agree to provide equipment, materials, working space, and technical assistance, including a master printer. In fact, you might want to stipulate that your agreement will be terminated if the services of a particular master printer aren't available to you.

What responsibilities will I have?

You will be required to assist with proof correction (if you don't do the printing yourself) until you approve the *bon à tirer,* which the printer will use as a standard with which to judge the quality of succeeding prints. And you must hand sign the prints.

What rights will I give the publisher?

You'll give the publisher the right to publish, promote, and sell your work.

Who owns the copyright?

Unless you agree in writing to the contrary, you own it. So make sure your copyright notice is placed in the stone or fixed by hand later. Your contract should also require the publisher to register the copyright with the Copyright Office in your name (Chapter 2).

What do you mean by a cancellation clause?

In order to protect yourself against future accusations that your limited edition of original prints exceeded the limit, your contract should have a cancellation clause. It should state that the publisher agrees to deface or destroy the image on the stone, plate, screen, or block (if you don't do the printing and cannot efface the stone yourself) so overruns on the edition, restrikes from the original

plate, and reprinting on different papers won't occur. The contract should further require the publisher to furnish you with a cancellation proof, a print made from the damaged plate, as proof of effacement.

What should be in a termination clause?

It should provide that all rights you granted the publisher (to publish, sell, promote) revert to you on termination. And if you gave him or her the copyright, be sure to demand that it be transferred back to you on termination. Finally, you might want your contract to give you the opportunity to purchase the plate, if it doesn't belong to you and the contract terminates before the edition is complete.

Who usually publishes reproductions?

In general, retail dealers and small printers don't get involved in publishing reproductions. Reproductions are usually made by wholesale publishers who sell to retail stores or through advertisements. These businesses frequently have their own printing plants, but sometimes they contract the work out to outside printers. Occasionally, an artist will publish his own reproductions, which he pays a printer to make, and sell them through retail outlets.

If I publish reproductions, what should I charge a retail store?

Charge about 50 percent of the retail price.

What should be in a contract with a publisher of reproductions?

Most large publishing firms offer relatively inflexible contracts, which you may not be able to change unless you're a proven moneymaker. If you're not, don't sign just any contract—make sure the terms put forth in the following clauses suit you: remuneration; publication rights; return of original art; revisions; and insurance. See below for details.

How do reproduction publishers pay?

Sometimes they pay royalties, but usually they pay flat fees (see above).

What is an average royalty on a reproduction?

Since editions of reproductions are generally very large, from 1,000 to 5,000, the royalty would be much smaller per print than

that paid on a limited edition of original prints. Thus, 2.5 to 5 percent of the wholesale price would not be out of line; neither would even half that if royalties are based on retail price. This means that if an edition of 3,000 reproductions sold wholesale for $10, and your royalty was 2.5 percent, you would earn $750 if the edition sold out.

What would an average flat fee be?

There's no such thing as an average fee. But many publishers will pay a flat fee that is in the neighborhood of the amount you would make in royalties if the edition sells out. So if you were asked to do an edition similar to the one described in the previous paragraph, you would probably be offered $650 or $700.

Are artists' fees for reproduction based on reputation?

Somewhat. But unlike publishers of original prints, who pay big names more than unknowns, publishers of reproductions base their fees to a large extent on their enthusiasm for the work itself and their estimate of its sales potential in terms of a pleasing image, rather than on the artist's reputation.

When do publishers pay flat fees and royalties?

Flat fees are generally paid within 30 days of delivery of the original artwork, and royalties every six months—so get the timing of these payments in the contract. And once again, make sure you have a clause granting you the right to inspect the publisher's financial records regarding your work.

Who owns the copyright on the original artwork?

You do, unless the publisher demands it and you're willing to give it up. If you retain it, make sure to put proper copyright notice on the painting or drawing (see Chapter 2) and register it.

Who owns the copyright on the reproductions?

Again, you do, unless you're willing to give it up. If you keep it, your contract should require the publisher to place copyright notice on the reproductions and register it with the Copyright Office in your name.

Should I give up my copyright?

If giving up the copyright seems unfair to you, you have the option of not signing the contract. But the deal might be lucrative

enough to make selling your copyright worthwhile. Nevertheless, you might try to amend the contract so if your contract terminates, copyright reverts to you. Better still, if you have enough clout, you should try to grant only limited publication rights.

What do you mean by limited publication rights?

This means you limit the right to reproduce your artwork to an edition of only a certain number of reproductions. This doesn't concern an edition of reproductions that's advertised as a limited edition—if that is the case, the publisher is bound to reproduce only a certain number of reproductions and then efface the plate, just as a publisher of original prints does.

When reproductions are not limited in this sense, theoretically the publisher can reproduce your work indefinitely—and without further compensation to you unless you're being paid royalties. But if you're working on a flat fee basis, you should grant publication rights for only a limited number of reproductions, say 5,000. Then if the publisher wants to reproduce more, he or she would have to pay you another fee.

Will the publisher want to copyright this limited edition of reproductions?

Yes, he might want to, if you grant him the copyright.

Why would he want to copyright in his own name?

Even though he has the rights to only one edition, he does have a vested interest in the reproductions, and he may not want to rely on you to sue if infringement occurs, figuring that most artists like to avoid legal confrontations.

Who owns the painting or drawing after it has been reproduced?

That's up to you and the publisher and should be clarified in your agreement. Chances are the publisher only wants the rights to reproduction, but there's no guarantee he'll give the work back unless it's clearly stated in the contract.

Can the publisher request that I make changes in my image?

That depends on what's in the contract. Many companies will demand this right. On the other hand, if your reputation is secure, you ought to be able to eliminate this clause, substituting one of your own that prohibits such requests.

CONTRACT WITH PUBLISHER

Dear Mr.

Graphics Unlimited ("GU") has acquired from _____ ("the Artist") the right to reproduce a painting entitled "Arabesque" ("the Work") upon the following terms and conditions:

(1) The Artist hereby grants to GU the exclusive right throughout the world to publish, manufacture, advertise, distribute and sell color reproductions of the Work ("the Reproduction").

(2) Each Reproduction shall be approximately _____" in size, excluding margins.

(3) In consideration hereof, GU shall pay to the Artist upon execution of this Agreement, as a nonrefundable advance against the royalty hereinafter specified, the amount of $_____.

(4) GU shall pay to the Artist a royalty of 1.2% of retail price per copy for each Reproduction sold by GU.

(5) GU may cause the Work to be reproduced by such method and by such entities and means as GU in its sole discretion may select.

(6) GU shall furnish to the Artist, without charge, six (6) Reproductions and the Artist may purchase additional Reproductions at fifty percent (50%) of the retail price of each Reproduction.

(7) The Artist shall deliver the Work to GU simultaneously with the execution of this Agreement. GU shall retain the Work and shall proceed promptly to have plates made. The Work shall be returned to the Artist within 180 days of the date of this Agreement. While it is in the possession of GU, the Work shall be insured against all risks.

(8) Each Reproduction will carry a legend indicating the size and medium of the Work, and the name of the Artist. If the Artist so advises GU in writing within five (5) days after the date of this Agreement, the legend on each Reproduction will include the nationality and date of birth of the Artist.

(9) The ownership of the copyright in the Reproduction shall at all times reside in GU and the ownership of the copyright in the Work shall at all times reside in the Artist.

Figure 10. This is an actual example of a contract used by a leading publisher (the name has been changed). It is shown here because it represents a fair contract from the artist's standpoint.

(10) The Artist warrants originality, authorship and ownership of the Work; that the Artist has the full power to enter into this Agreement; that neither the Work nor the Reproduction has been heretofore used or published; that no right in the Work or Reproduction has heretofore been assigned, licensed or transferred; and that the use or publication of the Reproduction by GU will not infringe upon any copyright, proprietary or other right of any third party. The Artist agrees not to authorize others to use or publish the Work or the Reproduction during the term of this Agreement.

(11) This Agreement is to continue in effect for the term of the copyright on the Reproduction.

(12) GU shall keep accurate books and records with respect to all transactions herein contemplated, which shall be available for inspection and copying by the Artist at reasonable times and upon reasonable notice during regular business hours in order to verify any statement or accounting rendered hereunder.

(13) If GU shall have sold more than fifty (50) Reproductions during the prior six (6) months, GU shall account to the Artist ninety (90) days following each June 30 and December 31 during the term hereof, each such accounting to be accompanied by that amount, if any, therein shown to be payable.

(14) This Agreement contains the entire understanding of the parties and shall be construed under and in accordance with the laws of the State of _____.

Please confirm that the foregoing accurately and completely sets forth our entire understanding by signing and returning the enclosed copy of this letter.

Very truly yours,
Graphics Unlimited

By _____
James Brown, President

Confirmed and Agreed to:

Artist

Who carries insurance on my artwork?

While the publisher has the artwork, he should insure it, so make sure that's in the contract.

What's an example of a good contract with a publisher?

Look at the one shown in Figure 10. It's an example of a contract used by a leading publishing house that gives the artist a fair break.

Ten

THE ARTIST AND THE MUSEUM

LENDING

INSURANCE

DONATING

SELLING

Every artist dreams of having the opportunity to exhibit his or her work in a prestigious museum. The usual ways to achieve this goal are to be invited by the museum to take part in an exhibition, to be selected for a juried exhibition, or to sell or donate work to a museum. (You can also bequeath work and rent through museums, but the former topic will be taken up in Chapter 17 and the latter was discussed in Chapter 3.)

Once your work has been accepted by a museum, you may be too elated to think about the legal and financial details involved in this honor, but you should keep the following things in mind.

If I'm invited to lend work for exhibition, will I get a contract?

Probably. Most museums have standard contracts, such as the one in Figure 11, detailing the terms concerning the loan of a work for an exhibition. Each term may be subject to negotiation. If you don't get a contract automatically, ask for one.

In general, what do museum loan agreements cover?

An exact description of the work received for loan, the length of the loan, plus clauses detailing:

1. Loss or damage—who's responsible at what times.

2. Value—how much the work is really worth (see below).

3. Insurance coverage—who provides it at what times (see below).

4. Option to buy, if any.

5. Restoration and repair—who will supervise and pay for them.

6. Framing. The museum is probably not going to pay for this, even when you've been invited to exhibit.

7. Reproduction rights. You'll probably want to grant them for catalogs and publicity work.

8. Sale price, if your work is for sale. Although museums don't usually sell work for artists, you're likely to find this occurring during regional juried shows.

If there's a purchase prize, how much should it be?

A purchase prize for an open exhibition should be at least equal to two-thirds of the amount you can expect to sell the work for. If your prints, for example, sell for $300, the purchase prize should be at least $200. If it isn't, it won't be worthwhile competing unless you think the prestige will make up for the financial loss. If that isn't the case, then when you enter the show, indicate on the entry blank that you don't wish to be considered for the prize.

Who carries insurance if a museum invites me to exhibit?

The museum should, but if you already carry insurance on your work, they may agree to reimburse you for your insurance payments for the time they possess the work. Museum coverage is usually "wall to wall," meaning that they insure work from the time it leaves the wall of your studio (or gallery or whatever) until it returns. Occasionally, a museum may refuse to insure work if it's too fragile.

If a museum refuses to insure work that's not fragile, you should refuse to lend it unless they specifically agree in the contract that they'll compensate you fully in the event of loss, damage, or theft.

Who sets the valuation on my work for insurance purposes?

As a general rule, you will. However, if the museum feels you've made an unreasonably high valuation, they may insist on a more realistic value, and they may demand that the value exclude your dealer's commission.

Museums sometimes balk at valuations placed on works made from an artist's model by an industrial operation, such as a steel fabricating plant. The Whitney Museum of American Art, for

WHITNEY MUSEUM OF AMERICAN ART / LOAN AGREEMENT

945 Madison Avenue, New York, N.Y. 10021 (212) 794-0600

Please complete, sign and return. The blue copy is for your records.

EXHIBITION

Area
Code

Lender_____ Telephone (Business) ()_____
(Home) ()_____

Address_____
(Unless otherwise instructed below, work will be shipped from and returned to this address)

Credit_____
(Exact form of lender's name for catalogue, labels and publicity)

Name of Artist_____Born_____Died_____
(year) (year)

Address of Artist_____

Title of Work_____

Medium or Materials and Support_____

Size: Painting, drawing, etc. (excl. frame or mat): H_____ W_____ Outer dimensions of frame: H_____ W_____

Sculpture (excl. pedestal) or relief: H_____ W_____ D_____ Approx. Wt._____

Pedestal: H_____ W_____ D_____ Approx. Wt._____ Detachable?_____

Date of Work_____If date appears on work, where?_____

Signature If work is signed, where?_____

Is Work for Sale?_____Selling Price_____ (See conditions on the reverse)

Insurance Value (U.S. Currency) $_____
(See conditions on the reverse; insurance cannot exceed selling price, if any)

Do you prefer to maintain your own insurance?_____If so, estimated premium_____

Framing: Is the work framed?_____If necessary, may we reframe or remat the work?_____May we substitute
plexiglas for glass?_____.

The work will be returned to the lender in its original frame or mat unless other arrangements are made with the Museum in writing.

Photographs: Which of the following are available: Black and white photographs for catalogue reproduction and publicity? (If known,

please give negative number)_____ Color separations or plates?_____ Transparencies?_____

Color slides, post cards or other reproductions for sale?_____

Unless permission is declined here, it is understood that this work may be photographed, telecast and reproduced for publicity purposes
connected with this exhibition and for illustration in the Museum's catalogue and other publications, and that slides of it may be made
and distributed for educational use.

Special Instructions: Ship from_____ Return to_____ Other_____

Duration of Loan: ☐ at Whitney Museum only; ☐ at Whitney Museum and subsequent tour.

THE CONDITIONS OF THIS LOAN AS STATED ABOVE AND ON THE REVERSE ARE ACCEPTED.

Signed:_____ Date:_____
(Lender or authorized agent)

Figure 11. This is an example of the type of agreement you should receive from a museum when you lend work for an exhibition. Before you sign such a contract, be sure to check the conditions on the back.

CONDITIONS

1. The Whitney Museum of American Art (the "Museum") will exercise the same care with respect to the work of art referred to on the reverse (the "work") as it does in the safekeeping of comparable property of its own.

2. The work shall remain in the possession of the Museum and/or the other museums participating in the exhibition for which it has been borrowed (the "participating museums") for the time specified on the reverse, but may be withdrawn from such exhibition at any time by the Director or Trustees of the Museum and/or of any of the participating museums. The work will be returned only to the owner or lender at the address stated on the reverse unless the Museum is notified in writing to the contrary. If the legal ownership of the work shall change during the pendency of this loan, whether by reason of death, sale, insolvency, gift or otherwise, the new owner may, prior to its return, be required to establish his legal right to receive the work by proof satisfactory to the Museum.

3. The Museum will insure the work wall-to-wall under its fine-arts policy for the amount specified by the lender on the reverse against all risks of physical loss or damage from any external cause while in transit and on location during the period of this loan; provided, however, that if the work shall have been industrially fabricated and can be replaced to the artist's specifications, the amount of such insurance shall be limited to the cost of such replacement. If no amount shall have been specified by the lender, the Museum will insure the work at its own estimated valuation. The Museum's fine-arts policy contains the usual exclusions for loss or damage due to war, invasion, hostilities, rebellion, insurrection, confiscation by order of any Government or public authority, risks of contraband or illegal transportation and/or trade, nuclear damage, wear and tear, gradual deterioration, moths, vermin and inherent vice, and for damage sustained due to and resulting from any repairing, restoration or retouching process unless caused by fire and/or explosion. The lender agrees that, in the event of loss or damage, recovery shall be limited to such amount, if any, as may be paid by the insurer, hereby releasing the Museum, each of the participating museums, and the Trustees, officers, agents and employees of the Museum and of each of the participating museums from liability for any and all claims arising out of such loss or damage.

4. If the lender chooses to maintain his own insurance, the Museum must be supplied with a certificate of insurance naming the Museum and each of the participating museums as an additional assured or waiving subrogation against the Museum and each of the participating museums. If the lender shall fail to supply the Museum with such a certificate, this loan agreement shall constitute a release of the Museum and of each of the participating museums from any liability in connection with the work. The Museum cannot accept responsibility for any error or deficiency in information furnished to the lender's insurer or for any lapses in coverage.

5. The Museum assumes the right, unless specifically denied by the lender, to examine the work by all modern photographic means available. Information thus gathered will remain confidential and will not be published without the written consent of the lender. It is understood that the Museum will not clean, restore, or otherwise alter the work without the consent of the lender.

6. The Museum's right to return the work shall accrue absolutely at the termination of the loan. If the Museum, after making all reasonable efforts and through no fault of its own, shall be unable to return the work within sixty days after such termination, then, the Museum shall have the absolute right to place the work in storage, to charge regular storage fees and the cost of insurance therefor, and to have and enforce a lien for such fees and cost. If, after five years, the work shall not have been reclaimed, then, and in consideration for its storage, insurance and safeguarding during such period, the work shall be deemed an unrestricted gift to the Museum.

7. If the work is for sale and is sold during the period of this loan, the lender shall pay the following amount to the Museum to be used exclusively for the Museum's Art Purchase Fund: 5% of the selling price on a sale to another institution; on any other sale, 10% of the first $25,000 of the selling price and 5% of the selling price, if any, in excess of $25,000.

example, says in its agreement, "That if the work shall be industrially fabricated and can be replaced to the artist's specifications, the amount of such insurance shall be limited to the cost of such replacement."

If I leave work to be considered for open exhibition, will it be insured?

No. When you leave work for museum officials to consider for inclusion in a show, you'll receive a receipt. (The same holds true if you leave work for them to consider buying or accepting as a donation.)

The receipt usually informs you that the museum will not insure the work, nor will they pay for shipping and packing costs. Indeed, should you not pick up the work when notified, the receipt may state that the work will be shipped to you collect or stored at your expense.

On the more positive side, museums are liable by law for loss or damage if they fail to exercise proper care of the artwork (see Chapter 12 on bailments).

Will it be insured if selected for inclusion in the show?

Yes. When your work is selected for an exhibition, you'll be asked to sign a loan agreement—just as you are if you're invited to exhibit—which should promise to insure the work.

Will a museum charge a commission if it sells a work?

They will probably take a minimal commission; 10 percent would be about average.

If I donate artwork, can I take a tax deduction?

Yes, but if the work you're donating to a museum is your own, you may only deduct the cost of the material used to create the work—not the fair market value.

Only people donating works of others can claim a deduction of the fair market value.

If I donate a work of art, can I demand permanent display?

Museums don't like gifts with strings attached. In fact, most museums refuse to accept donations at all if restrictions are placed on them. So unless you're extremely influential, this demand—as well as any others, such as how work is to be displayed—will probably be denied.

How much of a discount will a museum ask for when buying?

The usual museum discount is 10 percent, although they might ask for more.

Can I demand to get first chance to buy back a work I sell?

Probably. This provision, of course, would come into effect only if the museum later decided to sell your work. Many museums routinely agree to this, so incorporate this requirement into your sales agreement.

Can I borrow back my work for exhibitions?

Most museums will go along with this practice. But if you want to insure their cooperation, make it one of the terms of sale after finding out what the museum's policy on this is.

If I sell a work, can I dictate display terms?

Not unless your clout is extraordinary—otherwise, you probably won't be able to get such a requirement into your sales agreement.

If I sell my work, will the museum want the copyright?

They may, but most likely they will simply want to be granted reproduction rights.

Will I get royalties for reproductions?

As a matter of courtesy, museums sometimes pay the artist a royalty on reproductions suitable for framing and on reproductions used on Christmas cards—although not usually on postcards—regardless of who owns the copyright, or even if the work is in the public domain. They'll also generally share royalties with an artist if they sell the reproduction rights to someone else. The only time they don't pay royalties is when the reproductions are made for educational purposes, such as slides for slide shows or book illustrations.

Despite their generosity, however, it's a wise idea to keep the copyright.

Why should I keep the copyright?

Because you might want to sell reproduction rights to others. You might also want to limit the uses the museum plans for reproduction. You will certainly give a museum "noncommercial" reproduction rights for use in catalogs. And you may willingly grant

them the right to reproduce your work for framed reproductions and Christmas cards to be sold in the museum shop. But you might not want to give them the right to translate your work into other mediums and objects such as tapestries, coasters, T-shirts, etc. So keep control over these rights by retaining copyright.

Will a museum make transparencies of my work for me if I own the copyright?

Yes, but they usually charge a hefty fee. Say, for example, a publisher plans to do a book on your work, and you are expected to furnish reproduction-quality transparencies. If some of this work is owned by a museum, they will charge you the same reproduction fee they charge anyone else. So make sure you make transparencies prior to delivery of work to a museum.

If I want to sell artwork through museum shops, will they buy or take it on consignment?

Museum shops buy most items outright, paying the artist a wholesale price usually equivalent to one-half the retail price. But they will also take work on consignment and charge the artist a commission of between one-third and one-half of the retail price. Another common practice is to offer a combination of purchase and consignment. For example, a shop manager planning to buy a line of jewelry from an artist will usually buy the less expensive items outright and take the more expensive pieces on consignment.

Eleven

THE CONTENT OF ART: CAN IT GET YOU INTO TROUBLE?

LIBEL

INVASION OF PRIVACY

FLAG DESECRATION

OBSCENITY

Times change, and so do fashions in art and law enforcement. In modern times Supreme Court justices have watched a lot of movies in the dark, and they have rarely come out smiling. Thus our bleary-eyed justices have pronounced from time to time—contradictorily—on the constitutional status of art. Art is protected by the First Amendment but obscenity is not. Nor is libel, invasion of someone's privacy, or desecration of the Stars and Stripes. The First Amendment guarantees everyone in this country freedom of speech, and art is legally considered either pure speech (for example, a mural or still life painting) or symbolic speech (for instance, a sculpture or construction using the flag). In general, an artist of serious intent need not fear criminal or civil charges because of what he or she puts on canvas or on a wall or in a gallery window, even when the imagery involves sex or nudity or public controversy.

But there are limits. Despite some improvement in obscenity law, it continues to be a can of worms. Technically, it is now an issue to be decided by juries in individual cases (and under the guidance of a judge's instructions). But there won't be a trial at all if the local police don't first exercise their own judgment and decide the offending display—be it innocent nudity or immodest

mischief—is not art but rather obscenity. And who can say when the high-mindedness of local community standards may become the moving force in a police vigilante action to "clean up" the community by seizing art or prosecuting artists? It doesn't happen every day, but it could happen someday. And the same legal vagueness and practical uncertainty are also present in the areas of libel, privacy, and flag desecration.

What is libel?

Everyone has the right to a good professional and private reputation, i.e., a reputation free from false and malicious injury by others. Causing such an injury by public utterance—a speech, a newspaper article, or an artwork—may be libel. If you paint a libelous picture but hide it in your studio, you won't be accused of libel because the offended party can't claim to have lost his or her good reputation in the eyes of business associates or the general public. But if it's exhibited or published, you may be in for trouble.

What sort of artwork would be libelous?

Libelous work depicts someone falsely in such a way that his or her reputation suffers. For example, a libelous work might depict someone as a drunk or as having a sexual problem. Or if you paint specific members of your local medical society dripping with blood and gore and grinning from ear to ear, these doctors will no doubt scream libel.

What if it is true?

If the depiction is a completely accurate portrayal and you can prove it, you would win your case if sued for libel. But proving what's actually true—not just what seems to be true—may be harder than you think.

How often are fine artists sued for libel?

Frankly, I've heard of only one case—but that doesn't mean it doesn't happen more often. For example, if you've painted a movie actress who is famous for playing ingenues as a common prostitute and called the picture *A Star on the Street,* it would be a good idea to hesitate before showing it in public. You may have meant it simply as a comment on the age-old combination of careerism and sex, rather than as a personal slur, but that doesn't matter. You might end up facing a libel suit even though you had no intention of maligning her.

What artists run the biggest risks of being sued for libel?

Cartoonists. In their exaggerated, humorous, or satirical treatment of public figures, they frequently walk a fine line between what's libelous and what's described as "fair comment."

What was the libel case you referred to?

The suit filed by Anthony Siani and Jack Silberman against Paul Georges (all three are New York artists). Here's the background: For years these three men had debated the question of whether art should be created for people (the position Siani and Silberman held) or for art's sake (Georges's philosophy).

To illustrate his viewpoint, Georges painted *The Mugging of the Muse* in 1973. It depicts two men, wearing masks resembling the faces of Siani and Silberman, mugging a woman, the Muse. The attack seems to have hurt the men, rather than the woman.

In a pretrial deposition, Georges said: "The Muse represents art, which is innocent, and as such, represents the artist. The picture demonstrates that one cannot hurt the Muse. Those who attack the Muse only hurt themselves and turn against themselves. The artist believes that the painting allegorically represents his view that when you attack art you attack yourself."

The painting was first seen by the public in *American Artist* in May 1974, accompanying an article I had written about the students of Hans Hofmann (Georges's teacher).

It was seen again when Georges gave a slide lecture in 1975 at the Association of Figurative Artists, a group all three belonged to. The audience laughed and shouted, "There's Siani, there's Silberman."

At this point, Siani and Silberman sued Georges for libel, saying the painting accused them of being violent criminals and damaged their reputations.

At the trial, Siani and Silberman asked the jury to believe that Georges had literally described the plaintiffs as criminals and was therefore guilty of libel. The jury agreed with them.

On appeal, Georges argued that the painting was part of a long tradition of allegorical art and as such could not carry the literal meaning the plaintiffs ascribed to it. Furthermore, the painting constituted an expression of opinion about Siani and Silberman's view of art and such a comment was protected by the First Amendment, which guarantees freedom of speech.

The appellate court agreed. It said that the plaintiffs could not prove that anyone at the lecture actually thought them to be criminals. More important, it said that the First Amendment did protect Georges's right to express his opinion.

What is fair comment?

The privilege of fair comment applies to statements in writing or artwork about well-known public figures or about unknown individuals who are unexpectedly thrown into public life (such as victims of crimes). Fair comment is similar to the right to freedom of the press. Anyone in the news can be legally subjected to a certain amount of ridicule or contempt by writers and artists, as long as the depiction remains a reflection of the person's performance in public life. When it goes beyond this, fair comment no longer applies. For example, a cartoonist might fairly depict a hawkish congressman as a warlord, but she'd better not portray him as susceptible to bribery and controlled by organized crime unless she's prepared to prove it.

Fair comment also protects art critics against suits by artists who don't like the way their art was reviewed. So forget about suing someone who said in print that your latest exhibition was a real bomb—you placed your work in the public spotlight, so it's open to fair comment.

What is invasion of privacy?

Under some state laws, the right to privacy prohibits the use of the name or image of any person for commercial or advertising purposes without his or her written consent. Violation of this right is known as invasion of privacy. The purpose of these laws is to prevent unscrupulous persons from exploiting the valuable names and pictures of people—usually public figures—to increase the sale of products without paying adequate compensation for use.

What does this mean to artists?

It means that commercial artists and photographers must get permission from their subjects before their artwork goes into an advertisement or on a commercial product. If you've painted a recognizable picture of Cher, for example, which is to be used on T-shirts, you'll invade her privacy if you don't get her permission.

If the person is dead, must you get permission from the heirs?

No. Privacy applies only to living people.

How do invasion of privacy laws affect the fine artist?

The implications of these laws for fine artists are much less clear than for commercial artists and photographers because there

have been hardly any cases. This in itself indicates that very little danger exists for the artist creating a work of art not intended for advertising or commercial purposes. In fact, at least one court has found that a serious work of art cannot represent an invasion of privacy with respect to a person depicted.

If I paint portraits of famous persons for magazine covers, must I get their permission?

No. Even though the picture will appear on a commercial product, you are protected by the doctrine of fair comment discussed above. You're allowed to paint any public figure or private individual who is somehow newsworthy as long as you don't libel him or her.

What if I paint portraits of public figures from photographs, for sale?

This could be invasion of privacy. Technically, you're painting these particular people because of the financial benefit involved, so you might be considered to be commercially exploiting them for your own gain. On the other hand, you'd probably be able to claim protection under the doctrine of fair comment. It doesn't seem as though any cases have resolved the issue, perhaps indicating its unimportance as a practical matter.

If a commissioned portrait I painted is rejected, should I get permission before I exhibit or sell it?

To be on the safe side, yes, get permission from the client, though it's not likely that the person who commissioned you would sue you for invasion of privacy. Nor could he sue you on these grounds in all states. In New York State, for example, the mere exhibition of a portrait is not sufficient to bring suit for invasion of privacy. But since state laws differ, it's a good idea to protect yourself by getting permission in writing from your client.

When would I sue someone for invasion of privacy?

When your name is used for commercial or advertising purposes. Take the example of the case of *Harry Neyland v. the Home Pattern Co., Inc.* Briefly, Neyland had authorized a magazine called *Arts and Decoration* to reproduce his painting. Some time later, an ad promoting patterns for embroidered pillows appeared in the *Ladies' Home Journal,* a magazine published by the Home Pattern Co. One of the designs resembled the painting in *Arts and Decoration.* The composition was altered slightly, but the text of

the ad baldly stated "The C. W. Morgan [a square-rigger] on the pillow comes straight from the painting by Harry Neyland."

Neyland sued for infringement of copyright on the painting, but he didn't stop there. He sued for invasion of privacy because his name had been used for purposes of trade, and he won.

When else should a fine artist worry about invading the privacy of his clients?

Anytime you plan to list the names of your private collectors in magazine copy, catalogs, programs, and so on, get written permission first. The collectors may not want their names published and could bring action against you if you do.

What's flag desecration?

The act of desecrating the American flag has never been defined once and for all, although many state and federal laws prohibit it.

What do these laws prohibit?

Most laws forbid mutilation and other unconventional uses of the flag, as well as casting contempt on it. The wording of a New York State statute is typical of these acts. It says: "Any person who . . . shall publicly mutilate, deface, defile, or defy, trample upon or cast contempt upon [the flag] either by words or acts . . . shall be guilty of a misdemeanor."

Don't flag desecration laws violate the First Amendment?

Sometimes. The courts have found certain ones unconstitutional, particularly those that prohibit the placement of symbols or writing on the flag.

Other courts have held that these statutes are justified in order to prevent a breach of peace or to protect the flag as a symbol representing national sovereignty.

Most flag desecration cases occurred during the Vietnam War—when many artists used the flag in unorthodox ways to protest U.S. military policy—and the sound and fury over flag desecration has abated. The *Radich* flag desecration case, which was decided in 1974, indicated that freedom of speech, as guaranteed by the First Amendment, is a higher priority than laws condemning flag desecration. This case should set a precedent for some years to come.

What did the court say in this decision?

The flag and that which it symbolizes is dear to us, but not so cherished as

those high moral, legal and ethical precepts which our Constitution teaches. When our interests in preserving the integrity of the flag conflict with the higher interest of preserving, protecting and defending the Constitution, the latter must prevail, even when it results in the expression of ideas about our flag and nation which are defiant, contemptuous or unacceptable to most Americans. United States ex rel. Radich v. Criminal Court of the City of New York.

What is the legal definition of obscenity?

The courts have been attempting to define obscenity for years. The latest definition is that sexually explicit material is legally obscene if a "reasonable person" would find that, taken as a whole, the work lacks serious literary, artistic, political, or scientific value.

What is meant by a "reasonable person"?

Unfortunately, the courts do not define a "reasonable person." Still, this concept of a "reasonable person" is better than previous Supreme Court rulings that allowed "community standards" to determine obscenity. Under those rulings, the courts permitted the least tolerant communities to determine what is of artistic or literary value.

What are the chances that a fine artist will be arrested for obscenity?

The chances are not very great that you will have problems with this. Works of art are usually considered serious attempts to express artistic concepts and sentiments and are thus protected by the First Amendment. So, even if your work contains nudes or even explicit sexual references, it's not likely that you would be arrested for obscenity. Law enforcement groups are more concerned with cracking down on sexually explicit books and magazines that are thrust on the public by aggressive sales campaigns.

Nevertheless, it can happen.

Do you have an example? Yes, in August 1974, Maine artist Russell Aharonian began work on a mural commissioned for a mall in Portsmouth, New Hampshire. In the past, Aharonian's mixed-media work had frequently included themes that some might consider erotic, and the shopping mall collage-mural was to be another step in the development of his work.

Except that he didn't get very far. On the day he began to work, some passersby noticed that some of the artist's collage-photos

were of nudes, and they felt the photos were erotic. By the end of the second day, their objections had brought out the police, who asked Aharonian to stop work. He did so. The police then seized various materials and covered the uncompleted mural with a huge dropcloth. A week later, when Aharonian returned to Portsmouth to reclaim his materials, he was arrested and charged with violation of the New Hampshire obscenity statute.

Sounds incredible, doesn't it? That a respected artist in the process of creating a work of art based on his own imagery could be charged with obscenity. It wasn't as if he were deliberately trying to titillate with pornographic images; the thought that he was being obscene, much less that he was committing a crime for which he could be arrested, had probably never entered his mind.

Aharonian's was not a landmark obscenity case. The police had pulled a real boner by seizing his materials without first fulfilling certain legal requirements (see below). Because of this technicality, the charge against him was dismissed and the question of whether his work was obscene never had to be decided.

Nevertheless, if your work depicts nudes or genitalia or is in some way erotic, you might think twice before you spend time and money mounting a show in an unfamiliar place, especially if the work is to be shown to minors or a captive audience.

Why does the presence of minors make an exhibition of my work more dangerous?

Some states prohibit the sale to minors of sexually provocative materials. In New York, for example, it's a crime to sell or offer for sale any art object depicting nudity, sexual conduct, or sadomasochistic abuse to anyone under eighteen.

What do you mean by a captive audience?

A captive audience is composed of people who, because of a specific situation, have no choice but to look at the obscene material. Court cases involving captive audiences usually refer to people who send out unsolicited sexually explicit materials through the mails, an enterprise most fine artists won't be engaged in.

But here's a case where a captive audience transformed an act of free speech into an act against the community. In 1970, an art instructor at the University of Massachusetts accepted an offer for a twenty-four-day exhibition of his works in a heavily traveled corridor in the Student Union. After the show was hung, considerable controversy arose over its sexual nature, and college authorities removed it after five days. The instructor charged the

officials with invasion of his constitutional rights and sued for an injunction ordering the officials to make the space available to him for the remaining nineteen days. Said the instructor: "Art is as fully protected by the Constitution as political and social speech."

The court disagreed. It said, rightly or wrongly:

There are words that are not regarded as obscene in the Constitutional sense that nevertheless need not be permitted in every context. Words that might properly be employed in a term paper about Lady Chatterley's Lover *or in a novel submitted in a creative writing course, take on a very different coloration if they are bellowed over a loudspeaker at a campus rally or appear prominently on a sign posted on a campus tree.*

The Court concluded: "Freedom of speech must recognize at least within limits, freedom not to listen." Or in this case, freedom not to look.

Can policemen seize my work if they think it's obscene?

Yes, but only if they have prepared for seizure with proper actions—procedural steps that the New Hampshire police in the Aharonian case evidently didn't think about. Before any seizure or confiscation of exhibited works of art for obscenity can take place, an impartial hearing must be held to decide whether there are grounds for seizure. And before the hearing, you should have advance notice and time to engage a lawyer. The notice should inform you of who is making the charges against you and, particularly, your work, and precisely what those charges are. Then you and your lawyer appear before an impartial judge to argue your case. At the hearing, the law enforcement officers who testify that the work is obscene must have seen the work—they can't rely on the word of others. Then the judge decides whether the work is obscene. Only after that can your work be seized; otherwise, seizure is unconstitutional, even if the police come armed with a search warrant.

What should I do if the police seize my work before a hearing?

If they're determined to have their way, don't resist them physically. Instead, protest orally that they're violating the First Amendment by not allowing you a hearing, and ask them to make a note of this in their records. As you saw from the Aharonian case, you now have a great defense. An impartial hearing is a must, no matter what.

What's my chief protection against charges of obscenity, libel, invasion of privacy, and flag desecration?

The First Amendment. Countercharging that your accusers violated your right to freedom of speech is an often-used defense. The First Amendment can also be used when you want to sue someone who censors or confiscates your work. Being arrested on an obscenity charge, for example, is a pretty rare event. But having some community or educational body censor your work isn't. From time to time, the newspapers report on a town council demanding the removal of an exhibition of nudes. The people involved don't want the artist arrested—they just want the exhibit taken down. In this case, you could charge them with violating "those high moral, legal and ethical precepts which our Constitution teaches" and *your* First Amendment right to freedom of speech.

Twelve

INSURANCE: GETTING WHAT YOU NEED

INSURANCE ON ARTWORK

VALUATION

INSURANCE ON THE STUDIO

WORKERS' COMPENSATION

GROUP PLANS

The following quote comes from one of the definitive books on art law, Feldman and Weil's *Art Works Law, Policy, Practice* (Practising Law Institute, New York): "Insuring works of art should be separated into three categories: (a) insurance for collectors; (b) insurance for dealers; and (c) insurance for museums." But what about insurance for artists? Not one mention is made of insuring an artist's work, although much of the book is devoted to the problems of the creators of art.

The reason is that, unlike most museums, galleries, and collectors, artists don't often have the luxury of deciding whether and to what extent they wish to insure their own art in their studios. Artists' insurance is hard to get because the insurance companies consider it too risky. Why? Insurance companies regard the security and construction of many artists' studios as poor, and the companies find it difficult to assign values to works by artists who have not established a market.

In other words, if you haven't sold enough work over a long enough period of time that you have plenty of evidence of what your work is worth, an insurance company cannot value it.

And that, in a nutshell, is why artists get short shrift on the subject of insurance. Nevertheless, it's an important subject to examine. Nonrelated insurance coverage for health and life isn't within the scope of this book, but, at the end of the chapter, the

names of organizations that offer protection to individual artists under group policies in these areas are listed.

What kinds of insurance should an artist consider?

Insurance on your artwork, on your studio, and on employees. Each will be described below.

What kind of insurance should I get for my artwork?

That will depend on the sort of risks you have. A risk can be anything that threatens your artwork, such as fire, theft, water damage, or vandalism. If your studio is in a wood building surrounded by other wood structures, you would want to insure against fire. If you live in a high-crime area, you'd want a policy for theft. You can insure against risks by purchasing individual policies for fire, theft, or whatever, or buying one all-risk fine arts policy.

What's an all-risk fine arts policy?

Although "all-risk" isn't a precise definition of this kind of insurance, it does protect your artwork against fire, theft, water, vandalism, and other major threats. Its standard exclusions are usually limited to such risks as war, nuclear damage, insects, vermin, wear and tear, gradual deterioration (from the weather, for example), damage to fragile items, and damage due to repairing or restoring.

Is it more economical to buy an all-risk policy or individual policies?

There's no question that one individual policy—for example, for fire—will be cheaper than an all-risk policy. But the premiums (the annual cost of the insurance policy) on several policies—one for fire, another for theft, and a third for vandalism—may cost more than one all-risk policy. In any event, shop around. Call up several different insurance agents or brokers and ask them the prices of different policies.

Is it a good idea to insure for just one risk?

It's very possible that you might want to insure only against fire. Most artists feel fire is the greatest threat to their work, and, to keep costs down, they opt for fire insurance only. An insurance broker told me, for instance, of an artist whose work sells in the

six figures who buys fire insurance only. Why? He recently bought a bank building to use for studio and storage space. With his paintings locked up in vaults, he's not worried about burglary or other dangers. But you don't need your own bank to regard fire as your biggest and perhaps only real risk.

Does a fire insurance policy cover my work out of the studio?

No, it doesn't. A simple fire insurance policy covers work only when it's in the studio. Therefore, before you lend work to a gallery or museum, you should make sure they have an insurance policy that would cover your loan.

Does an all-risk fine arts policy cover my work out of the studio?

Your policy can be written to extend coverage on artwork when it's in your studio, when it's traveling to shows, and when it's at its destination. In other words, you can extend coverage every time your work leaves the studio if you so desire.

An all-risk fine arts policy is a form of inland marine insurance, which is a type of insurance that can be tailored to fit your needs (unlike fire insurance). Inland marine may be an unfamiliar term to you, but it's a common type of property insurance. Originally written to protect goods in transit, inland marine insurance now covers a potpourri of valuable properties, such as jewelry, furs, and works of fine art. Collectors, for example, insure their artwork under a form of inland marine insurance called a "personal articles floater."

What is a personal articles floater?

A personal articles floater is a type of insurance that covers individual pieces, each of which must be appraised and its value written into the policy.

Does a collector always use a personal articles floater?

No, he might insure his artwork under his homeowner's policy, which insures his residence and its contents as a whole against a number of risks for a lump sum—$50,000 for the house and $30,000 for the contents, for example. But if he wants broader coverage against more risks or occasionally sends part of his collection to exhibitions, he would get a personal articles floater. Also, if he wants to make sure a claim for loss or damage of a work is paid in full, he would get a personal articles floater for fine arts.

Can I insure my artwork under a personal articles floater?

No. A personal articles floater, which is relatively cheap compared with the all-risk fine arts policies bought by artists, is not suitable for you—your work is classified as business, rather than personal, property.

You could easily take out a personal articles floater; I know brokers who do insure artists' unsold work this way. They reason that the insurance carrier won't know whether the work is business property or work you plan to keep personally. Unfortunately, though, a problem arises when you try to collect a claim. If the claim is small, you might get away with this subterfuge. But if it's large, you can expect a penetrating examination by the insurance company, followed by the rejection of your claim.

Why do I have to establish a value for my work?

For two reasons. First, you must establish a value for work in order to buy an all-risk policy. Most all-risk fine arts policies insure individual pieces in the same way that artwork is insured under a personal articles floater. This means that a value must be assigned to each work before it can be written into a policy. If you can't establish the value of your artwork, you won't be able to insure it with an all-risk policy.

Second, if you buy fire insurance instead of the all-risk policy, you must establish a value to guarantee that claims will be paid. Establishing a value prior to the purchase of a fire insurance policy isn't necessary—theoretically, you can buy fire insurance for any amount you want as long as you're willing to pay the premiums.

Can you illustrate this? Suppose you have at any one time twenty paintings in your studio, and you think they're worth $500 a piece. You can probably easily buy a fire insurance policy that insures them for $10,000. But should you have a fire, the insurance company won't necessarily pay $10,000 if all the work is destroyed. The company isn't going to accept your word on what the work is worth—it will demand objective proof of its value.

How do I establish this value?

If you sell regularly and you or your dealer can produce the bills of sale to prove the prices you're accustomed to charging and getting, you should have no problem establishing values.

If you don't sell regularly, you might as well forget about insuring your artwork.

What do you mean by selling regularly?

There's no way of knowing what an insurance company will call a consistent sales record. When you buy insurance, you have to negotiate with the insurance company officials over terms, and they hold the upper hand. They can, for example, decide that your work isn't worth insuring at all because of the hazardous conditions you live in. And in the same vein, they may decide that a brief sales record of a small number of works isn't a consistent sales record. You can point out that a three-year record of ten sales a year of $1,000 paintings can't be compared to the sales record of some other products and that ten paintings isn't a bad sales record in the art market. And you may convince the company. The point is you have to sell them on the fact that your work is valuable and should be insured. If they don't agree, you'll have to forget the insurance.

How do I prove that work has been lost or destroyed?

By keeping accurate records as outlined in Chapter 3. Otherwise, you'll have no proof of work if it is destroyed or stolen. So as soon as a work is finished, photograph it and assign it an inventory number. Then record the date completed, size, medium, tentative selling price, and any other relevant information. *Be sure to store these records in a safe place outside your studio.*

How much should I insure my work for?

If you can't afford—or don't want—to pay the premiums on a policy that would totally insure your work, decide how much work you think you can afford to lose. In other words, figure out how easy it would be to replace lost or damaged work.

But if you plan to carry fire insurance only, before you decide to insure for less than the full value, consider the concepts of co-insurance and how much you're *really* insuring your work for.

How much am I really insuring my work for?

You probably think that when you insure $20,000 worth of work against fire for less than the full value, for $15,000, for example, and all the work is destroyed in a fire, you'll receive $15,000. That's true. But you might also believe that if only part of the artwork is destroyed by fire, say $10,000 worth, the insurance company will pay you $10,000. Not true.

Many states have laws requiring you to insure a certain percentage of the value of the property—usually 80 or 90 percent—to

receive the full amount for a partial loss. If you don't comply with the state requirement, you'll bear some of the loss, thus becoming a co-insurer of a certain percentage of the work.

What's a co-insurer?

If you don't comply with state requirements, you'll end up paying some of your partial loss yourself (co-insurance). To figure out what that amount or percentage is, divide the amount of insurance you bought by the amount of insurance required by law (ask your agent) and multiply the resulting percentage by the amount of the partial loss.

Suppose your artwork is valued at $10,000. If, according to state law, you must insure 80 percent of it to receive the full amount of a partial loss, you should insure it for $8,000. If you only insure your work for $6,000 and then sustain a fire loss of $4,000, the insurance company will pay only $3,000 ($6,000 divided by $8,000 = 75 percent, and 75 percent of $4,000 = $3,000). This means you're a co-insurer of 25 percent of the partial loss.

If I don't insure my work, can I deduct its loss from my income tax?

If a work is stolen or destroyed by fire or whatever, you can deduct from your income tax only the cost of the raw materials that went into the work. Thus, if your works sell for about $1,000 each, but each one costs only $50 to make, you can only deduct $50 each if your works are destroyed in a fire.

If I have insurance, can I deduct the loss from my income tax?

On the contrary. Any insurance money you receive for a claim that exceeds the cost of raw materials must be reported as income on your tax return. So if an insurance company pays you $500 for a painting that cost you $5 for paint and canvas, you'll have to report $495 as income. Of course, your insurance premiums are tax-deductible as a business expense.

How much will my dealer insure my work for while it's in his gallery?

That depends on your agreement. He may not insure it at all, or, if he does, it may be for less than the retail selling price. You should aim for an agreement that states that he'll insure the work for what it's worth to you, i.e., retail price minus his commission. And you should ask to be named a payee of his insurance policy.

What about insuring a work I lend a museum for an exhibition?

Be sure to ask if the museum will insure your work, whether its policy is all-risk, and whether its coverage is wall-to-wall. If the answers are negative, and you have an all-risk fine arts policy, you might want to ask your insurance broker to extend your coverage to insure the work while it's in transit and/or at the museum. If you have only fire insurance and want to extend your coverage, ask your broker to see if you can get some inland marine insurance on your artwork that will protect it while it's traveling and while it's at the exhibition.

What is wall-to-wall coverage?

Wall-to-wall coverage means that under the museum's all-risk fine arts policy, work is insured from the moment it leaves your wall until it returns.

If I lend a museum work with no contract, is the museum responsible for it?

Yes, even if it's not provided for in a contract, the museum can't shirk all responsibility. Under the law, anyone who agrees to hold someone else's property in a situation where both parties benefit from the arrangement is responsible for the loss or damage of the property if he or she is guilty of negligence (failure to exercise reasonable care). This situation is called a "bailment" in legal terms.

When else does a bailment exist?

There are many situations that qualify as bailments, but here are two that would have particular relevance for the artist: when you leave a painting for framing or restoration, and when you leave a portfolio or work at an advertising agency.

Is a bailment created if I leave work at a museum or with a dealer for consideration for a show?

Yes, but it might be considered a different type of bailment than the one discussed above that benefits both parties. You can also have a bailment where one party agrees to hold someone else's property but only *one* of the parties benefits. In this case, the holder of the property is responsible for loss or damage only if he or she is guilty of gross negligence, which is harder to prove than plain negligence (see below). A museum or gallery might argue that if you simply left work for consideration, the bailment existed

only for your benefit. Most courts, however, would probably find that because of the nature of their business, museums, galleries, and agencies all benefit from the ability to see potentially acceptable work. If that were the decision, you would have to prove negligence—not gross negligence.

What's the difference between negligence and gross negligence?

It's a matter of degree. Negligence may be considered as a failure to exercise reasonable care; gross negligence would be the complete failure to exercise any care. Once again there are no hard and fast rules that define these terms on a practical basis. But, for example, negligence might occur if work left for consideration by a museum was not put safely away but left in a hallway where it was damaged. Gross negligence usually occurs only under the most extreme circumstances. To take a rather absurd example, gross negligence would occur if the museum decided to store your work in the incinerator room, where it was destroyed.

Can I insure my studio at the same time I insure my artwork?

Yes, if you plan to buy only fire insurance. Your fire insurance policy would describe the property insured by the policy as your studio and its contents, which consist principally of fine artwork. If you want to insure your studio against other risks, you'll have to buy separate policies.

Where can I get a break on fine art insurance coverage?

Artists Equity Association offers a group program of relatively low-cost fine art insurance that covers an artist's work while it is in the studio. Up to 50 percent of the coverage applies when the artwork is either off your premises—on approval for purchase; out for restoration, framing, or casting; and, if necessary, at galleries—or in transit within the United States and Canada. Special coverage can also be provided for international shipments and/or for locations abroad.

Write: Artists Equity Association, P.O. Box 28068, Central Station, Washington, DC, 20005.

What kind of insurance do I need for my studio?

First of all, let's get a few facts straight. Your studio is a place of business, and all places of business should be protected by property insurance and casualty insurance.

What is property insurance? Property insurance protects against loss

or damage to buildings and/or their contents. Fire insurance is property insurance; so is burglary insurance.

What is casualty insurance? Casualty insurance protects against bodily injury to anyone on your property and is called liability insurance. If you have clients or tradespeople coming to your studio who might fall down stairs or slip on wet paint or injure themselves in some way, you'll want a business liability policy.

How do I get these types of insurance?

There are several ways to acquire these types of insurance coverage. Let's assume that your studio and your home are separate. As mentioned above, if you plan to insure your studio and your artwork for fire only, you could buy one fire insurance policy for the building and contents and one business liability policy.

If you want to insure the studio against a number of risks—fire, burglary, and water damage—you might be able to buy a combination of these property insurances plus business liability. This combination is called a commercial package policy. Most commercial package policies exclude property held for sale. Since your art is for sale, you won't be able to insure it under the commercial package policy—you'll have to purchase a separate policy for your artwork.

What if my studio is in my home?

If you own or rent a home, you'll undoubtedly cover it with a homeowner's policy. Homeowner's insurance is also a combination or a package of property insurance policies plus personal liability.

Now, if your studio is in your home and represents a smaller portion than the living quarters, you would probably be eligible for coverage of your studio by attaching to your homeowner's policy an "incidental studio endorsement," in insurance jargon.

Similarly, if your studio is in a loft and takes up most of the space, leaving just a small living area, you might opt for a commercial package with an "incidental residence endorsement." In either case, you must insure your artwork separately.

Is there another time I would buy business liability insurance?

Yes, if you're planning a large-scale project for which you're assuming the risks. Painting a mural on the outside of a building is a prime example of such a project, as injury might occur to the public if a paint can falls on a passerby or a car, or if a scaffold

collapses. In fact, if you're planning to use scaffolding, your state laws may demand insurance against both bodily injury and property damage. Check out these scaffolding laws with your local authorities, starting by inquiring at your city hall or asking someone at the firm that's renting you the scaffolding equipment. Then describe your project in detail to your insurance broker and ask him or her to get you a short-term insurance for the duration of the project.

When would I want workers' compensation insurance?

When you hire someone. By state law, you're required to provide workers' compensation insurance on all employees in case they're injured on the job. Information can be obtained from your state department of labor.

Do I have to insure volunteers?

It's hard to say. According to *Mural Manual* (Rogovin, Beacon Press, Boston), a book describing the ins and outs of public mural painting:

Even if the team is all volunteer, you may well be liable if any team member is injured. This is a "gray area" that you should go over with a lawyer in relation to your project. You may find it necessary to buy Workmen's Compensation or some other type of insurance to cover volunteer workers.

Is a group health or life insurance plan better than an individual policy?

Sales and administrative costs are significantly less when an insurance broker sells one plan to a group of many individuals rather than many plans to single parties. Furthermore, a group plan allows the insurance company to spread its risks over a far broader base than it can with an individual policy. For both these reasons, insurance companies charge individuals participating in group plans much smaller premiums.

What organizations offer group insurance plans for artists?

For life insurance, contact:

American Institute of Graphic Arts,
1059 Third Avenue, New York, NY 10021

Artists Equity Association, P.O. Box 28068,
Central Station, Washington, DC 20005

College Art Association of America,
149 Madison Avenue, New York, NY 10016

Graphic Artists Guild,
30 East 20th Street, New York, NY 10003

For health insurance, write to:

American Craft Council,
40 West 53d Street, New York, NY 10019

American Institute of Graphic Arts,
1059 Third Avenue, New York, NY 10021

Artists Equity Association, P.O. Box 28068,
Central Station, Washington, DC 20005

Artists Equity Association of New York,
32 Union Square East, New York, NY 10003

College Art Association of America,
149 Madison Avenue, New York, NY 10016

Foundation for the Community of Artists,
280 Broadway, Suite 412, New York, NY 10007

Graphic Artists Guild,
30 East 20th Street, New York, NY 10003

To compare, write these groups for more information. In some cases it is not necessary to be a resident of the area in which the organization is located, but you must be a member.

Thirteen

BOOKKEEPING MADE EASY

INFORMAL RECORDS

FORMAL RECORDS

CASH ACCOUNTING

EXPENSES

Chapter 3 discussed the records you should keep to catalog your work as a reference on costs, techniques, collectors, and so on, and to offer as proof in case of loss or theft or infringement of copyright. But these records represent only half of your bookkeeping chores—another kind of record must also be kept for tax reasons.

Before launching into a discussion of tax records, however, let me point out that I realize that you probably have a job to supplement the income you make as a self-employed artist. And to compute your taxes, you'll want to keep records pertaining to your job, like the stubs from your salary checks, as well as records involving your personal life, such as medical bills. This book, however, deals only with records kept on income made and expenses incurred from your self-employment.

Why I should record business income and expenses?

Records of business income allows you to figure out your yearly taxable income.

Records of business expenses are the supporting evidence you need to back up claims for tax deductions if you are ever questioned by the IRS. Furthermore, they're invaluable as an aid to making a complete list of deductions. Without them to jog your memory, you may forget about certain expenses altogether when you're preparing your tax return.

What do you mean by tax deductions?

The IRS allow you to deduct business expenses connected with

your self-employment from your income before you compute the tax on it.

What kind of records back up deductions?

According to the *Audit Technique Handbook for Internal Revenue Agents,* you are required to keep two types of documents: informal records and formal records.

What are informal records?

Informal records are all the papers you receive in the course of business. These would include cancelled checks, bank statements, and bills and receipts you receive for goods and services you've bought. If you're meticulous, you'll save movie stubs from films seen in connection with your artwork and cash register receipts for supplies, no matter how small the amount.

You may need several records to document an expense. A check alone isn't always accepted as proof by the IRS, particularly if the amount includes nonbusiness expenses, so make sure you get an itemized bill or receipt whether you pay by cash or check. In any case, all receipts and bills should record the appropriate dates, describe the time or service paid for, and be stored in a safe place. They can also be cross-referenced with checks. For example, on every bill you pay you might want to write, "Paid by Check No.——," and the date.

Should I have a separate bank account for my self-employment?

Absolutely. There's no better way to maintain accurate records than to deposit all income earned through self-employed activities in one account and pay for all expenses out of that same account. Otherwise, business and personal records can get mixed up. And if you support yourself from self-employment, write yourself checks from your business account for personal use, putting notations on your checks indicating what they are for. In this way, you'll have a record of withdrawals made to finance personal expenses without cluttering up your business account with checks written for personal items.

Should I pay most expenses by check?

Definitely. The endorsed cancelled check may serve as a receipt as long as it isn't written out to you or to cash. So don't cash a check first and then pay a bill.

And while we're on the subject of checks, an easy record-keeping device is the voucher check. Voucher checks, which are

available from your bank, provide spaces for the date of the bill, the items covered by the check, and their individual costs.

How do I keep receipts and bills?

One efficient system is to set up an alphabetical file with such headings as "Entertainment," "Supplies," "Travel," and so on. Another way would be to collect receipts and bills by the month.

Should I keep receipts from trips? Yes, but this doesn't have to be difficult. Gathering receipts when you go on a trip can be easy if you put them all in one envelope as you go along. When you return home, file them alphabetically or simply summarize the contents of the envelope on the outside, seal it with the receipts inside, and put it in the proper file.

What about receipts for tolls and gasoline? They can be collected in a similar way by keeping an envelope in your car at all times, along with a memo pad for recording mileage and expenses, such as parking, when receipts aren't available.

What kind of formal records must I keep?

Records that list or summarize income and expenses should be kept by either single-entry bookkeeping or, if necessary, double-entry bookkeeping.

What is single-entry bookkeeping?

Single-entry bookkeeping is any system that lets you list all of your expenses as they're incurred so you can add them up at the end of the year. All you need to say about most expenditures is how much they were and what they were for. Expenses for travel and entertainment must be accompanied by a few more details, which will be discussed a little later.

Where do I record this list of expenses?

In a simple pocket diary, if you like. Though it might seem that a diary would be just about the poorest possible way to substantiate tax deductions—after all, what's listed there depends on what you elect to write—it has the stamp of approval from both Congress and the IRS. The Internal Revenue Code and the IRS regulations both also mention a diary as the accepted way to substantiate entertainment expenses of less than $25 that aren't backed up by receipts.

More elaborate file systems can be found at any stationery store. Some systems provide separate columns for recording travel and

entertainment expenses; others may combine a log to record monthly expenditures and income with a filing system for your informal records.

What is double-entry bookkeeping?

Double-entry bookkeeping is a much more complicated system involving ledgers and journals in which every item is entered twice—once as a debit and once as a credit—so the books are always in balance. The only reason you would undertake such a sophisticated system would be if you ran a business, such as a craft store, where you would be recording checks from different accounts and making many disbursements to pay expenses.

In other words, it's the number of transactions that dictate the type of bookkeeping system you would use. The more transactions, the greater the chance of error in recording. The chief advantage of a double-entry system is that it checks itself—any errors in arithmetic or recording are revealed by "unbalanced" books and can be corrected at the end of each accounting period.

When do I record income and expenses?

This depends on the accounting method you plan to use—the cash basis method or the accrual method.

What's cash accounting?

Cash accounting is the simplest and most frequently used method of accounting, and it's the best for artists keeping single-entry books. Under this accounting system, you record income when you receive it and expenses when you pay them. So if you sell a painting in November but your client waits until February to pay, you record the income in February. Expenses are treated the same way. If you buy supplies in December but hold off payment until January, the expense would be reported in January.

What is accrual accounting?

Under the accrual method, income is recorded when "earned," not when received, and expenses when incurred, not when paid. "Earned" here means that by your performance you've "earned" the right to receive payment. If you sold a painting to a client in November, you earned the income then. Even if the buyer doesn't pay until January or pays in installments, your records must show that income was received in November.

The purpose of accrual accounting is to match up expenses more accurately with the income they produce, but cash account-

ing is more convenient and allows greater flexibility in adjusting income for tax purposes.

Is there any reason I might have to use accrual accounting?

Yes, if you run a business that involves the maintenance of large inventories—if you make and retail, for example, large unnumbered editions of ceramics—the IRS might require you to adopt at least a partial accrual accounting system. But until the IRS demands this, or unless your accountant believes for some reason that accrual accounting will improve your tax position, forget it. As a general rule, you have nothing to gain from accrual accounting.

How can cash accounting help my tax position?

If you want to increase your income to eliminate the possibility of the IRS calling your art a hobby (see Chapter 14), you could put off paying bills while asking clients to pay early. In other words, you might be able to persuade collectors to whom you sold your work in December to pay right away, instead of waiting for the first of the following month. At the same time, you could delay paying for that new kiln you just bought until after the first of the year. This might result in a profit for the year, and the IRS will probably not classify you as a hobbyist if you made a profit in three out of five consecutive years. If, on the other hand, you want to reduce your taxable income, you could reverse the process by asking clients to delay payment until after January 1, while you pay as many bills as possible.

But here's a word of caution. Dating your checks "December 31" doesn't automatically entitle you to claim the deduction for that year. To be valid, your checks must be *in the mail* on or before December 31.

Are there any bills I can't pay in advance?

You can pay anything in advance, but you can't claim a deduction for the prepayment of interest on loans, premiums on business insurance, or rent. They can only be deducted in the year they were incurred.

What expenses do I record?

Record the following:

1. Legal and accounting fees relating to your self-employment.

2. Premiums for business property insurance and for casualty insurance.

3. Supplies.

4. Postage.

5. Publications and professional journals that keep you abreast of professional developments.

6. Books that relate to your work.

7. Admission to theaters, films, museum exhibitions, and other artistic events that relate to your work.

8. Training in classes necessary for maintaining or improving skills.

9. Promotional expenses (ads, brochures, press releases, photography, and so on).

10. Capital expenditures (explained below).

11. Rent, utilities, and upkeep of a rented studio, if separate from your house; or mortgage interest payments, property taxes, upkeep, and utilities on a separate studio you own. (See below for how to divide up the expenses if you live and work in the same building.)

12. Telephone bills. (These too must be separated from personal bills.)

13. Local transportation.

14. Travel.

15. Entertainment.

What are capital expenditures?

Any item bought for business reasons that has a useful life for you of more than one year is considered a capital expenditure. The purchase of a building, a car, a camera, an easel, are all capital expenditures. Inexpensive items, even if they last a lifetime—such as palette knives—aren't considered capital expenditures.

What makes capital expenditures different from other expenses? They can't be deducted in one year, but must be deducted over a number of years. (This is called depreciation and will be discussed in Chapter 14.) Nevertheless, even though the full price can't be deducted right away, record the purchase in your records so you won't forget it.

How do I divide up expenses for a studio in a space used for both working and living?

This can be done in one of two ways: by rooms or by square footage, whichever is more advantageous to you. For example, the deduction for a one-room studio in a six-room house or apartment might be calculated as one-sixth the rent and expenses. But if the room used for the studio equals one-third of the square footage of the house, you would deduct 33 percent. Therefore, in the latter case, if your rent is $300 a month, you would claim $100 plus one-third of the utilities and upkeep as business expenses.

What if I own my own home? If you own your own home, you can claim as a business expense a portion of the depreciation (discussed in Chapter 14), the mortgage interest payments, the property taxes, and a portion of the utilities and repairs, such as plumbing, roofing, and guttering. But don't be greedy—the IRS won't accept all repairs as business expenses. If, for example, you have your driveway repaired, the IRS will consider this a legitimate expense only if clients visit your home-studio on a regular basis and leave their cars in your driveway. But if you use the studio solely to paint in and receive no business visitors, driveway repair is not a legitimate expense. (Not everyone can deduct studio expenses—be sure to read about them in the next chapter.)

How do I divide up telephone expenses?

To figure out how much of your phone bill is for business and how much for personal purposes, keep a pad by the phone for two months—neither your busiest nor your slowest business months—and write down all the calls you make, both local and toll. Ask your family to do the same. At the end of the two months, figure out the ratio of business calls to total calls for *each month*. Then take the average of the percentages. If one month 60 percent of the calls were for business, and the other month only 50 percent were business calls, you would claim 55 percent of your phone bills as a business expense.

Should I have a separate business phone? If business calls predominate, maybe you should have one, as the cost would be fully deductible. This precaution might be a good idea since IRS agents have been known to be real sticklers on the subject of telephone expenses.

What do you mean by local transportation?

Any business travel in a local area that does not represent

commuting back and forth to your studio. If you have a separate studio, the cost of getting there in the morning and back in the evening is not deductible. If your studio is located in your house, however, and you go out on appointments—to your dealer, then a framer, and finally a client—travel to your first appointment and back from your last one as well as all transportation in between is a deductible expense. (This is assuming, of course, that you have no other job to commute to.)

A notation in your diary describing such travel might look like this:

June 15
Appointment with Mrs. Jones in Larchmont for portrait sitting. Tolls and parking, $6.75; gas, $5.00 (cash).

Can I claim other expenses for my car?

Yes. Besides gas, oil, tolls, and parking, you can also deduct depreciation (see Chapter 14) and percentages of the maintenance, insurance, tires, and so on. Just make sure you get receipts for all these expenses.

Is there an easier way to calculate car expenses?

Yes. First, determine the number of miles you drive your car strictly for business each year. Then multiply the mileage by the IRS automobile mileage allowance (which changes from time to time; check the current rate with the IRS). The IRS mileage allowance is a cost estimate of what you spent per mile in gas, oil, maintenance, insurance, depreciation, tires, car washes, and so on.

Which way is better?

The mileage allowance is much easier to figure out, although it isn't as generous as it should be, and IRS authorities say that if you do a lot of driving for business—say 30,000 to 40,000 miles a year—you should make the computation both ways and pick the most advantageous calculation.

If I use my car for business and personal reasons, how do I divide up these expenses?

As a general rule, taxpayers who use cars for both business and pleasure are required to keep "adequate, contemporaneous records" (IRS jargon) of their business usage to qualify for tax credits and deductions.

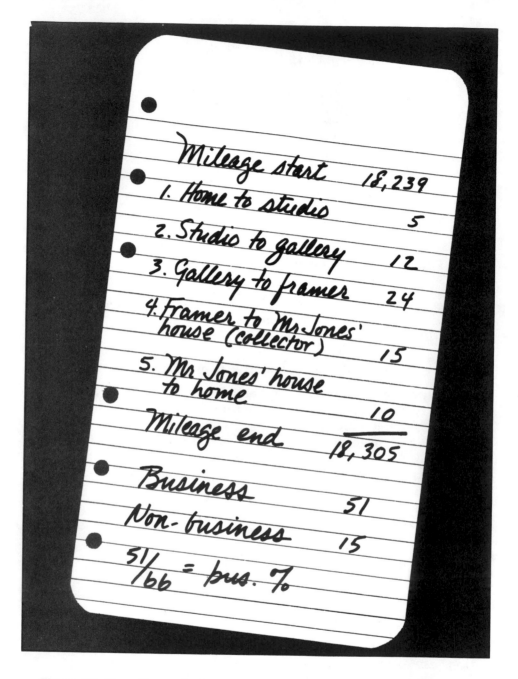

Figure 12. By making a simple entry into a diary every day, you can validate your auto expenses in the eyes of the IRS. This is an example of such a daily log.

So keep a diary handy in your car to record your daily business travel. The log or diary must include beginning and ending odometer readings, the persons you saw, and the business purpose of each trip. As the IRS says, log it or lose it.

When I travel, what expenses should I record?

You should record air, bus, train, and other fares to get you to and from your destination; taxis and other fares while you're there; your own automobile expenses, if you brought your car; food; lodging; tips; cleaning; telephone; and anything else you can think of. In other words, anything that costs you money while you're on a business trip.

Expenses under $25 need not be backed up by receipts (try to get them anyway, if you can), but all food expenses over $25 and all lodging, no matter what the cost, must be documented by itemized receipts that include the name and address of the hotel or restaurant.

How do I describe travel expenses in my records?

A description of travel expenses should include a day-to-day listing of expenses, plus the means of travel and the reason for the trip. A record of incidental expenses under $25 for the first day of a two-day trip might look like this in your diary:

June 28
Trip to Original Prints Atelier in Chicago to approve and sign edition of prints.
Tolls to airport, $1.50. Porter, $1.00. Taxis in Chicago, $6.55. Bellhop and room-service tips, $3.00. Lunch, $4.50.

What if the trip is both business and personal?

If the trip is primarily a business trip, you would record the fare to and from your destination, plus all other expenses, eliminating those that relate solely to the personal part of the trip. If, for example, you spent Monday through Friday talking to dealers and clients and the weekend visiting relatives, returning home on Monday, you should record everything but the weekend hotel and food bills.

If the trip is made primarily for personal reasons, record only the expenses involved in transacting business at your destination, such as restaurant bills and taxi fares.

Trips combining business and pleasure outside the United States are sometimes governed by more stringent regulations. If

you're planning a trip abroad, check with the IRS to see how much you can claim as a deduction.

What if my spouse comes along? Eliminate his or her expenses, even if it's solely a business trip. But you don't have to go overboard. If, for example, you take a $50 double room, you could claim the single-room rate, which might run $35, as a legitimate expense. You don't have to split the bill down the middle.

What about days that I'm away but can't conduct business?

Provided they aren't used for personal reasons, you can deduct expenses for these days if they're the results of unavoidable layovers, holidays, and weekends between business days.

Should I record expenses for a trip made to secure new galleries in distant cities?

By all means record them, although you may run into resistance on the part of the IRS in accepting them as a deduction, even though travel or entertainment for the purpose of seeking out new business is a legitimate business expense. If you're making a profit from your self-employment, you probably won't be questioned about this. But if you're not making a profit, you may be considered a hobbyist (see Chapter 14) and not a professional artist. In this case, the IRS may reject your right to deduct business expenses that exceed the income you earn from selling art. To counteract these charges, back up your claim with another type of informal record not mentioned before: letters.

What kind of letters? Letters to and from dealers, clients, publishers, and other business associates that discuss the purpose of your trip. So if you write letters to galleries saying you'd like to show them your work on a certain day, stash the carbon copies away in your informal records file, along with their responses. Letters help establish the legitimacy of your expenses and should be retained not only by the not-yet-profitable artist but by the successful artist as well.

Should I record travel expenses for trips made to distant places to pursue my art?

Yes. If you decide, for example, to paint landscapes of the national parks, go ahead and record the expenses involved. Once again, however, you may run into the problem of justifying them to the IRS if you're not making a profit.

Should I record day-trip meals?

No. You can't deduct out-of-town dining unless you stay overnight. Of course, if you take a client out to dinner, you could probably deduct part of the cost as an entertainment expense.

How much of the cost can I deduct?

You are limited to 80 percent of business meals and entertainment.

How do I record entertainment expenses?

Note the amount spent, the date, persons entertained, their business affiliations, where entertained, type of entertainment, and reason for the entertainment. Furthermore, since the IRS requires that these expenses be "directly related to or associated with the active conduct of your trade or business," you must discuss business before, during, or after your meal. You will no longer be able to deduct the cost of "goodwill" entertaining, such as a lunch with a potential client, unless business was actually discussed. So keep a record of what business topics you talked about.

How long should I keep my records?

For tax purposes, bills, receipts, and diaries justifying noncapital expenditures must be kept a minimum of three years after the date you file the tax return reporting them. Records of capital expenditures (real estate, cars, equipment, and so on) should be retained as long as you own the property.

Fourteen

HOW TO PAY YOUR INCOME TAXES

SCHEDULE C
BUSINESS INCOME
BUSINESS EXPENSES
HOME-STUDIO DEDUCTION
DEPRECIATION
HOBBY-LOSS PROBLEM

O kay, you've played by the rules all year long, scrupulously hoarding every scrap of evidence documenting payments and income and faithfully recording them in your diary. Now it's almost April 15—time to transfer these figures onto your tax return. But first let me say something about tax returns in general.

When you file an income tax return, you use Form 1040, *The U.S. Individual Income Tax Return* (see Figure 13). For some people, this one form is enough. But a number of other people, because of circumstances peculiar to their personal lives or the way they make money, must fill out one or more schedules or other forms to accompany Form 1040. For example, if you had enormous medical bills in any one year, you would itemize them on Schedule A instead of taking the standard deduction on Form 1040. You also deduct interest on mortgage payments and other taxes, such as property taxes, on Schedule A.

This chapter will teach you how to handle those portions of the tax return that deal with your self-employment. This mainly involves Schedule C, the *Profit or (Loss) from Business or Profession* statement (see Figure 14), the schedule on which you itemize business deductions and enter income from self-employment.

One final note: Tax laws keep changing. We had a major revision in 1986 that lowered tax rates while eliminating many tax loopholes. But minor changes occur every year as Congress passes

Form 1040 Department of the Treasury—Internal Revenue Service **1987** (O)

U.S. Individual Income Tax Return

For the year Jan.–Dec. 31, 1987, or other tax year beginning _____, 1987, ending _____, 19 _____ | OMB No. 1545-0074

Label

Use IRS label.
Otherwise,
please print or
type.

Your first name and initial (if joint return, also give spouse's name and initial)	Last name	Your social security number

Present home address (number and street or rural route). (If you have a P.O. Box, see page 6 of Instructions.)	Spouse's social security number

City, town or post office, state, and ZIP code	For Privacy Act and Paperwork Reduction Act Notice, see Instructions.

**Presidential
Election Campaign** ▶

Do you want $1 to go to this fund? | Yes ☐ | No ☐ | **Note:** Checking "Yes" will not change your tax or reduce your refund.
If joint return, does your spouse want $1 to go to this fund?. . | Yes ☐ | No ☐

Filing Status

Check only
one box.

1 ☐ Single
2 ☐ Married filing joint return (even if only one had income)
3 ☐ Married filing separate return. Enter spouse's social security no. above and full name here. _____
4 ☐ Head of household (with qualifying person). (See page 7 of Instructions.) If the qualifying person is your child but not your dependent, enter child's name here. _____
5 ☐ Qualifying widow(er) with dependent child (year spouse died ▶ 19 ____). (See page 7 of Instructions.)

Exemptions

(See
Instructions
on page 7.)

If more than 7
dependents, see
Instructions on
page 7.

Caution: If you can be claimed as a dependent on another person's tax return (such as your parents' return), do not check box 6a. But be sure to check the box on line 32b on page 2.

No. of boxes checked on 6a and 6b ▶ ☐

6a ☐ Yourself 6b ☐ Spouse

c Dependents

(1) Name (first, initial, and last name)	(2) Check if under age 5	(3) If age 5 or over, dependent's social security number	(4) Relationship	(5) No. of months lived in your home in 1987
		:		
		:		
		:		
		:		
		:		

No. of children on 6c who lived with you ▶ ☐
No. of children on 6c who didn't live with you due to divorce or separation ▶ ☐
No. of parents listed on 6c ▶ ☐
No. of other dependents listed on 6c ☐

d If your child didn't live with you but is claimed as your dependent under a pre-1985 agreement, check here . ▶ ☐
e Total number of exemptions claimed (also complete line 35)

Add numbers entered in boxes above ▶ ☐

Income

Please attach
Copy B of your
Forms W-2, W-2G,
and W-2P here.

If you do not have
a W-2, see
page 6 of
Instructions.

Please
attach check
or money
order here.

7	Wages, salaries, tips, etc. (attach Form(s) W-2)	7	
8	**Taxable** interest income (also attach Schedule B if over $400) . . .	8	
9	**Tax-exempt** interest income (see page 10). DON'T include on line 8	9	
10	Dividend income (also attach Schedule B if over $400)	10	
11	Taxable refunds of state and local income taxes, if any, from worksheet on page 11 of Instructions .	11	
12	Alimony received	12	
13	Business income or (loss) (attach Schedule C).	13	
14	Capital gain or (loss) (attach Schedule D)	14	
15	Other gains or (losses) (attach Form 4797)	15	
16a	Pensions, IRA distributions, annuities, and rollovers. Total received	16a	
b	Taxable amount (see page 11)	16b	
17	Rents, royalties, partnerships, estates, trusts, etc. (attach Schedule E) .	17	
18	Farm income or (loss) (attach Schedule F)	18	
19	Unemployment compensation (insurance) (see page 11)	19	
20a	Social security benefits (see page 12)	20a	
b	Taxable amount, if any, from the worksheet on page 12	20b	
21	Other income (list type and amount—see page 12)	21	
22	Add the amounts shown in the far right column for lines 7, 8, and 10–21. This is your **total income** ▶	22	

**Adjustments
to Income**

(See
Instructions
on page 12.)

23	Reimbursed employee business expenses from Form 2106 . .	23	
24a	Your IRA deduction, from applicable worksheet on page 13 or 14	24a	
b	Spouse's IRA deduction, from applicable worksheet on page 13 or 14 . . .	24b	
25	Self-employed health insurance deduction, from worksheet on page 14 .	25	
26	Keogh retirement plan and self-employed SEP deduction. . .	26	
27	Penalty on early withdrawal of savings	27	
28	Alimony paid (recipient's last name _____ and social security no. ____) .	28	
29	Add lines 23 through 28. These are your **total adjustments** ▶	29	

**Adjusted
Gross Income**

30	Subtract line 29 from line 22. This is your **adjusted gross income.** If this line is less than $15,432 and a child lived with you, see "Earned Income Credit" (line 56) on page 18 of the Instructions. If you want IRS to figure your tax, see page 15 of the Instructions . . . ▶	30	

Figure 13. Form 1040 is the U.S. Individual Income Tax Form Return. Although this is a 1987 return, Form 1040 remains basically the same every year.

Tax Computation

31 Amount from line 30 (adjusted gross income) **31**

32a Check if: ☐ **You** were 65 or over ☐ Blind; ☐ **Spouse** was 65 or over ☐ Blind.
Add the number of boxes checked and enter the total here ▶ **32a**

b If you can be claimed as a dependent on another person's return, check here . . ▶ **32b** ☐

c If you are married filing a separate return and your spouse itemizes deductions, or you are a dual-status alien, see page 15 and check here ▶ **32c** ☐

33a **Itemized deductions.** See page 15 to see if you should itemize. If you don't itemize, enter zero. If you do itemize, attach Schedule A, enter the amount from Schedule A, line 26, **AND** skip line 33b . **33a**

Caution: ◀ b **Standard deduction.** Read **Caution** to left. If it applies, see page 16 for the amount to enter.
If you checked any box on line 32a, b, or c **and** you don't itemize, see page 16 for the amount to enter on line 33b.
If **Caution** doesn't apply and your filing status from page 1 is: { Single or Head of household, enter $2,540 / Married filing jointly or Qualifying widow(er), enter $3,760 / Married filing separately, enter $1,880 } **33b**

34 Subtract line 33a **or** 33b, whichever applies, from line 31. Enter the result here **34**

35 Multiply $1,900 by the total number of exemptions claimed on line 6e or see chart on page 16 . . **35**

36 **Taxable income.** Subtract line 35 from line 34. Enter the result (but not less than zero) **36**

 Caution: If under age 14 and you have more than $1,000 of investment income, check here ▶☐ and see page 16 to see if you have to use Form 8615 to figure your tax.

37 Enter tax. Check if from ☐ Tax Table, ☐ Tax Rate Schedules, ☐ Schedule D, or ☐ Form 8615 **37**

38 Additional taxes (see page 16). Check if from ☐ Form 4970 or ☐ Form 4972 **38**

39 Add lines 37 and 38. Enter the total . ▶ **39**

Credits
(See Instructions on page 17.)

40 Credit for child and dependent care expenses *(attach Form 2441)* **40**

41 Credit for the elderly or for the permanently and totally disabled *(attach Schedule R)* **41**

42 Add lines 40 and 41. Enter the total . **42**

43 Subtract line 42 from line 39. Enter the result (but not less than zero) **43**

44 Foreign tax credit *(attach Form 1116)* **44**

45 General business credit. Check if from ☐ Form 3800, ☐ Form 3468, ☐ Form 5884, ☐ Form 6478, ☐ Form 6765, or ☐ Form 8586 **45**

46 Add lines 44 and 45. Enter the total . **46**

47 Subtract line 46 from line 43. Enter the result (but not less than zero) ▶ **47**

Other Taxes
(Including Advance EIC Payments)

48 Self-employment tax *(attach Schedule SE)* **48**

49 Alternative minimum tax *(attach Form 6251)* **49**

50 Tax from recapture of investment credit *(attach Form 4255)* **50**

51 Social security tax on tip income not reported to employer *(attach Form 4137)* **51**

52 Tax on an IRA or a qualified retirement plan *(attach Form 5329)* **52**

53 Add lines 47 through 52. This is your **total tax** ▶ **53**

Payments

Attach Forms W-2, W-2G, and W-2P to front.

54 Federal income tax withheld (including tax shown on Form(s) 1099) **54**

55 1987 estimated tax payments and amount applied from 1986 return **55**

56 Earned income credit (see page 18) **56**

57 Amount paid with Form 4868 (extension request) **57**

58 Excess social security tax and RRTA tax withheld (see page 19) **58**

59 Credit for Federal tax on gasoline and special fuels *(attach Form 4136)* **59**

60 Regulated investment company credit *(attach Form 2439)* . . . **60**

61 Add lines 54 through 60. These are your **total payments** ▶ **61**

Refund or Amount You Owe

62 If line 61 is larger than line 53, enter amount **OVERPAID** ▶ **62**

63 Amount of line 62 to be **REFUNDED TO YOU** ▶ **63**

64 Amount of line 62 to be applied to your 1988 estimated tax . . . ▶ **64**

65 If line 53 is larger than line 61, enter **AMOUNT YOU OWE.** Attach check or money order for full amount payable to "Internal Revenue Service." Write your social security number, daytime phone number, and "1987 Form 1040" on it **65**
Check ▶ ☐ if Form 2210 (2210F) is attached. See page 20. **Penalty: $**

Please Sign Here

Under penalties of perjury, I declare that I have examined this return and accompanying schedules and statements, and to the best of my knowledge and belief, they are true, correct, and complete. Declaration of preparer (other than taxpayer) is based on all information of which preparer has any knowledge.

▶ Your signature | Date | Your occupation

▶ Spouse's signature (if joint return, BOTH must sign) | Date | Spouse's occupation

Paid Preparer's Use Only

Preparer's signature ▶	Date	Check if self-employed ☐	Preparer's social security no.
Firm's name (or yours if self-employed) and address ▶		E.I. No.	
		ZIP code	

☆ U.S. Government Printing Office: 1987—183-084 23-0916750

SCHEDULE C (Form 1040) Department of the Treasury Internal Revenue Service (O)	**Profit or (Loss) From Business or Profession** (Sole Proprietorship) **Partnerships, Joint Ventures, etc., Must File Form 1065.** ▶ **Attach to Form 1040, Form 1041, or Form 1041S.** ▶ **See Instructions for Schedule C (Form 1040).**	OMB No. 1545-0074 **1987** Attachment Sequence No. **09**

Name of proprietor	Social security number (SSN)

A Principal business or profession, including product or service (see Instructions)

B Principal business code (from Part IV) ▶

C Business name and address ▶ ...

D Employer ID number (Not SSN)

E Method(s) used to value closing inventory:

 (1) ☐ Cost **(2)** ☐ Lower of cost or market **(3)** ☐ Other (attach explanation)

		Yes	No
F Accounting method: **(1)** ☐ Cash **(2)** ☐ Accrual **(3)** ☐ Other (specify) ▶			
G Was there any change in determining quantities, costs, or valuations between opening and closing inventory? (If "Yes," attach explanation.)			
H Are you deducting expenses for an office in your home?			
I Did you file **Form 941** for this business for any quarter in 1987?			
J Did you "materially participate" in the operation of this business during 1987? (If "No," see Instructions for limitations on losses.)			
K Was this business in operation at the end of 1987?			
L How many months was this business in operation during 1987? ▶			

M If this schedule includes a loss, credit, deduction, income, or other tax benefit relating to a tax shelter required to be registered, check here . . ▶☐
 If you check this box, you **MUST** attach **Form 8271.**

Part I Income

1a Gross receipts or sales	**1a**	
b Less: Returns and allowances	**1b**	
c Subtract line 1b from line 1a and enter the balance here	**1c**	
2 Cost of goods sold and/or operations (from Part III, line 8)	**2**	
3 Subtract line 2 from line 1c and enter the **gross profit** here	**3**	
4 Other income (including windfall profit tax credit or refund received in 1987)	**4**	
5 Add lines 3 and 4. This is the **gross income** ▶	**5**	

Part II Deductions

6 Advertising		**23** Repairs		
7 Bad debts from sales or services (see Instructions.)		**24** Supplies (not included in Part III)		
8 Bank service charges		**25** Taxes		
9 Car and truck expenses		**26** Travel, meals, and entertainment:		
10 Commissions		**a** Travel		
11 Depletion		**b** Total meals and entertainment		
12 Depreciation and section 179 deduction from Form 4562 (not included in Part III)		**c** Enter 20% of line 26b subject to limitations (see Instructions)		
13 Dues and publications		**d** Subtract line 26c from 26b		
14 Employee benefit programs		**27** Utilities and telephone		
15 Freight (not included in Part III)		**28a** Wages		
16 Insurance		**b** Jobs credit		
17 Interest:		**c** Subtract line 28b from 28a		
a Mortgage (paid to financial institutions)		**29** Other expenses (list type and amount):		
b Other		..		
18 Laundry and cleaning		..		
19 Legal and professional services		..		
20 Office expense		..		
21 Pension and profit-sharing plans				
22 Rent on business property				

30 Add amounts in columns for lines 6 through 29. These are the **total deductions** ▶	**30**	

31 **Net profit or (loss).** Subtract line 30 from line 5. If a profit, enter here and on Form 1040, line 13, and on Schedule SE, line 2 (or line 5 of Form 1041 or Form 1041S). If a loss, you **MUST** go on to line 32 | **31** |

32 If you have a loss, you **MUST** answer this question: "Do you have amounts for which you are not at risk in this business?" (See Instructions.) ☐ Yes ☐ No
 If "Yes," you **MUST** attach **Form 6198.** If "No," enter the loss on Form 1040, line 13, and on Schedule SE, line 2 (or line 5 of Form 1041 or Form 1041S).

For Paperwork Reduction Act Notice, see Form 1040 Instructions. Schedule C (Form 1040) 1987

Figure 14. Schedule C. The statement of Profit (or Loss) from Business or Profession is where you report expenses and losses from your work as a self-employed artist.

new laws and the IRS issues new regulations. So keep current by updating your information. An excellent tax guide for artists is *Fear of Filing*, published by the Volunteer Lawyers for the Arts in New York City and revised frequently.

What income is reported on Schedule C?

Almost anything you take in as a self-employed person is reported on Schedule C—for example, fees from the sale of completed art, for commissioned work, and for demonstrations and lectures, and the value of artwork received in a trade with another artist. You would also report royalties, fees you receive for selling or licensing copyrights on your work (see Chapter 2), and insurance proceeds from the loss or destruction of work (see Chapter 12). Most grants, prizes, and awards are taxable, but they're usually reported on Form 1040 itself, not Schedule C.

Are grants taxable?

Yes, unless you are a degree candidate receiving a grant for tuition and course expenses.

Are prizes and awards taxable?

Yes, unless they meet *all* the following conditions:

1. You're selected without taking any action to be considered for the prize or award

2. You're not required to render substantial future services as a condition for receiving the prize

3. The award is transferred to a charity. If you keep the money, you pay the taxes.

Is artwork I exchange with another artist income?

According to the law, it is, and you must include it as income on Schedule C. Even if you aren't eager to include it as income, it may prove a wise move in the future.

Why would it be wise to report this income?

Because if the work you receive appreciates in value and you donate it to a museum as a collector would, you'll be able to take a larger tax deduction than if you didn't report it. If you can prove that you, in effect, bought the work by reporting it as income, you may be able to claim a deduction for its market value

at the time you donate the work. In other words, if the work was worth $200 when you got it and $2,000 when you donated it, you could claim a deduction based on the larger figure. The reason for this is that the law says you can take a charitable deduction for the value of works purchased and held for more than one year before donation to a museum.

This is not so if you've merely received a gift. The recipient of a gift of art is treated like the artist who created it—eligible for nothing more than a deduction for the raw materials that went into the work. And you probably wouldn't be able to claim that either, since the artist probably deducted the cost of them during the year he or she made the work.

How do I estimate the income I receive in an exchange?

When you exchange work, find out how much the work you receive would sell for and subtract the cost of materials in the work you gave. The result is your income.

What business expenses may I deduct on Schedule C?

You may deduct all ordinary and necessary expenses, meaning those that can be expected to arise with a degree of regularity and are appropriate and helpful in the profession of being an artist. In other words, all those expenses mentioned in Chapter 13—supplies, postage, promotional material, travel, entertainment, telephone, studio expenses—are deductible.

As mentioned in the last chapter, some of these, such as telephone, car, and studio expenses, must be broken down into nondeductible personal expenses and deductible business expenses before the right amounts can be reported on your tax return. Others, those known as capital expenditures, must be depreciated, i.e., deducted over a number of years.

But before I get into depreciation, let me explain the limitations on deducting studio expenses and arts material expenses mentioned in Chapter 13.

Why might I not be able to deduct all my expenses for art materials?

The IRS says that businesses with inventories are allowed to deduct the cost of materials in the products they sell *only* in the year in which they are sold, and technically speaking, artists are businesspersons with inventories. Until the Tax Reform Act of 1986, however, the IRS rarely bothered to enforce this rule against artists. A footnote to the 1986 legislation, written specifi-

cally to apply to artists, authors, and photographers who claim large expenses against minimal incomes, reversed the IRS's position.

This means that ideally, if you sell, say, three paintings this year, you should calculate how much you spent for paint, canvas, and other supplies for them, and claim only this portion of your total expenses for arts materials. In reality, most accountants would advise you to make a "reasonable" judgment of how much you spent. If, however, you paint twenty paintings and sell none, you will have a hard time justifying deductions of all your art materials if challenged by the IRS.

Look for relief from this ruling in the future: As of this writing, the Authors Guild has rallied support in Congress for an amendment to permit total deductions by artists again.

Why might I not be able to deduct all my studio expenses?

You can deduct all your studio expenses if your studio is separate from your house. But if you want to deduct home-studio expenses (which include insurance, maintenance, utilities, and depreciation), the tax law says that you can deduct home expenses only up to the point at which they equal your net income from self-employment.

What is my net income?

Gross income from your self-employed activities minus all non-home-studio expenses. This means that if you rent your home, and you earned $1,000 last year from sale of your artwork, and you spent $1,000 for, say, canvas, stationery, and a brochure, you can't deduct anything for your home studio.

The law goes on to say that if you own your home and your studio is part of it, you can deduct expenses only up to your net income from self-employment minus certain deductions you'd be allowed anyway. These deductions are real estate taxes and mortgage interest payments.

How does this work? Suppose you earn $3,000, net, from self-employment, your home mortgage interest is $3,000 a year, and real estate taxes are $2,600. Other home expenses, such as the cost of heat, water, telephone, electricity, air conditioning, and similar expenses and depreciation (see below) amount to $7,200 for the year. If your studio takes up one-fourth of your house, you'll be able to claim one-fourth of the real estate taxes and mortgage interest payments as business expenses. One-fourth of $5,600 ($3,000 plus $2,600) equals $1,400.

Because you can write this expense off as a deduction anyway, you must subtract $1,400 from your $3,000 self-employment income to get the amount you can claim for expenses: $1,600.

One-quarter of the other home expenses ($7,200) comes to $1,800, but since you can only deduct $1,600, you won't be able to claim the remaining $200.

Can I carry forward these disallowed home-office business deductions?

Yes, and they will come in very handy if your income soars.

Are there any other limitations to home-studio deductions?

Yes. Your studio must be used exclusively—and on a regular basis—as the principal place of your self-employed business. By exclusively, the law means that your studio can't double as a bedroom or living room.

If I have a regular job, can my studio be a principal place of business?

Yes. You can have as many principal places of business as you have businesses. For example, if you teach, your school is your principal place of business for your teaching career and your studio is your principal place of business for your art career.

What if I'm a teacher required by my school to maintain an art career?

Even though your school may demand that you maintain your professional art career, you can't write off your studio expenses as business expenses for that reason alone. The law still requires that you make enough income from self-employment to equal studio expenses before you deduct.

How do I depreciate capital expenditures?

Because business assets have useful lives of more than one year, they can't be deducted totally in the year they are purchased. So first you must determine what ADR (asset depreciation range) class your asset falls into. These classes refer to the number of years a given asset is expected to be used in a business.

Here are some examples: The five-year class includes light trucks, cars, and computers. The seven-year class includes office furniture and fixtures and most other machinery and equipment. Your house is a 27.5-year property; a commercial building is a 31.5-year property.

Then you would depreciate the asset by using either the Accelerated Cost Recovery System (ACRS) or straight-line depreciation.

How can I find out for sure what ADR class my property falls into?

Ask the IRS.

What is straight-line depreciation?

Unlike ACRS, which accelerates payments in the early years, straight-line depreciation requires equal deductions in all years. To calculate, find out what your asset's ADR class is. Then divide the number of years into the cost of the asset. For example, if you purchased a $7,500 car, your straight-line deduction would be $1,500 a year since a car is a five-year property. However, you can't write off a full year's deduction in the first year.

Why can't I take a full deduction the first year?

Because of something called a "half-year convention." This convention says that a business asset is depreciable for only half of the taxable year it is placed in service, regardless of the date you actually began using it. So the deduction you can take the first year is one-half the amount that you'd take for a full year of depreciation.

When you dispose of the property—or at the end of the cost recovery period—you get to take the other half-year of depreciation. So a five-year car, for example, is actually depreciated over six taxable years.

How does ACRS work?

Right now the ACRS is using the 200 percent declining balance method. (But in the future, look to see if the IRS has simplified this calculation.)

The 200 percent declining balance method results in depreciation that is twice the straight-line depreciation in the first year the asset is used. In each subsequent year, depreciation computed under the 200 percent declining balance method becomes progressively smaller until depreciation figured under the straight-line method exceeds the accelerated depreciation. Then the straight-line method is used to complete depreciation of the asset.

Here's how it works. In January, you buy a pickup truck for $10,000, to transport your paintings. The truck is a five-year property, so it generates a $2,000 depreciation deduction for the

first year—that is, $10,000 divided by five years, then divided by two for the half-year convention, then multiplied by two for the 200 percent declining balance method.

Why would I want to depreciate by straight-line rather than by the faster ACRS method?

Depending on your tax situation, you might not want large deductions in certain years. For instance, you may be trying to avoid being called a "hobbyist" by making your business profitable in three out of five years. In this case, you might opt for the straight-line method with its smaller deductions in the early years so your income would exceed your expenses.

Is there any way to write off property faster than the ACRS method?

Yes. You can elect to take an immediate year-of-acquisition deduction of up to $10,000.

Can I take a first-year depreciation deduction on top of that?

No.

How do I depreciate a car I use for both personal and business reasons?

If you use the car for business more than 50 percent of the time, you can use ACRS. If you use it for business less than 50 percent of the time, you must use the straight-line method. There is a cap on depreciation deductions for luxury cars costing over $12,800.

What is this cap?

If you use your car more than 50 percent of the time for business and it costs more than $12,800, the maximum ACRS depreciation deduction is $2,560 for the first year, $4,100 for the second year, $2,450 for the third year, and $1,475 for the remaining years.

How do I depreciate used equipment?

Determine the ADR class and subtract its age. A two-year-old car, for example, would have a three-year recovery period for you.

What if the asset breaks down before the recovery period is over?

Deduct the entire amount left to be deducted in the year it breaks down.

How do I calculate the depreciation deduction on my house so I can make a home-studio deduction?

Here are the steps you would take to figure out the overall depreciation rate of your house:

1. Start with the purchase price of the house or the amount you spent to build it.

2. Subtract the land value, because land can't be depreciated. (You can get this amount from your tax assessor.)

3. Add in the cost of any major improvements, like a new roof.

4. Divide the results by the recovery period of 27.5 years. This gives you your straight-line depreciation deduction for the whole house.

5. Take the same percentage of the overall depreciation on the house as you used for other business home-studio expenses.

Must I use straight-line depreciation for my house?

Yes, the ACRS method is not allowed.

Do I get any other tax breaks for capital expenditures?

No. There used to be something called an investment credit, but it was eliminated by the 1986 Tax Revision Act.

What is the hobby-loss problem?

This chapter discusses deducting self-employment expenses from self-employment income; both are reported on Schedule C, the profit or loss statement. If income is greater than expenses, the profit from self-employment is reported on Form 1040 and added to your other income. If expenses exceed income on Schedule C, the loss is reported on Form 1040 and subtracted from other income. You can do this because, as a professional artist in the business of making and selling art, you are like any other business-person—if you spend more than you make in the course of business, you can deduct the loss from total taxable income.

The hobby-loss problem arises when the IRS decides to dispute the legitimacy of your right to claim a business loss on the grounds that you are not a self-employed professional out to make a profit but a mere hobbyist. A hobbyist, in the eyes of the IRS, isn't interested in making a profit since he or she is not really in business and is, therefore, not entitled to deduct a business loss from total taxable income.

Can a hobbyist deduct anything?

Yes, he or she is allowed deductions for expenses from the hobby up to the amount of income the hobby produces. For example, suppose a doctor takes up painting on Sundays and becomes proficient enough to sell $500 worth of work in one year to his colleagues. He spent $1,000 pursuing his hobby, but all he can claim is $500.

The problem, then, is to convince the IRS, if you're audited, that your loss is legitimate because you have a profit motive.

What do you mean by "audited"?

An audit is an examination of your tax return by an IRS official to see if you paid the correct amount of taxes.

What happens if we disagree?

If, after the audit, the official thinks you didn't pay the right amount but you think you did, you can appeal the decision to the district conference of the IRS and then to the appellate division. If you still don't agree, you can take your case to the United States Tax Court.

At any of these stages after the initial examination, you and the IRS can decide to compromise. In other words, a dispute over taxes isn't a cut-and-dried affair. If the IRS says you owe $500 in unpaid taxes and you believe you don't owe them anything, it may be wiser to negotiate a settlement somewhere in between rather than incur heavy legal and accounting fees trying to prove you're right.

Another way to handle a tax dispute if the amount in question is less than $1,500 is to sue the IRS in the Tax Court's small tax claims division. In this court, you don't need a lawyer to present your case (although it's helpful), and the decision is final—you can't appeal it.

How can I prove a profit motive?

The easiest way is to report a profit on Schedule C for any three out of five consecutive years ending with the taxable year in question. This will satisfy the IRS.

Making profits may not be as hard as you think. If you adopt the cash method of accounting recommended in Chapter 13, manipulation of income and expenses by delaying payment on expenses until after the first of the year and trying to collect as many fees as possible before the old year runs out may result in a profit. It may be a small one, but so what? Three years of small

profits and two of somewhat larger losses will boost you into the professional category; five years of small losses won't.

Can I prove a profit motive if I don't make profits in three out of five years?

Yes, although some auditors tend to see this measure as the only criterion. They are wrong. The regulations of the Internal Revenue Code set forth a number of factors that are used to determine whether or not there's a profit motive involved in any activity, and these factors have been backed up and elaborated on by court cases.

You don't have to qualify for every factor, nor will any one be crucial. Each case is decided on the sum total of the circumstances that affect your self-employment.

What are these factors?

The following six factors are important:

1. The manner in which you carry on your business. This means that if you keep records in a businesslike manner, as I described in Chapter 12, and engage in other activities—entering competitions, traveling to art shows, exhibiting in art galleries and museums, publicizing your work—you'll be all right on this score.

2. Your expertise. Expertise may be indicated by extensive study; gallery and museum exhibitions; gallery representations; awards and prizes; recognition as a talented artist in catalogs, newspapers, magazines, museum journals, and other publications that write critically about artists; and the ability to hold a teaching position in your particular field of art.

3. The amount of time you spend working as a self-employed artist. The IRS has never spelled out what it considers a significant amount of time to be. Working full-time would be ideal, of course—devoting yourself solely to making and selling art and not working at any other job. But if you have a job that allows you to work on a regular basis as a professional, the IRS should accept this. In at least one case, for example, the Tax Court ruled that four hours a day was enough. This doesn't mean that a smaller amount of time wouldn't also be sufficient, only that four hours satisfied that court in that particular case. The real point is that you must work on a consistent basis.

4. A prior history of critical or financial success—despite intervening periods when you didn't work or earn a profit—is a plus. For example, suppose you had established your reputation as an

artist, but then you married, had children, and devoted yourself entirely to being a parent. If you return to your artwork later, when your children are older, your old reputation should stand you in good stead in case of an audit.

5. Your history of income with respect to the activity. Selling more each year or selling at higher prices should impress the examiner hearing your case.

6. Your financial status. Here's where it pays to be poor. A lack of other substantial income reported on your income tax return should indicate that you need income from your art and that you can't afford a hobby. This should put you in a better position to prove your case than someone who makes a lot of money from other sources.

Do you know of someone who didn't measure up to these factors?

One of the most frequently quoted cases is that of Johanna K. W. Hailman, a rich Pittsburgh socialite who painted about 600 paintings throughout her life. Although she was recognized as a leading artist in western Pennsylvania and elsewhere, during her lifetime she sold only 50 works. These were priced between $700 and $1,500, and she refused to sell for less. All told, her income for an eighteen-year period from 1936 to 1954 was $7,200, while she reported expenses totalling $131,140. In 1954, the IRS, who for many years had compromised on expenses by allowing her an annual $3,000 deduction, decided enough was enough. It said her losses were excessive and held that she didn't intend to conduct her activities as a professional.

The Tax Court agreed, concluding that since expenses were eighteen times as great as receipts, only independent wealth permitted her to continue the activity—including the setting of high prices and the retention of most of the artworks. Therefore, said the court, her activity must be classified as a hobby pursued without the requisite profit motive.

Do you know a case of someone who overcame being classified a hobbyist?

Yes, the following case was excerpted from "The Hobby-Loss Challenge: For Many Artists Their Biggest Headache," by Tad Crawford in *American Artist*. It puts into perspective how the IRS factors for determining a profit motive can work for you.

Anna Maria de Grazia, who painted under the name Anna Maria

d'Annunzio, was the granddaughter of Gabriele d'Annunzio, the famous Italian writer and military hero, and was raised in Italy, where she became interested in painting in 1940. During World War II she served as a guide for the Allied Forces, but she continued her painting until 1944, when polio forced her to learn how to paint with her left hand rather than her right. In 1942 she won first prize in an exhibition by young painters in Florence and the same year placed third in a contest open to all Italians.

Giving up her art from 1943 to 1947, she resumed painting and exhibiting from 1948 to 1951. During this period she was admitted to the Italian painters union upon the attestation of three professional artists that she was a professional artist. In 1952, after moving to the United States, she married Sebastian de Grazia, and she neither painted nor exhibited until 1955, when she became a naturalized citizen. By 1957 she had studied with the artists Annigoni, Carena, and Kokoschka and had received recognition in a book on Italian painting in which her self-portrait and biographical background appeared.

She resumed painting in 1956 and 1957, supported by the modest income of her husband, who was a visiting professor at Princeton University. In 1957, after working in Princeton in a rented house and trying unsuccessfully to acquire a New York gallery, she felt her studio facilities inadequate and left in May to paint at the Piazza Donatello Studios in Florence. Her decision to go to Florence was prompted by familiarity with the art world in Italy.

Despite her return to Italy, she was still interested in getting a New York gallery and was told that a show at any prestigious gallery in New York would require numerous paintings. To achieve her goal, she began to create a significant body of work, painting four hours a day in 1957 and devoting additional time to stretching and preparing canvases and transacting business with art dealers and framemakers. By the end of 1957 she had completed 12 or 15 paintings, with ten more in progress. After 1957 she exhibited successfully, having a number of solo shows in Italy as well as exhibiting in Princeton and New York City.

In 1957 her paintings earned no income, but she incurred $5,769 in expenses; in 1958 she made $500, while her expenses were $6,854; in 1959 she earned $575 and spent $5,360; and in 1960 income amounted to $710, while expenses totaled $4,968. She did not keep formal business books but did have records relating to her receipts and expenses as an artist.

The IRS challenged her deduction of $5,769 in 1957 on the grounds that she had been merely pursuing a hobby, or preparing to enter a business or trade, but had not been engaged in the business or trade of being an artist in that year.

The Tax Court disagreed with the IRS. It concluded that she had been in the business or trade of being an artist in the year 1957. The Tax Court considered the following facts as significant of her profit motive: she began

painting in her youth and won prizes for her work; she struggled to overcome the handicap imposed by polio; she studied with recognized artists; she received recognition from the Italian painters union and in critical publications; she had exhibitions both prior and subsequent to 1957; she worked continually and unstintingly at her painting and necessary incidental tasks; she had no other sources of income so that losses were a financial strain; and she had constantly increasing receipts in the years after 1957.

The Tax Court also rejected explicitly the argument that she had merely been preparing to enter a trade or profession, stating that the history of her art activities onward from 1940 rebutted any such contention. In a notable section of the decision, the Court wrote, "It is well recognized that profits may not be immediately forthcoming in the creative art field. Examples are legion of the increase in value of a painter's work after he receives public acclaim. Many artists have to struggle in their early years. This does not mean that serious artists do not intend to profit from their activities. It only means that their lot is a difficult one."

Should I get professional help if I'm audited?

Yes. Get a lawyer or CPA to accompany you to your audit hearings. Don't appear by yourself. Sure, you can go it alone, but it will probably cost more in the long run. And don't count on the friendly neighborhood bookkeeper or tax preparer who filled out your return. These people can only answer questions about the work they did on your return. They can't negotiate settlements or take cases through the various levels of appeal. Lawyers and CPAs, on the other hand, can develop the factors of your case favorably, and their presence at initial conferences with IRS agents may clear up your difficulties immediately.

Fifteen

OTHER TAX CONSIDERATIONS

ESTIMATED TAXES
SELF-EMPLOYMENT TAX
UNINCORPORATED BUSINESS TAX
SALES TAX

You may think you've read everything you ought to know about taxes in this book already—or maybe just more than you want to know. Unfortunately, as a self-employed artist, you're faced with the possibility of filling out even more forms than those already discussed. So here's more on taxes.

As a self-employed person, do I have to pay taxes in advance?

Yes. The last chapter discussed filling out Form 1040 and its accompanying schedules and forms for return with your check to the IRS on or before the April 15 deadline, but paying taxes isn't quite that easy for the self-employed person. You do have to file a tax return on April 15 for the previous year's income, but you also have to file returns and pay taxes during the year in which you're earning the income.

What's the point of this?

What the IRS is actually doing is asking you to be your own employer and withhold wages to be remitted as taxes as if you were employed by someone else. According to the law, anyone who earns more than $500 not subject to withholding tax must file Form 1040 ES. This is true of both fully self-employed people and the self-employed who also have jobs. Form ES consists of an estimated tax worksheet and four declaration vouchers. The first declaration voucher reports the amount you think you'll owe in taxes for the current year. That amount may be paid in full at that time or in installments on April 15, June 15, September 15, and

January 15. Payments are sent to the IRS along with the other three vouchers. Either way, 90 percent of your actual tax must be paid by January 15. If it isn't, the IRS can penalize you.

How do I know how much to pay?

By April 15, you'll know how much you have made during the first three months of the year and what expenses you have incurred. By using the worksheets that come with the voucher, you can estimate your tax for that period. Simply multiply by four to get your estimated tax for the year. The IRS doesn't expect you to hit the figure on the nose—all it cares about is that you have paid 90 percent of it by January 15. If your income falls off or increases drastically during the year, you can adjust payments to accommodate the change by January 15.

What if I haven't paid 100 percent of my tax bill by January 15?

If, by January 15, you have paid 90 percent of your tax but still owe the government more, just send the remainder with your regular tax return (Form 1040) for the previous year on or before the April 15th deadline—just as employees do if their employers haven't withheld enough taxes from their wages.

What if I've overpaid by January 15th?

If you overpay, note this on Form 1040 and indicate on your declaration voucher that you want this overpayment either credited against the first estimated tax payment due for the current year or spread out over each of the four installment payments. Or you can simply ask for a refund.

Isn't there an easier way to pay my estimated tax?

Yes. Instead of trying to estimate your taxes, you can simply pay in installments an amount equal to 100 percent of the taxes you had paid by January 15 of the previous year. Even if this amount falls way below the taxes you actually owe, the IRS will not penalize you. Of course, you would have to make up the difference when you submit your return on April 15.

Must I pay estimated income taxes if 90 percent of my taxes are withheld from another job?

No. And even if you find that your art income soars during the latter part of the year, meaning that 90 percent won't be paid by

January 15 by withholding, you can still rectify the situation by filing a declaration voucher with a payment on this income by January 15.

As a self-employed person, must I pay Social Security tax?

Yes. If you were employed, your employer would deduct a certain amount from your paycheck to pay the Social Security tax. Since you're self-employed, you must pay it yourself. The tax is called the Self-employment Tax and is reported on Schedule SE.

If I'm employed as well as self-employed, must I pay self-employment tax?

Possibly. Every year the IRS establishes how much of your income is subject to a Social Security tax, whether it's the self-employment tax or the Social Security tax taken out of your paycheck by your employer. If you don't earn that amount in wages, your net income from self-employment is subject to Social Security tax up to the amount of the difference.

Could I ever overpay the Social Security tax?

Yes, if you have two jobs in one year and earn more than the maximum amount subject to Social Security tax and both employers deduct the tax, you would overpay. If that happens, just deduct the overpayment on Form 1040.

What other taxes may I have to pay?

It's possible you may have to pay a state unincorporated business tax. Since corporations have to pay taxes, many states reason that it's unfair that unincorporated businesses get away tax-free. To equalize the situation, they impose an unincorporated business tax. And they impose it on you. Even if you think of yourself as just a painter or a sculptor, if your state has such a tax, its tax department sees you as a business if you're earning money from your art, and it taxes you as a business over and above your personal income tax. So find out if your state has an unincorporated business tax. It usually isn't much, and it's better to pay it now rather than wait for your state tax department to catch you for nonpayment.

Must I collect sales tax on artwork I sell?

Yes, if you sell art as a retailer, most state laws require you to charge and collect a sales tax.

Who is a retailer?

You're a retailer if you sell your art to the person who plans to use it, as opposed to someone who would resell it. In other words, if a collector comes into your studio and buys a piece of art to hang on his or her wall, you've just made a sale on the retail level and must charge a sales tax.

If I sell or consign work to a gallery, am I responsible for the sales tax?

No. A sales tax is collected only once—on the final sale. If you sell or consign work to a gallery—or a frame shop—the owner becomes the retailer and is responsible for collecting the tax. You are, in effect, only a wholesaler selling goods for resale.

Who collects the sales tax at art shows and exhibitions?

Whoever handles the sales. If you do it yourself (or if someone who's helping you out does it), you'll have to collect the tax; if all sales go through the sponsor of the show or festival, it's his or her responsibility.

How do I collect the sales tax?

First, you must register with your state sales tax department, which may require you to put down a minimum deposit. Then it will issue you a sales permit and resale number and supply you with the appropriate forms to be filled out and returned when you remit the tax. In most states, sales tax returns are filed quarterly.

Next, record all sales taxes on your sales invoices, and report them in your bookkeeping system along with income. (Make sure you keep these records accurately in case you're ever audited.) Then every three months, or whatever the appropriate time period is, total the taxes collected as indicated in your records and send a check for that amount, along with the return bearing your resale number, to the state sales tax department.

What if I sell work at out-of-state art shows?

If that state has a sales tax, you must collect it. And rumor has it that tax agents lurk about the booths of artists who sell well at out-of-town shops and fairs to see if they're complying with the law. The best course of action, then, is to apply to the sales tax department of that state for whatever forms of permits it requires for out-of-staters setting up temporary shop within its boundaries.

What else is a resale number good for?

A resale number also allows you to buy at wholesale prices and avoid paying sales tax on certain supplies. A tax can be charged on goods only once—at their final sale. This means materials and supplies purchased for incorporation into another product are not taxable. In other words, canvas, paint, stone, clay, and other art supplies should not be taxed when sold to you—providing you've applied for and received a resale number—because they will be taxed again when they end up as the final product, the artwork.

What supplies aren't tax-exempt?

Supplies that don't end up in the final product you plan to sell, such as brushes, knives, and easels.

How do I avoid the sales tax on tax-exempt supplies?

When you go into an art supply store, tell the clerk that supplies are tax-free for you and show him or her your resale number. The clerk marks on the sales invoice that the sale is a "resale," records your resale number, and leaves the tax off the bill.

Sixteen

HOW TO REDUCE TAXES

ASSIGNING ROYALTIES

RETIREMENT PLANS

INCORPORATION

Nobody wants to pay more taxes than necessary, and there used to be a number of devices you could employ to reduce them. Now that the 1986 Tax Revision Act has been enacted, however, very few are left. Gone are the allures of tax shelters. Income averaging is a thing of the past. Still, there are a couple of strategies you might consider.

What are they?

You should think about assigning royalties, retirement plans, and incorporation.

What do you mean by assigning royalties?

As explained in Chapter 2, you can transfer your copyright to others by either giving it away or selling it. Suppose you own the copyright on a work that has been reproduced in a large edition. The edition is selling well and will probably be reissued, and you're being paid a royalty on each sale. If you're in a high tax bracket, the amount of taxes you'll have to pay on these royalties may be considerable.

But if you give your copyright to one of your children—say a son who is fourteen—he'll be paid the royalties, not you. Since he's probably in a low income bracket, his taxes on the royalties will be considerably less.

But—and this is a big but—if your child is under fourteen, assigning royalties loses its tax advantage. Unearned income received by a child under fourteen is taxed at his or her parents' top rate unless the child's earnings are less than $1,000.

Furthermore, thanks to the 1986 tax bill, children, no matter

what their age, will no longer be able to claim a personal exemption. Instead, they will be allowed to use $500 of their standard deduction to shield unearned income from taxes.

What are retirement plans?

Retirement plans, known as Keoghs and Individual Retirement Accounts (IRAs), are investment plans offered by banks, federally insured credit unions, savings and loans, brokerage firms, mutual funds, and insurance companies. These plans may be identical to other investment plans, but before you put your money into one of them, make sure it is labeled an IRA or Keogh plan.

What sort of investments are offered by these institutions?

The most common are savings accounts, certificates of deposit, treasury bills, stocks and bonds, and insurance annuities.

Who is eligible to set up an IRA?

Anyone under the age of 70½ who has earned income during the taxable year can set up an IRA.

Who is eligible to set up a Keogh?

Anyone who makes a profit from self-employed activities can set up a Keogh.

How much money can I invest in an IRA?

You may contribute annually either $2,000 or 100 percent of your gross income, whichever is less. For example, if you earned only $1,000 this year from your painting, that's the most you could contribute.

What if I have a nonworking spouse?

You can contribute $2,250 or 100 percent of your gross income, whichever is less.

What if my spouse works?

You can both contribute the maximum amount.

How much money can I invest in a Keogh?

This depends on whether you are contributing to a "defined contribution" Keogh plan or a "defined benefit" Keogh plan. If you're contributing to the former, you can invest each year the

lesser of $30,000 (a figure that will undergo a cost-of-living adjustment in 1988) or 20 percent of your net self-employment earnings.

If you're contributing to the more complicated defined benefit plan, you invest an amount that is necessary to fund an eventual retirement payout based on actuarial tables for your life expectancy. That annual benefit can't exceed the lesser of $90,000 or 100 percent of your average earnings for your three consecutive years of highest earnings.

How do retirement plans reduce my tax?

If you qualify (see below), the money you invest in a retirement plan is deducted from gross income, reducing the amount of tax you'll have to pay. It's taxable later, of course, when you start withdrawing funds for your retirement. But by then you'll probably be in a lower tax bracket and the taxes on your investment will be lower. Furthermore, the interest or dividends or whatever you earn from your investments is likewise not taxable until withdrawn.

Who is eligible to deduct contributions to Keogh plans?

Anyone with a Keogh can deduct his or her contributions to the plan.

Who is eligible to deduct contributions to an IRA?

If neither you nor your spouse is covered by a company-sponsored retirement or pension plan, you can claim a full IRA deduction.

If either you or your spouse is covered by a company plan, you will still be able to claim a full IRA deduction if your adjusted gross income is below $40,000 on a joint return or $25,000 on a single return.

For couples with a company plan and incomes between $40,000 and $50,000, and single individuals with incomes between $25,000 and $35,000, a partial deduction is allowed.

Couples with a company plan and incomes above $50,000 on a joint return and individuals reporting $35,000 on single returns will not be entitled to a deduction.

However, all taxpayers can put money into IRAs each year, and the money will be allowed to grow and compound tax-free until withdrawn.

When can I make withdrawals from the retirement plan?

You may begin withdrawing from your retirement plan when you

reach the age of 59½, and you must have withdrawn some of it by the age of 70½.

Can I ever withdraw money before I am 59½?

Yes, you can withdraw money if you become disabled.

What happens if I withdraw money before 59½ and I'm not disabled?

You must include the amount of the withdrawal in your income in the year you withdraw it and pay income tax on it. In addition, the IRS demands a 10 percent penalty tax on the amount withdrawn prematurely.

Do I have to make a contribution every year to a retirement plan?

If you buy an insurance annuity, naturally you have to pay yearly premiums. Otherwise, the answer is generally no. In fact, you can usually stop investing in a retirement plan altogether any time you want and then simply withdraw funds from it after you reach age 59½.

Can I have only one Keogh or IRA?

No, you can have as many Keoghs or IRAs or both as you want.

What should I look for before opening a retirement plan?

Listed below are a number of questions to ask about factors involved in retirement plans. None of these fees or conditions is necessarily bad in itself, but too many of them may indicate that the plan is too costly or restrictive and you would be well advised to seek another.

1. Must I pay any fees to establish the plan?

2. Is there a yearly fee after it is established?

3. If no fee is charged at present, can one be imposed in the future?

4. Am I obliged to maintain the plan for a certain period of time?

5. Must I pay a penalty if I withdraw my funds prematurely?

6. Am I guaranteed a definite rate of return on my investment?

7. What is the minimum investment required to open the plan?

8. If I decide to withdraw my money or have it transferred to another retirement plan, how long will the transaction take?

9. If my funds are earning a stated rate of interest, how often is the interest compounded?

How do I decide which plans are best for me?

Ask yourself these questions about your financial situation:

Do you expect to be contributing to your retirement plan for only a short period of time, say less than ten years? If so, this would mitigate against insurance policies that charge large upfront fees. It might also influence you against other plans that have high initial costs.

If a financial emergency arises before you are 59½, is it likely that you'll have to make a withdrawal from your retirement fund? In this case you would again probably rule out an insurance policy. You would also not want to lock yourself into a long-range certificate of deposit that imposes stiff penalties for withdrawals on top of the early withdrawal penalty you'll pay to the IRS.

Do you need a definite amount for your retirement? If so, consider a plan that assures you at least that amount. Annuites can promise this. So can certificates of deposit if you can continue to get guaranteed high interest rates. Mutual funds might not.

Do you have some flexibility in the amount you can invest? For instance, if you're not strapped for funds and you're relatively young, you might want to split your funds between growth and conservative investments, i.e., an aggressive mutual fund and a high-interest certificate of deposit.

What are current rates of return offered by comparable retirement plans? Before selecting your retirement plan, you should shop around and compare the rates offered by comparable plans. So if you decide you want to open an IRA at a savings bank, make some phone calls to other savings and loan institutions in your area and compare the yields that are being offered. Or, if you are considering an IRA with a mutual fund, compare growth records over the past ten years, their current yields, and sales fees. Remember that even a small difference in yield over a year's time can become a substantial amount in a few years.

Can I transfer funds from one account to another?

Yes. If you choose one plan and decide to transfer these funds into another account, you can do so as many times as you want.

Why would I want to incorporate?

There are two basic reasons why businesses incorporate, businesses meaning any commercial activity from the art you make for sale all the way up to the operations of multimillion-dollar companies. These reasons are limited liability and tax advantages. But first you must understand just what a corporation is.

What is a corporation?

A corporation is a separate legal entity owned by one or more stockholders. Although the stockholders run the corporation, it operates solely in its own name. It can sue or be sued, hold legal title to property, and otherwise perform the same business acts as an individual. Thus, the corporation—not the stockholders—owns or rents the premises where work is performed, pays the bills out of a bank account that's in its own name, collects checks written to it, pays salaries to employees, and distributes profits to the stockholders.

When you incorporate, you become the sole stockholder, or at least the majority stockholder (many states require more than one stockholder), of a company in the business of producing artwork. Since you're the producer, you also become an employee of the corporation. When artwork is sold, the corporation—not you—pockets the money and pays you a salary, which, since you run the company, you determine. Then, if there are any profits left over after all business expenses, including your salary, have been deducted and taxes have been paid, you can return these profits to yourself in the form of a dividend.

What is limited liability?

Since the corporation is distinct from its stockholders, they're not liable for the debts and obligations of the corporation. However great the corporation's debts, creditors can't get at the personal assets of the stockholders because the debts of the corporation are not the debts of the stockholders. All of which adds up to what is called limited liability.

Why would I want limited liability?

There aren't too many instances that an artist would. In the course of your business, it's unlikely that you would incur very large debts. But the one example that does come to mind is if projects that might imperil others are your business.

Suppose, for example, you construct large sculptures for public places and assume all expenses until the projects are complete. No

matter how unlikely it might seem, there's always the possibility that the scaffolding might topple over during creation or installation, seriously injuring bystanders. You'll be carrying business liability insurance (see Chapter 12), of course, but the corporate form of doing business would limit your liability if damages exceeded the sum you're insured for. In other words, you personally could not be sued for injury or death.

What are the tax advantages of incorporation?

With personal income tax rates lowered in 1986, the tax advantages of incorporation decreased for most small-business operators. In fact, the whole question of whether to incorporate is a highly individual one that only you and your accountant can answer.

Aren't there any fringe benefits of incorporation?

Maybe. A corporation can set up a medical expense reimbursement plan under which the company takes a business deduction for the medical expenses paid, while employees (that's you) are not taxed on the reimbursements received. These plans can be valuable since the floor for deductible medical expenses is 7.5 percent, effectively precluding most people from claiming these deductions on their personal returns.

But even this isn't such a break, because self-employed people who do not incorporate are allowed to deduct 25 percent of the cost of their health insurance premiums regardless of the 7.5 percent limit.

What are the disadvantages of a corporation?

Double taxation, for one. Since you are a corporate employee, your wages are deducted from taxable corporate income, but you must pay personal income tax on your salary (and on dividends, if there are any). So you're really taxed twice, unless you form an S corporation (see below).

And even if you do manage to make a small savings in taxes, it still may not be worth it. A small savings on taxes may not justify the extra time you'll have to devote to maintaining a corporation. And therein lies the second big disadvantage. The IRS is a stickler about individuals or small groups abiding by the formalities that go along with doing business as a corporation, such as calling stockholders' meetings, recording minutes, submitting reports, and so on. Sloppy corporate minutes and other seemingly minor matters often provide the IRS with an opening for a successful attack on your right to be a corporation.

What is an S corporation?

One way to describe it would be to say it's a minicorporation. An S corporation, sometimes known as a small-business corporation, must pay state and city corporate taxes (if there are any), but unlike a regular corporation, it doesn't pay federal corporate income taxes. You only pay personal income tax on all taxable income that the corporation earns.

An S corporation is usually used for a start-up business, and it is the form of incorporation you'd investigate first.

Does an S corporation offer the same limited liability as a regular corporation?

Yes.

Does an S corporation offer the same medical plan deduction?

No. You would only be allowed to deduct 25 percent of the cost of a health insurance plan, just as other self-employed people are.

How much money should I be earning to consider incorporation?

As a rule of thumb, don't think about incorporating unless you have a net income from your self-employment (income after business deductions have been deducted) of $75,000 or more.

If I earn that much, how should I decide to incorporate?

In the first place, get an accountant or lawyer to help you. The decision to incorporate can only be made after an in-depth analysis of your particular financial position.

But what your discussions will probably boil down to is this: Where tax advantages are marginal—unless there is a compelling need for limited liability—incorporating isn't worth it in terms of the time and energy spent maintaining the corporation or the money spent to pay someone to do it for you.

YOU AND YOUR ESTATE

ESTATE TAXES
VALUATION
ESTATE PLANNING
WILLS
EXECUTORS

Some years ago, Arizona artist Ted de Grazia burned 100 of his paintings atop Angel Cliff in the Superstition Mountains in a romantic protest against estate taxes. According to a newspaper account of the event, de Grazia was reported to have said, "When I sell a painting and take in money, I expect to be taxed. But I don't think there should be a tax on paintings and other works of art that aren't sold. My heirs couldn't afford to inherit my works."

What he said wasn't exactly accurate, but he got his point across. The fact is that artwork left in an estate may be taxable, greatly increasing the value of the estate, and thus the taxes on it. Since de Grazia's protest, Congress has changed the laws regulating estate taxes so artists don't have to worry much about how their heirs will fare. The new laws have increased the amount automatically exempt from estate taxes as well as what a spouse can claim as a deduction. The result of these actions, explained below in greater detail, is that the estates of most artists will never be taxed at all.

Still, some artists' estates will be, and they may be taxed for one and only one reason: When unsold artwork is included in an artist's estate, the value of the estate is increased.

Before exploring how you may avoid the problem of inclusion of artwork in an estate, however, let's first look at estate taxes themselves.

How are federal estate taxes calculated?

First, all property you owned at death is totaled to arrive at a figure called the total gross estate. Property in the total gross estate includes life insurance policies, real estate, stocks, bonds, artwork, and so on.

Second, debts—such as medical bills, mortgages, and funeral expenses—are subtracted from the total gross estate to calculate the adjusted gross estate.

Third, a marital deduction (defined below) is deducted from the adjusted gross estate. The result is called the taxable estate.

Finally, once taxes have been calculated on this amount, a tax credit (defined below) is deducted to determine the amount the estate owes the federal government.

What is a marital deduction?

All property you leave to your spouse is automatically exempt from taxes. This is called a marital deduction.

What is a tax credit?

A tax credit is the amount that is automatically subtracted from estate taxes before they're paid. The tax credit is currently $192,800. Put in different terms, a tax credit is equivalent to an exemption of $600,000.

A tax credit applies to both estate and gift taxes.

What are gift taxes?

Gift taxes are taxes that are paid by the giver of a gift worth over $10,000. You can give away property worth up to $10,000 (or $20,000 if you give gifts jointly with your spouse) tax-free to as many people as you want each year. But you must file a gift tax return and pay a tax on gifts over that amount.

How are gifts taxed?

As of this writing, gifts (and estates) are taxed at progressive rates that rise from 18 percent to 50 percent. You can either give $600,000 away tax-free (on top of any $10,000 gifts) during your lifetime or leave the same amount tax-free in your estate—but not both. If you choose to give gifts during your lifetime, you must file a gift tax return and pay the tax. Then, when you die, the IRS adds the amounts of the gifts and the taxes back into the estate and it's given a tax credit of $192,000. Furthermore, you can generally make unlimited gifts to a spouse without payment of any gift tax.

How are income taxes paid when someone sells artwork he received as a gift?

When a person sells artwork he received as a gift, he pays income tax on the profits just as the artist would, i.e., he pays a tax on the difference between the sales price and the price of the materials that went into the work of art—if the artist has not already deducted them. So, if a person sells a painting he was given for $3,000, and the cost of materials was deducted by the artist, the gift recipient would pay tax on $3,000.

How are income taxes paid when someone sells artwork he received as a bequest?

The heir must pay income tax on the difference between the sales price and the market value of the artwork in the estate. So if a painting was valued at $4,000 in the gross estate and you sold it for $5,000, the heir would have to pay income tax on $1,000.

Will there be state estate taxes?

Your estate may be subject to a state tax, usually called an inheritance tax, if your state has such a tax. In fact, your estate may even have to pay an inheritance tax in several states. If you have property in more than one state—say you have a house in one and a vacation retreat in another—each state, if it has a tax, can impose tax on the property located within its borders.

The regulations governing state inheritance taxes vary greatly from state to state, so it's impossible to generalize about them; find out what they are in your state.

Isn't it highly unlikely that, unless I am a superstar artist making megabucks, I will have a taxable estate?

Probably, but many people don't realize the true value of their assets. So let's look at a hypothetical case.

Paul Artist and his working wife Ann lived in New York City. They had two children. Twenty years ago the couple purchased, very cheaply, a loft now worth $350,000 and an upstate cottage now worth $100,000. Mortgages on both were paid off. Paul had $50,000 in a savings account, while Ann owned $50,000 in stocks and bonds left by her parents and a $50,000 pension plan through her company.

When Ann died, she left her estate tax-free to Paul, who converted the pension plan into more bonds. When Paul died, he left 30 major paintings in his studio. His work sold regularly

through his gallery at $5,000 a piece, so it was valued at $150,000. The gross estate (to simplify, we'll assume the couple had no debts) totaled a whopping $750,000, forcing the children to pay taxes on $150,000 after claiming the $600,000 exemption.

So you can see that our hypothetical case isn't so unrealistic, particularly if you live in an area with inflated real estate values. Still, without that $150,000 worth of artwork in the estate, the children's tax bill would have been zero.

How can estate taxes be reduced?

Estate taxes can be reduced in two ways. First, your executor can place a low valuation on your work when calculating the value of your estate. The second way, estate planning, is discussed a little later.

What do you mean by valuation?

Valuation is the fair market value of any property at the time of death or six months after death, whichever is less. Or, as the IRS defines it, valuation is, "The price at which the property would change hands between a willing buyer and a willing seller, neither being under any compulsion to buy or sell and both having reasonable knowledge of relevant facts."

In other words, what a work would normally sell for if the buyer wasn't a close friend of yours buying work as a favor, and you or your dealer aren't cutting the price to pay the rent or for some other drastic personal reason.

Does fair market value include gallery commission?

Unfortunately, yes. The market value is what the property would sell for to a purchaser, not what you would net from a sale. The same principle holds true with other property, such as real estate and stocks and bonds. They're valued in the estate at what they sell for in the marketplace, without regard to broker's fees.

Who makes the valuation?

The executor of your will, whose role is discussed at the end of the chapter, makes the valuation.

How does the executor make the valuation?

He bases fair market value on what your work regularly sells for. If you didn't sell regularly before death, he will probably ask for a lower valuation of your work. To justify a low valuation, he'll

argue that, while your work was offered for sale over a period of time, the public didn't buy it, meaning that its value was lower than its selling price. For example, if you sold some works five years ago at $1,000 but nothing since, and you didn't reduce your prices, the executor will claim that your work wasn't worth $1,000 per piece. Instead, he might say it was worth $500 or $100, whatever he thinks is justified.

Why is a low valuation a good idea?

Because it reduces the value of your estate and, hence, the estate taxes.

How can an executor justify a lower valuation than fair market value?

More often than not, prices for artists' work decline rather than increase after death. Even if you're a popular artist, unless you have a solid critical reputation, chances are your prices won't hold up. A well-known lawyer was quoted in *American Artist* as saying:

I have a friend (not a client, I might add) who gets $15,000 to $20,000 a painting and has done so for years. If I were the executor of his will, I would take the position that his paintings were worth not more than, say, $10,000 at death, and I'd justify that amount by arguing that his prices might go down just as well as up. Fashions in art are capricious; what's in today is out tomorrow. Even if an artist has a big name during his lifetime, it may vanish quickly after death.

The lawyer told me in private the name of his friend, and he did indeed have a big name and one backed by purchases by the largest museums and by critical acclaim.

Is going for a low valuation the best course of action?

In most cases, yes, and the IRS usually accepts the line of reasoning mentioned above. Some executors with very prestigious clients, however, will claim the actual valuation of a body of work, arguing that it's more important to them to protect the artist's reputation than it is to reduce the value of his or her estate. In other words, in order to maintain sales prices at the level they were before the artist's death and increase them if they can, these executors won't want the word to get out that they undervalued the artwork, even though they did so only for tax purposes.

What happens if the IRS doesn't accept my executor's valuation?

After your executor files the estate tax return on your estate, the

IRS has three years to challenge the return. If the IRS challenges the valuation, the works are submitted to the IRS Art Advisory Panel for its valuation. This panel is made up of a rotating group of museum directors, curators, and art dealers.

What is estate planning?

Estate planning is what you can do now to reduce estate taxes and provide more income for your heirs. A complete discussion of estate planning is outside the scope of this book because we are concerned here only with what you decide to do with one particular kind of asset—artwork. But all your assets should be taken into consideration when planning a strategy to reduce taxes and maximize income for heirs. One way to reduce taxes, for example, is to make sure life insurance policies aren't calculated as part of the value of your estate. You can do this by signing over total rights to the policy to your spouse or child, although you continue to pay the premiums.

You might also consider setting up a trust. Trusts are estate-planning devices that give title of property to a trustee to use for the benefit of the beneficiaries.

How do you design an estate plan?

Estate planning is a total concept—what you can do now to maximize your estate when you die—that can only be put together after you assess your assets, your heirs' needs, and your life situation. You start by making an inventory of all your assets and calculating the taxes that must be paid on them. Then analyze the needs of your heirs by asking yourself such questions as: How much will my spouse need to run the household after I'm gone? Can he or she keep up the mortgage payments? Can he or she earn this amount or must I provide for it in the will? Must I provide some long-term support for an aging parent or a handicapped child?

Finally, you must take a hard look at the facts of your own life. For example, while eliminating a life insurance policy from your estate by signing all rights over to your spouse is a good way to reduce your estate, it may not be such a good idea if you have something less than the perfect marriage and divorce is a possibility.

In essence, what you're doing is examining a number of alternatives in view of your particular situation. Even the two basic objectives of estate planning—reducing taxes and maximizing income—may at times be seen as alternatives. Reducing taxes may, on certain occasions (discussed below), conflict with maxi-

mizing income. The whole point is to pick the best alternative to solve your estate problems.

Will I need professional help to do this?

Yes. A professional knows how to steer you through all the estate tax traps that might cost your heirs thousands of dollars. For example, the laws governing exemptions from state inheritance taxes vary from state to state, and the professional who knows how they work may be able to cut down the size of your state tax bill. A professional can also tell you when joint ownership of property is a good thing and when it's not. A professional can set up trusts for those whom you feel need long-term support but aren't capable of managing assets themselves. And a professional can advise you on the type of insurance best suited for your needs.

Who will I ask to be my estate planner?

First you'll want a lawyer to help you plan your estate and to write your will for you. As estate planning continues, you may want to request specific help from an accountant, an insurance agent, and officers in a bank trust department, if necessary.

When you pick a lawyer, make sure that estates are his or her specialty. General practice lawyers do not have sufficient expertise in the field.

How does artwork enter into estate planning?

As mentioned above, estate planning has two major objectives: to reduce taxes and to maximize income for your heirs. To achieve the first objective, you should try to reduce the value of your taxable estate by eliminating artwork. This can be accomplished by leaving art to a museum or other charitable institution in your will, so your estate can claim a charitable deduction, and by giving artwork away during your lifetime.

To maximize income, you can try: (1) to enhance the value of the artwork, so when your heirs sell it, they'll receive as much for it as they can; and (2) to insure that they'll pay as little income tax as possible on the profit they receive from the sale of artwork.

How does leaving work in my will to a museum reduce my tax?

Works given to tax-exempt cultural institutions, such as museums, schools, or historical societies, are eliminated from your gross estate as charitable deductions. If the market value of your paintings is $1,000 each and your estate gives twenty paintings to a museum, you will in effect have reduced your estate by $20,000.

Are there any other advantages to leaving work to museums?

Yes. A museum that knows it will get a bequest from you on your death may be highly motivated to sustain interest in your work. It may give you shows during your lifetime and commitments for exhibitions after death. This should increase your reputation and, hence, the market value of all of your artwork—both while you're alive and when your heirs sell works left to them.

If I leave work to a museum, can I demand that it be exhibited?

Not really. Although leaving work to a museum is generally a good idea because the museum may feel it's in its best interest to nurture your reputation both before and after your death, this isn't always the case. The largest and most prestigious museums— which are bombarded by bequests—refuse to accept any with strings attached. Others, particularly if they're financially strapped, may accept a bequest because they plan to immediately resell it. But all of this should be made clear in an agreement with the museum before you put any such bequests in your will.

What can I do to insure exhibition in a museum that I leave works to?

What you can do depends on the kind of clout you have and the kind of relationship you have with the museum (or other cultural institution). It may be possible for you and your lawyer to work out a compromise agreement with an institution that would be mutually beneficial. Take, for example, the agreement abstract painter Hans Hofmann made with the University of California. To make sure that his work would be displayed, he promised the university a considerable amount of money to build a wing to house his work. You, too, might have to offer the institution you're dealing with something—perhaps the right to sell a certain number of works in return for a guarantee to exhibit what's left in the bequest—in order for you to get the deal you want.

What if the museum fails to fulfill its part of the contract?

What happens then depends on your executor. If you've picked someone who's unable or unwilling to fight a legal battle for you, the institution will probably get away with it.

But, aside from what an executor can do after the fact, you may be able to take some preventive action in advance. You could, for example, demand that a clause be inserted into the contract giving your heirs the right to buy back the work at a specific price if the museum no longer wishes to stand by its part of the bargain.

Is there a disadvantage to leaving work to a museum?

Yes. While the estate taxes are reduced, the value of the estate will be decreased. In other words, your heirs may lose valuable income.

How do I decide which is best?

By making an inventory of your assets, recommended as a prerequisite to designing an estate plan, and figuring out the taxes on them. In this way, you can see what your heirs will have to live on after taxes. If your liquid assets (insurance policies, savings accounts, and other assets that can easily be converted into cash) are on the slim side, you might be more apt to bequeath a good portion of your work, thus reducing taxes. If, on the other hand, liquid assets are sufficient for your heirs and you're confident that the prices on your work will remain the same or rise, you might consider leaving all or almost all of your work to your heirs.

Is giving artwork away during my lifetime a good way to reduce the value of an estate?

Giving artwork worth $10,000 (or $20,000 if your spouse gives the gift jointly) each year is definitely a good strategy since it is tax-free. Giving away work worth more than this amount may not be a good idea, because it will be taxed at the same rate as assets in your estate.

Nevertheless, it may still be a good strategy to give artworks as gifts and pay tax on them, even if they're worth more than $10,000, if you expect them to appreciate in value. If they do increase in value over the years, your estate will be that much larger. For example, if you give three paintings now worth $12,000 to your son and pay gift tax on them, even if their value rises to $24,000 when you die, the other $12,000 won't be taxed.

From an income tax standpoint, is it better to give work away or leave it in an estate?

With respect to income tax, it might be better to leave it in the estate. The reason is that the heir who sells the painting pays income tax only on the difference between sales price and market value of the painting in the estate. A gift recipient must pay income tax on the difference between the sales price and the cost of the materials.

Why do I need a will?

There are basically three reasons why you should have a will: to insure that your estate goes to whomever you want; to reduce taxes and maximize income for those you want to be your heirs; and to make sure the assets in your estate are disposed of in the way you want and by whom you want.

What if I don't have a will?

In this case, all these matters will be decided by state law. If you don't leave a will, the state will decide who your heirs are—and they may not be the ones you had in mind. You might, for example, have wanted the entire estate to go to your spouse. But if you die without a will and you have a child or children, the state will decide who gets what. In New York state, for instance, if you have a spouse and two children and you die without a will, the children get two-thirds of the estate. Or you might want your estate to go to a friend because you were never close to your relatives. The state, however, will undoubtedly decide that members of your family should inherit the estate.

Who will dispose of my estate if I don't have a will?

The state will appoint an administrator to handle your estate. This person may be a family member or a complete stranger. If you had a will, you would have named your own executor to do the job, and you could have dictated in your will how you wanted it handled. You could have specified who was to have specific pieces—relatives, friends, cultural institutions—and how you wanted work sold, exhibited, and reproduced. Work left intestate (in an estate not covered by a will) and disposed of by an outsider appointed by the state—who probably has no knowledge of the art world—may not fare as well.

What does an executor do?

An executor administers the estate. This means he or she pays funeral expenses and all outstanding debts incurred before death, places a valuation on your work, files a tax return, and distributes the assets according to directions in the will. If artwork is used to pay taxes or provide income for heirs, the executor must try to sell it for the best price. He or she may also have to negotiate for reproduction rights and register copyrights. And since executors are bound by strict legal standards, they must act prudently and in the best interests of the estate. For example, an executor may have to decide whether a lucrative offer to reproduce one piece of

artwork, which would increase the heirs' income, would be detrimental to the critical reputation of a total body of work. All in all, the job of executing an artist's will can be a tricky one. (See the end of the chapter for whom to pick as your executor.)

Who should write a will?

You can legally write it yourself, but I can't think of a worse idea. This is not a do-it-yourself project—vague, improperly worded wills are frequently found invalid by the courts. So get yourself an estate lawyer, preferably one with an understanding of the commercial aspects of the art world.

What goes into a will?

Wills come in all sizes and shapes from the simplest to the most elaborate. In general, however, a will simply specifies what you want done with your assets. (If there are any specific bequests, such as a wish to give a particular work to a particular person, make sure the work is labeled, indicating that it's to become the property of the person named in the will.)

A will also names your executor and defines his or her powers. You can spell out how you want your artwork to be sold, exhibited, reproduced, restored, and altered, or you can put this in a letter of instructions.

What is a letter of instructions?

A letter of instructions is a set of guidelines for the executor to follow at his or her discretion in handling the estate. It's not a legally binding document, but it is extremely useful to the executor in fulfilling his or her duties.

How do I decide what goes into a will and what goes into a letter of instruction?

Since wills are legally binding, they should contain only those instructions about your artwork that you feel must be carried out by the executor. If you have properly planned your estate, you'll know precisely what these instructions should be. In other words, once you've determined what your assets are and what your heirs need, you can develop a policy as to how your artwork should be disposed of. Therefore, if you have other assets sufficient to satisfy the needs of your heirs, you can afford to define strictly what the executor may or may not do with your artwork in a will.

However, where artwork must be sold to maximize income for heirs or to pay taxes, you won't want to place so many restrictions

on the executor that he or she won't be free to make the necessary decisions to increase your heirs' income as much as possible. In this case, you should put your advice on these matters in a letter of instructions.

What instructions should I give concerning the sale of my work?

Suppose it's not necessary to sell artwork to pay taxes or provide income, and you have great faith in your dealer and wish her to continue to represent your estate after you die. In this case, you could insert a clause in your gallery contract providing for the continuation of her representation after your death. Then, in the will, you might say, "I hereby direct the executor to sell my paintings only through XYZ Gallery."

But if artwork must be sold to pay taxes or provide income, you may not want to tie your executor to one particular dealer no matter how pleased you've always been with her. Maybe they won't get along; maybe the executor should be allowed the flexibility to change galleries to get a better deal. So you might simply advise your executor in a letter of instructions to deal with the XYZ Gallery. This gives him the option of changing galleries if he thinks it best.

What should I say about exhibitions?

Some exhibitions of your work, whether you're alive or not, don't enhance your reputation. This might be because the work is shown in an inappropriate place or alongside inferior artwork. The point is that you have to figure out what sort of exhibitions are inappropriate so you can prevent your work from being shown in them after your death. For example, Mark Rothko, the abstract expressionist, considered the placement of his paintings within the Four Seasons restaurant located in New York's Seagram Building an inappropriate atmosphere for his work despite the fact that both the restaurant and the building are among the most elegant in the country. You may not be quite so particular, but you might object to the display of your work in a commercial venture, such as a restaurant.

Since the inappropriateness of exhibitions is somewhat difficult to define precisely, the place for such instructions would probably be in a letter of instructions rather than in the will.

What about repairs and completions?

You should leave instructions on how and by whom work should be repaired or restored and how and by whom it should be completed if you want it to be completed. Once again, the most

appropriate place for these instructions would probably be a letter.

What should I say about alterations?

Instruct your executor not to allow any alterations, unless, of course, you don't care whether your work is altered. You might not think this issue will come up, but look what happened to David Smith's estate.

David Smith, one of America's most important abstract sculptors, chose art critic Clement Greenberg as one of the executors of his estate, which consisted primarily of welded steel sculptures. In 1974, word leaked out that Greenberg had altered some of the works remaining in the estate: One work was stripped of its paint and apparently varnished, another repainted, and a third permitted to rust and deteriorate. It's hard to believe that Smith, who renounced one of his own works as "60 pounds of scrap steel" after alteration by a purchaser, would have wanted his work to be treated like this. But there was nothing in his will or in a letter of instructions that prohibited alterations.

So you might want to take a strong stand on this issue and state firmly in your will that your work is not to be altered in any way.

What should I do about reproductions?

Throughout your career, you may have maintained a certain policy in regard to reproductions. For example, you may have allowed your oil paintings to be made into reproductions suitable for framing. If so, you might advise your executor to continue this policy in a letter of instructions. But don't stop there. After your death, he may be confronted with a situation that never presented itself to you. Someone may come along and offer to reproduce your work in a totally different medium—jewelry, fabrics, or whatever. If the offer is lucrative, he may feel compelled to accept it, or at least seriously consider it, so as not to be accused by the heirs of wasting the assets of the estate. But would you want to see your work reproduced like that? Think about the possibilities involved in reproductions, far out though they may seem, and let your executor know your feelings on the subject in the letter of instructions.

Less extreme are the problems involved when executors and/or heirs reproduce sculpture.

What are the problems involved with sculpture?

These are ethical problems that arise when executors and/or

heirs, without any authorization from a will or a letter of instructions, cast bronzes, not from master plasters or waxes, but from bronzes made by the sculptor; enlarge the work; or translate it into new materials. The heirs of Julio González, for example, cast some of his works in bronze, although he always used iron.

How can I prevent these practices from happening?

The College Art Association recommends that you leave clear and complete instructions in a letter of instructions or a will as to how you want your work reproduced or whether you want it reproduced at all. You might, like Jacques Lipschitz, reject the idea altogether. Lipschitz said in his will:

These terra cotta and plaster models are the prime of my inspiration, my only true original work, and are the most precious property I possess. It is my desire that no reproduction of any sort except photographs be made from said terra cotta and plaster models.

Who can I pick to be my executor?

You can pick anyone, but your choice will probably be a family member, a friend, your dealer, your lawyer, or your bank.

Are executors paid for their work?

As a rule, executors who benefit from the will themselves waive all fees. Others are allowed to charge a fee that represents a percentage of the estate. The maximum percentage is usually limited by state law, and you can count on banks to go for the highest fees, with lawyers right behind them.

Can I have more than one executor?

Yes, but this is practical only if your estate is unusually large and complex or if you want to make sure that any conflict of interest will be detected by the other executor or executors.

What if the executor dies before my estate is settled?

You should provide for this event by naming an alternate (or alternates) in your will.

Who should I pick as an executor?

Choose someone with the following qualifications: absolute integrity; general business acumen (this might eliminate family and friends); specific knowledge of your art business (banks will, and

lawyers may, rate low on this score); and the ability to gain the trust and confidence of your heirs, to prevent arguments from arising between them and the executor.

Also, since settling an estate can be time-consuming and could take years to accomplish, look for someone who is young enough and possesses enough energy to get the job done.

Before you make a definite choice, make sure that there's no conflict between the interest of your estate and that of your executor. A conflict of interest would generally occur if your executor sells other artwork besides yours and might therefore be in a dilemma over whose work to promote more strenuously. In other words, an artist friend or a dealer might not be an ideal choice.

Who is the ideal choice?

Providing he or she has all the qualifications mentioned above, pick the person who will inherit the bulk of the estate. In other words, someone who has his own best interests at heart as well as yours, since you think enough of him to leave him most of your worldly possessions. This way you won't have to worry whether he'll do right by the estate or the other heirs. And such a choice won't deplete the estate with a large executor's fee. Even if your heir/executor retains a lawyer to help him settle the estate, the lawyer's fee will be—or should be—less than if the lawyer were the executor.

If your estate is very large and consists of much artwork that must be disposed of, you might consider joint executors. In this case, the wisest choice might be one executor with a wide knowledge of the art world and another with business expertise. In other words, your spouse, dealer, or an artist friend, and a lawyer or bank officer. If you choose a dealer or an artist as an executor, however, think about limiting his responsibilities strictly to those connected with your art—where his expertise lies—and let the bank or lawyer do the rest.

SELECTED BIBLIOGRAPHY

Chamberlain, Betty. *An Artist's Guide to the Art Market.* New York: Watson-Guptill Publications, 1983.

Crawford, Tad. *Legal Guide for the Visual Artist.* New York: Madison Square Press, Inc., 1986.

Crawford, Tad, and Mellon, Susan. *The Artist-Gallery Partnership.* New York: American Council for the Arts, 1981.

Feldman, Franklin, and Weil, Stephen. *Art Works: Law Policy, Practice.* New York: Practising Law Institute, 1974.

Goodman, Calvin J. *Art Marketing Handbook.* Los Angeles: gee tee bee, 1984.

Volunteers Lawyers for the Arts. *Art of Filing.* New York: Volunteer Lawyers for the Arts, 1988.

Volunteer Lawyers for the Arts. *To Be or Not To Be: An Artist's Guide to Not-For-Profit Incorporation.* New York: Volunteer Lawyers for the Arts, 1982.

Zigrosser, Carl and Gaehde, Christina. *A Guide to the Collecting and Care of Original Prints.* New York: Crown Publishers, 1965.

INDEX

Greenberg, Clement, 229
Gross negligence, 172
Guide to the Collecting and Care of Original Prints (Zigrosser), 128

Hailman, Johanna K. W., 201
Harry Neyland v. the Home Pattern Co., Inc., 159–60
Health insurance, 215, 216
Hobbyist, 180, 186, 197, 198, 199, 201–2
Hofmann, Hans, 157, 224
Home-studio deduction, 182, 194–95, 198
Hors commerce, 131
Hughes, Judge, 34

Illinois, print law in, 133, 135
Income: net, 194, 216; recording, 179–80; taxable, 192–93, 198
Incorporation, 116, 119–20, 214–16
Individual retirement account (IRA), 210, 211–13
Injunction, 18, 35
Inland marine insurance, 167, 171
Installation, 70, 71, 103
Insurance, 47, 50, 102, 112, 147, 165–75, 192, 212, 213, 222; all-risk, 166, 167, 168, 171; amount of coverage, 169–70; casualty, 173; commercial package, 173; dealer, 102, 170, 171–72; fire, 166–67, 168, 172; group plans, 172, 174–75; homeowner's, 173; inland marine, 167, 171; liability, 70, 173–74, 215; museum, 149, 152, 167, 171–72; personal articles floater, 167–68; property, 172–73; valuation of work for, 149, 152, 168–69; wall-to-wall coverage, 171; workers' compensation, 174
Interior designer, 64, 90
Internal Revenue Code, 200
Internal Revenue Service (IRS), 118, 120, 176, 177, 178, 180, 182, 183, 186, 193–94, 198, 199, 200, 204, 205, 212, 213, 215, 220, 221–22
Invasion of privacy, 155, 156, 158–60, 164
Investments, 210–13
Invoice, 43, 44–48, 207
Italy, 36

Jackson, Robert H., 34

Jacobs, Lenore, 55
Juried show, 17, 51–52

Kennedy, Edward, 37–38, 49
Keogh plan, 210–13

Labor, cost of, 40, 60–61
Lawyers, 30, 115, 116, 120, 203, 216, 223; in drafting contract, 16, 85; estate, 227; volunteer, 16, 17
Lawyers for the Creative Arts, 17
Legality of purpose, 10–11
Letter of agreement, 14–15
Letter of instruction, 227–30
Liability insurance, 70, 173–74, 215
Libel, 11, 155, 156–57, 159, 164
License, exclusive and nonexclusive, 32
Limited edition: prints, 130, 132, 133; reproductions, 144
Limited liability, 116, 119, 214–15, 216
Lipschitz, Jacques, 230
Loss. *See* Damage and loss

Maintenance, of commissioned work, 68, 74
Maquettes, 22, 57, 62
Maryland, 84
Massachusetts, 84, 102; moral rights law in, 37, 49
Master printer, 127, 129
Materials and supplies: for commissioned work, 70, 71; costs of, 60, 193–94; tax-exempt, 208
Merchants, contracts between, 16
Michigan, 84
Minnesota, 83, 102
Minors, and obscenity, 162
Models, 22, 63
Mon Oncle d'Amérique, 36
Moral rights (reserved rights), 36–37, 48, 49, 74
Morris, Robert, 55
Mugging of the Muse, The, 157
Mural Manual (Rogovin), 174
Murals, 70, 73, 161–62, 173–74
Museums, 10, 12, 148–54; bequests to, 223–25; commission, 49, 152; discounts, 43, 90, 153; donations to, 152, 192–93; insurance, 149, 152, 167, 171–72, loan agreement with, 148–49, 150–51; Museum of Modern Art, 20; rental contracts

with, 49–50; sales to, 153, 154; Whitney Museum of American Art, 149, 152

Mutual agreement, 11

National Endowment for the Arts, 118, 121

Negligence, 171, 172

Net price system, 81–82

New Hampshire, obscenity law in, 161–62, 163

New Mexico, 84

New York City, cooperative galleries in, 107, 109

New York State, 84, 159, 162, 226; moral rights law in, 36, 37, 49; print law in, 132–33

Neyland, Harry, 159–60

Nonexclusive rights, 32, 33

Nonprofit organizations, 117–18, 119–25; funding of, 118, 121–25; incorporating, 116, 119–20; tax-exempt, 118, 120–21

Obscenity, 11, 23, 155–56, 161–63, 164

Offer, 13, 14

One-year rule, 12–13

Option, 14

Oral contracts, 10, 12, 13, 15–16, 18–19

Oregon, 84, 102

Organizations. *See* Nonprofit organizations

Paintings, 11, 13, 15, 20, 21–22, 25, 36, 37, 54, 56, 57, 60, 61, 77, 91, 219, 221, 228

Partnerships, 116–17

Patent, 38

Payment: for consignment sale, 93, 97; date, 46; default, 72, 93; late, 76; schedule of, 71–72, 140; *See also* Royalties

Penalty clause, 75

Percent for Art Program, 76

Personal articles floater, 167–68

Photographs, 22, 34, 36, 37, 42, 43, 57

Police, seizure of artwork by, 162, 163

Portraits, 56, 60–61; fee for, 61–62; permission for, 159; rejected work, 73, 159

Preliminary work, 62–63

Price, pricing, 14, 39–42, 51, 142; charitable sales/auctions, 50; cost calculation in, 40–42; discounts, 43, 80, 90; net, 81–82; recordkeeping, 42–43; sales, 81, 90–91, 96; wholesale, 137; *See also* Fee

Print Council of America (PCA), 126–27

Printer's proof, 131

Prints, 37, 126–35; cancelled plate, 131; categories of printmakers, 127; hors commerce, 131; laws governing documentation of, 47, 132–35; limited editions, 130, 132, 133; numbered, 29–30; original defined, 126–27, 128; posthumous sale of, 131; printer's proof, 131; publisher of, 127, 137–42; *vs* reproductions, 128; restrikes, 130–31; signed, 128–29; states, 132; trial proof, 132

Print workshops, 138

Prizes and awards: in juried show, 17, 51; purchase, 149; taxable, 192

Profits, 37, 39, 41, 108, 138, 214, 219; motive, 199–203

Profit (or Loss) from Business or Profession (Schedule C), 188, 190–91, 192, 193, 198, 199

Property insurance, 172–73

Proposal, 57, 60, 62, 124

Publication: accidental, 20, 24, 28; defined, 23–24, 32, 35; rights, 144

Public domain, 23, 153

Publicity, and credit clause, 74

Publisher, 11, 12, 18, 21, 136–54; defined, 136; of original prints, 127, 137–42; of reproductions, 142–47

Radlich flag desecration case, 160

Reasonable person, and obscenity, 161

Receipts: check as, 177–78; consignment, 89, 96, 100; file of, 178

Recision, 18

Recordation, certificate of, 33

Records, 42–43, 169, 176–87, 207

Registration, certificate of, 26–27

Rentals: contract, 49–50; dealer, 94, 97, 101

Reproduction, 11, 18, 20, 22, 25, 31;

Edited by Brigid A. Mast
Designed by Bob Fillie
Graphic Production by Hector Campbell